Bezalel's Body

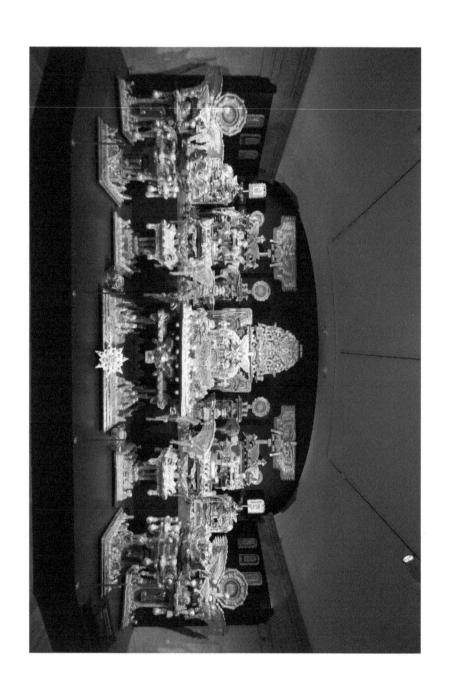

Bezalel's Body

The Death of God and the Birth of Art

KATIE KRESSER

Foreword by Bruce Herman

CASCADE *Books* · Eugene, Oregon

BEZALEL'S BODY
The Death of God and the Birth of Art

Copyright © 2019 Katie Kresser. All rights reserved. Except for brief quotations in critical publications or reviews, no part of this book may be reproduced in any manner without prior written permission from the publisher. Write: Permissions, Wipf and Stock Publishers, 199 W. 8th Ave., Suite 3, Eugene, OR 97401.

Cascade Books
An Imprint of Wipf and Stock Publishers
199 W. 8th Ave., Suite 3
Eugene, OR 97401

www.wipfandstock.com

PAPERBACK ISBN: 978-1-5326-4564-8
HARDCOVER ISBN: 978-1-5326-4565-5
EBOOK ISBN: 978-1-5326-4566-2

Cataloguing-in-Publication data:

Names: Kresser, Katie, author.

Title: Bezalel's body : the death of God and the birth of art / Katie Kresser.

Description: Eugene, OR: Cascade Books, 2019. | Includes bibliographical references.

Identifiers: ISBN 978-1-5326-4564-8 (paperback). | ISBN 978-1-5326-4565-5 (hardcover). | ISBN 978-1-5326-4566-2 (ebook).

Subjects: LCSH: Art—Philosophy. | Art—History. | Christianity and art. | Aesthetics—religious aspects—Christianity. | Theology and art.

Classification: BR115 A8 K74 2019 (print). | BR115 (ebook).

Manufactured in the U.S.A. 11/07/19

For Todd, Ellis and Zani,
who put up with my hermetic habits.

The pronoun "You"
Is a heavenly thing,
A vibrating string,
That makes my heart sing.

*

Oh the angels are robed
In heavenly white,
And witness the beautiful,
Noble and right,

And look on the tower,
Like adamant flower,
Where creatures are twined
In all sweetness and power.

*

. . . but they most love to see
In the deep Trinity
The wellspring of everything true:

The secret of
Pronoun
"You."

—k.k.

Contents

Illustrations*

* See my text captions for more information about the interior artworks. All object sizes are rounded to the nearest centimeter, except in cases where dimensions are unobtainable or the object is very large.

Foreword

By Bruce Herman

Katie Kresser's words consistently break open a space for the sustained human gaze—for seeing and responding afresh to the mystery of works of art in all their particularity and stubborn physical presence. She clears away obstacles preventing our seeing and authentically encountering the work of art—enabling us to benefit from Art's *work* among us. And her big idea is that Art does indeed have work to do among us, all of us, that in it may be an antidote to the prevailing malaise of our time: functional narcissism, a widespread phenomenon symbolized perhaps in the technological and social power of the camera "selfie"—self-images we generate promiscuously with little regard to any real communal identity. We are no longer defined by "duty" or membership in a defined community to which we must affiliate. We are increasingly autonomous creatures who "invent" or define ourselves over and over again via social media—and there are fewer and fewer claims on our identity other than our own whimsy, neurosis, vanity, or perceived and real isolation.

Dr. Kresser asks afresh a very old question: "What is Art?" and she finds in Art a means of establishing worth and meaning outside the self—in the space beyond our own skin, beyond the selfie. Her concept is elegant and simple on one level—but her argument inquires of Art regarding its capacity to point beyond the tendency of humans to hide from themselves, from others, and from God. Art, according to Kresser, is *otherness* manifest—and as such calls us out of hiding, out of ourselves and into the world—a dangerous world of real others and their claims on us and upon our identities. In the last stanza of T. S. Eliot's magnum opus *Four Quartets*, just before the poet quotes Julian of Norwich's "all shall be well and all manner of thing shall be well" he writes of a ". . . condition of complete simplicity / Costing not

less than everything . . ." and that costly simplicity is precisely what Kresser points toward in *Bezalel's Body*. It is the potential "unity of consciousness" that the Catholic theologian Hans Urs von Balthasar examines in his magisterial *The Glory of the Lord*. This simplicity is one that contains within itself the potentiality for all things—for it is the "still point of the turning world" and the icon of God invoked in Colossians 1: 15–17:

> He is the image of the invisible God, the firstborn of all creation. For by Him all things were created, both in the heavens and on earth, visible and invisible, whether thrones or dominions or rulers or authorities—all things have been created through Him and for Him. He is before all things, and in Him all things hold together.

Art is *otherness* manifest—and art derives, according to Kresser, from the very life of the Holy Trinity—which is otherness revealed within the very being of God, from Christian tradition enshrining the Incarnation, making art possible. It is the very nature of the Trinity to be in relationship—not self-contained autonomy—and therefore also as the prime source for generating images. Images flow from our ability to see the face of the other—and God is the source of our ability to enter into relationship and to live before the face of the other.

Relationship and otherness are constitutive of Being itself. God is not a monad—not a singular being that absorbs all into Itself, but a Person or persons in eternal conversation, in communion. The ultimate simplicity of Being itself is from and for and toward communion—and Art has the special role to point in this direction, away from the solipsism of an autonomous self, and outward toward the Other, toward that same communion. In Dr. Kresser's account, the biblical story itself is Art—a set of images offered to our minds and hearts and lives—images that point toward the consummation of the ultimate relationship between God and God's creation. And the God that Kresser writes about is not one who creates in order to establish Its own worth—but rather for the sake of the Creation itself, to place the value and worth outside God's self. We are invited into the dance of *perichoresis*—the Trinitarian mutual indwelling grounded in God. This "three-personed God" (Milton) engages in *kenosis*, in creating space for others. And Art is analogous: the artist creates a work that exists outside herself, making space in the self for that work, and in so doing there is temporary self-loss. This then, according to Kresser, is the primordial art act—the self-emptying of God in the very act of creating "something rather than nothing," and in so doing allowing limitation on

God's own being. This is what artists do at their best: empty themselves in the act of making—a high-risk enterprise with no guarantees.

Dr. Kresser examines, as her first consideration, the African American janitor and self-taught folk artist James Hampton whose *Throne of the Third Heaven of the Nations' Millennium General Assembly* is a near-miraculous assemblage of trash and cast-off materials transfigured to evoke the throneroom of St. John's vision on Patmos, the book of Revelation that caps the Christian Bible. Hampton had no fame or art career, and he created this masterpiece in his garage—away from public acclaim and critique. He created it from an inner compulsion akin to the need for sleep and food, the high-risk activity of making without guarantees. Hampton *had* to make this astonishing piece of art. It was not aimed at self-aggrandizement or money or worldly acknowledgements. It came from that "condition of complete simplicity costing not less than everything"—the urge to create regardless of risk.

Kresser goes on in her account of Art to explore the deep need for this simplicity and unity of consciousness, where artist and artifact play a substantive role in community—pointing the way out of the maze of the isolated self. She develops her theme and variation in a series of insightful chapters that examine in succession the Christian contribution to cultural history (specifically the history of Art); a theory about the space between us and "zones of subjectivity"; the politics and poetics of self-understanding and Art's unique role for mediating the social and politico-religious spaces between us; and finally the central mystery of God's artistic self-emptying as mirrored in human making and in the stubborn reality of the Art object—the "body" referred to in her title.

That "body" is the central reality of God's creation "by water and the word"—the ultimate lover of the Creator, a God who creates for genunine relationship, not for self-glorification. The glory of the Lord (per Balthasar) is paradoxically discovered in God's death and dying (in our place)—that is, God's glory is in the loss of glory—loss of self, and is perfectly sung about in the great Christ Hymn contained in St. Paul's letter to the church at Philippi (Philppians 2: 6–10):

> . . . who, although He existed in the form of God, did not regard
> equality with God a thing to be grasped, but emptied Himself,
> taking the form of a bond-servant, and being made in the like-
> ness of men. Being found in appearance as a man, He humbled
> Himself by becoming obedient to the point of death, even death
> on a cross. For this reason also, God highly exalted Him, and
> bestowed on Him the name which is above every name, so that

at the name of Jesus every knee will bow, of those who are in
heaven and on earth and under the earth . . .

That loss and the death of God are the occasion for the birth of those
who choose God and who become God's people on earth—children of One
who humbled himself. Bezalel's "body"—symbolized in the Tabernacle built
with architectural plans supplied by God!—becomes the ultimate place of
meeting between God and humankind, not in a desert with a pillar of cloud
or fire, but in the Incarnation itself and also in human community brought
into being by Art.

The *Body* in Dr. Kresser's title is therefore also *us*—the human race—
the creatures God has made. . .creatures who become makers in God's own
image. And we find our peace, our ultimate vocation in this: that we can
become co-creators with the Creator, making things that manifest love and
unity and shalom—that divine peace which alone can heal our divisions
and soul-sickness. Katie Kresser has cleared great obstacles away toward
that end through this small book with an expansive idea. And as a painter, I
am deeply grateful for her pioneering work here.

Preface

This book tries to explain why, spiritually and historically speaking, visual art has been a big deal. It tries to explain the mystique of the thing we call "art," and it tries to undergird that mystique with theological truths. That might seem like a strange thing to attempt. Isn't the value of art more or less obvious to everyone, after all? Unfortunately, it's clear that it's not. In many Christian religious circles, for example, visual art has been poorly understood for centuries (that's why it's almost absent from much Christian practice). Meanwhile in the art world, the search for meaning often takes a backseat to commerce. Few institutions, therefore, are left to carry the flame.

Now, who should care about that? Well, there are a lot of professionally-invested people who should care (artists, museum curators, art collectors, and art historians like me). But that's not all. I think there are a lot more people who *would* care if they had available to their minds the full range of imaginative possibilities history has to offer.

The place and time we are born into dictates what our imaginative horizons will be. That is a very scary thing. It means that if we're unlucky (due, perhaps, to tragedy, oppression, misinformation, or war), there are whole categories of wonderful things that can just disappear from social consciousness—that can become as if they had never existed. Imagine if you had never seen a rainbow, and thus didn't have a word for one. Or imagine if you didn't know about Shakespeare, and so the names "Romeo" and "Juliet" didn't have any meaning. The things we experience, and the things that are handed down to us, carve out spaces in the big, dark, unknown of the universe—they are like lenses or windows—that expand our understanding and give us metaphors for grappling with existence. The thing we call "art" is one of the most powerful of these metaphors, but I'm afraid we're losing a sense of its meaning.

Visual art (think of a painting by Leonardo da Vinci) is a very important part of our mental furniture, and it was gifted to us by a Christian worldview that is at least partially fading away. We can think of visual art like a great wardrobe or fireplace—homey and majestic, familiar and mysterious, imposing and inviting all at once. It sits there, agreeably waiting, and it holds something vital inside. As this book will show, the thing it holds is the secret to loving *otherness*—to loving the richness of everything separate from the egotistical self.

I want to help us rediscover the core meaning of art before our collective social imagination, in the twenty-first century, gets going too far in the wrong direction. There are many other things, in these turbulent days, that we likewise need to discover and hold on to. Art is just one. So this book is just a tiny part of the imaginative reclaiming we need to do. But I hope it can go a little ways toward a kind of shoring-up, a kind of gathering-up of good things, at this moment so late in history but also at the brink of something new.

Acknowledgments

I wouldn't have been able to complete this book without the help of lots of people. The artists Laura Lasworth, Scott Kolbo, Alison Stigora and Andrew Hendrixson, along with my pastor the Rev. Matt Poole, all listened to my ideas and read parts of the text. The artist and theologian Shannon Sigler gave me valuable feedback early in the writing process. The Japanese art historian Michitaka Suzuki sowed intriguing seeds in my imagination and helped me understand Christian imagery from a different cultural perspective. The artist, writer, and educator Bruce Herman (who also wrote my foreword) was an invaluable sounding-board and cheerleader, and my conversations with him over the years have undoubtedly helped crystallize this book's central ideas. The theologian Rick Steele graciously commented on the later drafts of this manuscript, bringing to bear all his erudition, ear for language, and eye for detail; for this I am extremely grateful. Librarian extraordinaire Kristen Hoffman helped me hunt for images and navigate the copyright landscape. And of course the editorial team at Wipf and Stock, including editor-in-chief K.C. Hanson, provided invaluable help polishing and fact-checking. I'd also like to thank the Center for Scholarship and Faculty Development at Seattle Pacific University for a grant that enabled inclusion, here, of more color illustrations than I'd originally hoped for. And finally, I'd like to thank my family: my husband, Todd, my daughters, Ellis and Zani, and my mom and dad, for their patience and support. It's hard living with (or constantly babysitting for) someone who's writing a book.

Introduction

Art and Otherness

PRICELESS

In 2017, a recently discovered painting by Leonardo da Vinci titled *Salvator Mundi* ("Savior of the World") sold at auction for an unprecedented 450 million dollars. This relatively small oil painting depicts Jesus Christ, fulcrum of the Christian religion, looking outward and holding a crystal globe in his left hand. His right hand is raised in a traditional gesture of blessing, familiar from Byzantine icons stretching back to the early centuries of the Christian faith. Leonardo's trademark "smokiness" (*sfumato*) is evident in the painting, recalling the famous *Mona Lisa*. (In fact Christie's auction house, which sold the painting, marketed the work as "the male *Mona Lisa*.") The artwork is thought to have landed in the collection of the Emirati royal family and is slated to debut at the Louvre Abu Dhabi.[1]

1. The *Salvator Mundi* was expected to debut at the Louvre Abu Dhabi in early 2018 but has not gone on display as of autumn 2019. The art media is abuzz with rumors of its destruction or disappearance. For a summary, see Small, "Has the Salvator Mundi *Really* Gone Missing?"

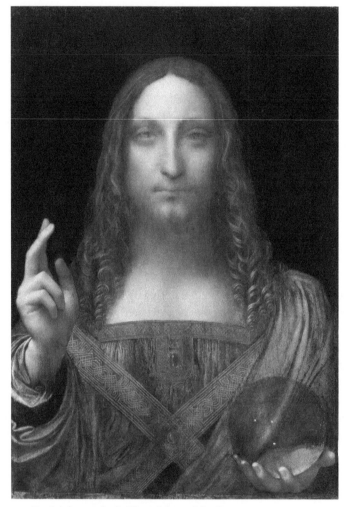

Fig. 0.1. Leonardo da Vinci, *Salvator Mundi*, ca. 1500, 45 x 66 cm.
Photo courtesy of Tim Nighswander/Imaging4Art
and Salvator Mundi LLC/Art Resource, New York.

But why did a Muslim family purchase a Christian painting for more than 450 million dollars—an amount greater than the GDP of several small countries? Why, furthermore, did the work attract interest from collectors as far away as China, Russia, and Saudi Arabia? There are many reasons—some political, some economic, some aesthetic, some no doubt spiritual. But overall, this episode highlights something unique about visual art: of all things made by human hands, visual art stands out for its ability to radiate pricelessness. In the fine art object, unimaginable value is concentrated into

a small and precious space. But why? How can we explain the mystique of something like the *Salvator Mundi*? What, in other words, is "Art," and what is its appeal to the human soul?

This book offers a scaffolding for understanding the central use of visual art in the world. Its argument is built on two simple premises: 1) that the individual human life is best understood as a journey in *coming to terms with otherness,* and 2) that fine art is a symbolic embodiment of that "otherness." Every one of us is destined to answer this singular moral question: will I commune with the good things outside of me (God and his "very good" creation),[2] or will I focus on myself? Visual art, I will argue, gains its power from configuring that "good outside"—in its sheer, independent, *outsideness*—for the viewing consciousness. It continually poses that central moral question (where will I look?) under different conditions and guises, every time we approach it, every time we glance. And the artwork has another, more fraught mystique, for it takes this core dynamic and makes it portable, purchasable and (in some ways) controllable. In so doing, it can arouse an almost magically captivating desire. Have history's iconoclasts been right to destroy fine art? I don't think so. But their sense of its danger is compelling proof of its power.

It's very difficult to think about visual art clearly—especially the prestigious kind destined for museums, the secular temples of the modern world. This is because our notion of art is so intertwined with anxieties and resentments about status. The appreciation of "good" art has come to signal sophistication and well-roundedness, and by extension, membership in the elite. The understanding of obscure, esoteric art connotes insider knowledge or rare genius. A deep feeling for the beauty of art has come to signal exquisite complexity and sensitivity—another kind of genius. The elevated contexts of fine art (the prestigious museum, the austere gallery, the swanky auction house) induce feelings of competitiveness and self-consciousness, and these associations emanate down even into humbler spaces. It's difficult to pinpoint authentic value within this fog of conflicts of interest. But even these moral traps speak to something foundational about visual art: such corruption is possible *because* of fine art's moral symbolism. As a proxy for *otherness,* fine art seems almost ensouled. Thus ownership over it (whether actual physical ownership or intellectual "ownership" in the form of understanding) is almost like owning a universe, or owning of a fragment of God.

It's an interesting historical curiosity that a word for "art," as we understand it today, was largely unknown to the very ancient world, and was

2. By "good things," here, I mean generally God's good creation. "God saw all that he had made, and it was very good" (Gen 1:31).

even unknown to many non-Western cultures until our modern era of glo-balization. In this book, I will argue that "art" is an invention of Christian culture—a response to the Christian paradigm shift that yielded a disori-enting new perspective onto the divine. Art's core role, I will argue, was to configure a new kind of *positionality* between God and humankind—a positionality that was initially very difficult to grasp and sustain. I think viewers of art have always unconsciously felt this, but now is the time to state it outright.

Put another way, art, as an exalted but elusive object of contempla-tion, insisted on the maintenance of what I will call *axis* in the new human–divine relationship that Christianity unveiled. With the dawn of the Chris-tian paradigm, two spiritual propositions became clear 1) that humans were meant to exist in *personal relationship* with the divine, and 2) that humans were charged, as a necessary corollary, to *maintain distance* from the divine across an axis that could be symbolized by the *gaze*. In the new Christian world, individuals were bid to move around this axis, ever spinning and looking, but they could never come unmoored—they could not (or should not) collapse the distance between themselves and the Divine Other they faced. If they did, a dynamic spiritual equilibrium would be compromised; the divine dance would fall into chaos, its beautiful choreography lost.

Like all human expression, this book is an extension of its author's per-sonal experience. I am an art historian, specializing in the art of the modern West (and particularly the art of the United States), though I began as a student of Early Christian and Medieval art. I was born and raised in a small Midwestern agricultural town, estranged from (and even hostile toward) so-called "elite culture," though I ended up receiving my graduate degrees from Harvard University. This background, I think, has made me interested in investigating the real meaning of the Western cultural "canon"—a canon that often seems to be the exclusive domain of the elite, but which really came from grassroots social drives. On top of this, I am a Christian whose worldview is thoroughly informed by the historical claims of traditional Christianity; this has led me to recognize similarities between my present and the Early Christian past. Finally, I am a woman and mother whose per-spective is informed by her social role and all that implies: her experience of life-generation and childrearing, her awareness of being visually objecti-fied, and her early steeping in a religious culture (known as "evangelical") of moral judgment and striving that could often take on a highly gendered cast.

This book is addressed, then, to different but overlapping groups. First, it is addressed to Christian thinkers of all kinds (theologians, pastors, crit-ics, artists, and patrons of culture) who may be interested in getting to the

bottom of the spiritual power, so double-edged, that art seems to wield. (I am particularly mindful of Christian communities that have been starved of the visual in worship.) Second, this book is addressed to art-thinkers of all kinds (whether Christian or not) who seek greater understanding of the "art" phenomenon and its Christian-cultural roots; indeed, there is renewed interest in the secular academy today in the theological origins of the thing we call "art."[3] Third, this book is addressed to people who, like me, have felt a strong ambivalence toward the "canonical" Western tradition—an ambivalence stemming from powerful attraction joined with a sense of exclusion. (This may include people deeply invested in today's debates around race, gender, sexuality, and other forms of identity.) And finally, this book is addressed to anyone interested in a history of human consciousness as it evolved under Christianity, both as a social construct and a response to mysterious forces. I believe visual art, properly understood, can illuminate much that is strange and confusing in our postmodern, digital age.

BEZALEL'S BODY

I have argued that fine art, as a Christian invention, is meant to convey *otherness* of a particular kind, and is also meant to embody how relationship with that otherness should be practiced. Christianity, of course, emerged from Judaism, and the Hebrew Bible itself contains a few important examples of objects that modeled a similar, elusive otherness to early audiences. Indeed, because the ancient Israelites rejected the possibility of "living," manipulable idols, their sacred works were the closest things to today's art in the ancient world.

One work that foreshadowed the Christian art-of-otherness was the Hebrew Tabernacle: a sacred space centered on the Ark of the Covenant and thought to contain precious and miraculous relics. The Tabernacle's exterior was dazzling, covered with jewels and precious metals. The Ark within was surmounted by two golden angels facing each other across a void. This was the treasure immortalized in pop culture through movies like *Raiders of the Lost Ark*, and remnants of the Tabernacle are supposedly preserved in locations as far flung as Rome, Ethiopia, South Africa, Ireland, and Egypt.

3. See for example Crow, *No Idols: The Missing Theology of Art*. Thomas Crow is a leading scholar of early modern art who, after a decades-long career, has identified theology as the "missing" vector in analyses of the rise of modernism. Operating from the theological (rather than the art-historical) side of the divide, the theologian William Dyrness and the artist Jonathan Anderson have recently shown how theological subtexts have frequently been present (if unacknowledged) in modernist art. See Anderson and Dyrness, *Modern Art and the Life of a Culture*.

By considering this "priceless" prototype we can begin to understand the function of art for human consciousness.

In Exodus chapter 31, the narrative recounts how a man named Bezalel was chosen to lead the construction of the Israelite Tabernacle and the Ark of the Covenant:

> Then the LORD said to Moses, "See, I have chosen Bezalel son of Uri, the son of Hur, of the tribe of Judah, and I have filled him with the Spirit of God, with wisdom, with understanding, with knowledge and with all kinds of skills—to make artistic designs for work in gold, silver and bronze, to cut and set stones, to work in wood, and to engage in all kinds of crafts.[4]

The language here is oddly descriptive. Why didn't God simply say that Bezalel was gifted and leave it at that? Instead, far from giving imperious assurances, God spelled out for Moses how Bezalel would be something like today's multi-media artists: he would work in gold, silver, and bronze; he would cut and set stones; he would work in wood. No available material would be neglected, and Bezalel's skill would showcase all. Indeed by listing these materials, the author of Exodus gives us an immediate sensory impression of things like physicality, texture, and luster. The gold and silver promise to glimmer. The stones will be heavy and smooth. The wood, in contrast to the stone, will be warm and brown and grained, and just a little more pliant, more fragile. An aesthetic feast is promised.

Later, the Lord goes on:

> I have given ability to all the skilled workers to make everything I have commanded you: the tent of meeting, the ark of the covenant law with the atonement cover on it, and all the other furnishings of the tent—the table and its articles, the pure gold lampstand and all its accessories, the altar of incense, the altar of burnt offering and all its utensils, the basin with its stand—and also the woven garments, both the sacred garments for Aaron the priest and the garments for his sons when they serve as priests, and the anointing oil and fragrant incense for the Holy Place. They are to make them just as I commanded you."[5]

This is another passage of excess—foreshadowing, perhaps, the theologian Paul Tillich's beautiful formulation of "holy waste"[6]—and here

4. Exod 31:1–5.

5. Exod 31:6b–11.

6. "Holy Waste" is that excess of love and exuberance from which both the creative act and the beautiful gesture come. A paradigmatic example is Mary Magdalene's "waste" of perfume poured on the feet of Christ. This kind of "waste" not only honors

specific objects are mentioned. There's the "pure gold lampstand"; imagine its brilliance. There's the rounded basin; the woven garments both soft and rough; the anointing oil with its viscosity; and the fragrant incense with its pungency, its cloudlike ephemerality, its gaseous ability to flow and surround. Almost all of our senses are activated through this description. God, in fact, is assuring Moses that the new tabernacle will be a fitting emulation of the prophet's own multi-sensory experience of the burning bush, with its dazzling blaze, its smoky odor and its accompaniment by the voice of God.[7] When it comes to his people's psychological need for an object of reverence, in other words, God will provide. In their richness, these biblical passages record one way of manifesting the assertive, perplexing "otherness" all art would come to evoke.

As a template for later artistic practice, there are at least two ways to view this passage about Bezalel. One view casts Bezalel as a "prophet" (albeit a visual one) whose work should stand alongside that of verbal prophets as dogmatic and authoritative. That's one reason why Bezalel has often been invoked to bolster the importance of "Christian artists."[8] Just like Old Testament prophets and Christian pastors, Bezalel is "called" by God and equipped with skill from on high. In the traditionally aniconic (that is, image-free) Protestant church, especially, Bezalel has been used to rescue Christian artists' self-esteem and make a forceful case for why artists should be heeded at the highest levels of the Christian spiritual hierarchy. According to this interpretation, artists are prophets who send messages not in words, but in media like paint or stone.

To view art as *communication*, however, is to miss something fundamental about its essence. Thus a second way to think about the above passage in Exodus is to consider the proxy *body* it demands. Unlike words (which in their deepest form are spoken), artworks are *material things* that stand in opposition to their audience. Even when they are composed of mere light projected on a screen, visual artworks stand outside the viewing eye to *confront* it. Thus the title of this book, *Bezalel's Body*, does not refer to the physical body of the artist Bezalel himself, but to the tabernacle-body that Bezalel made. Quite apart from any inspiration, gifting, or authority, Bezalel and his fellow craftsmen were responsible for manifesting a new kind of platform for interaction. Bezalel did not convey prophetic messages so much as he provided a space for psychological alignment. His tabernacle

God, but it is essential for our mental health and happiness. See Tillich, *The New Being*, Chapter 6.

7. Exod 3.

8. See, for example, Noland, *The Heart of the Artist*. Bezalel is discussed several times in this text, perhaps most notably on pg. 36.

demanded confrontation, acceptance, and in the end, respectful distance (of course, the Ark could not be touched). In short, it enforced an axis of "otherness" in both body and spirit.

I use the word "otherness" here to encompass our experience of anything truly outside of ourselves—whether an ineffable God, other human beings, or even natural objects insofar as they make claims to our respect. The Bible cryptically posits that we are "fallen," and central to this condition is the fact that other wills besides our own are fundamentally disorienting and threatening, resulting in movements to subsume, over-master, self-isolate, self-negate, or co-depend. Indeed the Bible's foundational narratives— first about Adam and Eve in the Garden of Eden and second about Cain and Abel—illustrate this fact clearly, as my next chapter will discuss. Our "fallenness" makes interpersonal contact inherently dangerous and deeply traumatizing, even from earliest childhood. And because our understanding of God is often mediated by our experiences with the physical world, this trauma makes apprehension of the divine especially difficult. For this reason the Tabernacle—and all art, which brings otherness to consciousness—was born.

But the Tabernacle and the Ark also manifested something stranger— and even more redemptive. The subtitle of this book mentions not only the "birth of art," but the "death of God." Perhaps there are Nietzchean resonances here (and the attentive reader will find that this book draws heavily on Romantic-era philosophy), but the "death of God" I discuss is not a genuine snuffing out. Rather, I am referring to an interpretation of death as *necessary separation*—as an earthly form of a deeper celestial principle.

Upon his Ascension into heaven, Jesus (who had died), said,

> But very truly I tell you, it is for your good that I am going away.
> Unless I go away, the Advocate will not come to you; but if I go,
> I will send him to you.[9]

How mysterious and disappointing it must have been to some early believers: it was *necessary* that Jesus go! And how convenient this would be later on for explaining why this supposedly immortal teacher is not still with us. Yet the faithful are bound to take seriously and harmonize all of Jesus's claims.

And so I am drawn to interpret Jesus's ascension as the core act necessary to maintain the human–divine *axis* I described above. The ascension, I believe, was the shimmering obverse of Jesus's physical death, revealing the true meaning (or *a* true meaning) of all mortality in the Christian paradigm.

9. John 16:7.

Mortality enforces separation in a world infected with swallowing greed. It pitilessly forces recognition of true meaning, true *otherness*, among people whose suffocating social power structures (and ultimately, devouring egos) claim to define everything. Mortality—death—sets things right.

Thus by leaving, by twice dying (in the body through his crucifixion and to social consciousness when he ascended), Jesus resisted containment. Yet as God incarnate, ascended in the body, Jesus remains ontologically (that is, in essence) connected to the human race, creating a tension and a charge. Across this line of distance traverses the Holy Spirit, the Advocate, strengthening the cord yet preserving its vastness and integrity forever. For humankind's participation with God (as we will see) demands the eternal maintenance of a sort of infinite distance—the distinction between Subject and Object, Knower and Known—so that our eyes may eternally meet God's eyes in love. That is what makes fulfillment of the first commandment possible: to "love the Lord your God with all your heart and all your mind and all your strength."[10] To operate as itself, Love requires distance across a divide.

ART AS RELATIONAL

The story of Bezalel, then, begins to configure the "artwork" (still unlabeled by history) as a special kind of proxy, or substitute. Apart from any question of content (symbolism, grandeur, messaging) the Tabernacle incarnated "otherness" in a way nothing before it could, sending the viewing mind questing toward a separate, threatening, and awe-inspiring Presence—in a word, the Being called God (and by extension, everything into which God had embedded sovereign life). Developments in modern conceptual art notwithstanding, visual art is always, somehow, intrinsically *physical* and *monumental*, and art history shows us that artists have always been driven to *build*. Like beavers or ants, artists obsessively fashion simulacrum-"others" that occupy their own space in the world. When Ernst Gombrich wrote in his famous *Story of Art* that "there is really no such thing as Art . . . only artists," I think that's what he meant.[11] Art is not defined by adherence to some external standard, or even by the viewer's experience of profundity, but by its emergence from a raw desire to *manifest*. Reaching even into prehistory, humans have built not only homes and tools, but objects that have embodied *otherness itself*, even if they also performed other functions (consider talismanic objects like the *Venus of Willendorf* or the bison at Tuc

10. Luke 10:27.
11. Gombrich, *The Story of Art*, 5.

d'Audoubert). These makings reveal an evolutionary need to confront a separate "witness" in the drive to survive and grow.

Art, which demands contemplative distance, helps our bodies, our full sensory selves, accept *otherness-as-such*. This leads toward the experience of true human community and ultimately toward the experience of God (both the experience *known by God*, as a trinitarian community, and the experience *of* God, as an object of knowing). In Matthew 25:40 Jesus said, "Truly I tell you, whatever you did for one of the least of these brothers and sisters of mine, you did for me." This verse is often read to mean that our regard for God should cascade downward to become regard for others. However, I believe that for some of us, the opposite is true: thus Jesus affirms that *by loving others we can learn to love God.*[12] The central concept of Christianity is the Incarnation—the manifestation of God in earthly flesh. Indeed, as the church father Athanasius insisted in *De Incarnationis*, the physical known is a necessary vehicle for approaching the unknown.[13] For Athanasius (and for me), our native fear, distrust and narcissism imprison us in the core of the self. From there, we must use nearby objects as crutches for limping outward, until at length were are free and "porous"[14] amidst the All.

It is no accident, then, that the best art theory of the last two centuries has identified the mysterious thing we call "fine art" as a relational phenomenon. This stands in contrast to still-influential art theories hailing from the Renaissance period, when theorists and their followers (inspired by the ancients) were preoccupied with art as a manifestation of the highest sensory beauty and profundity, unsullied by sin and death, superior to the lowly world, and thus reflective of a kind of royal, Edenic perfection. For Renaissance thinkers, art stood above ordinary humanity and judged it from afar—always finding it wanting. As the neoclassicist painter Joshua Reynolds declared, "a mere copier of nature can never produce anything great."[15]

12. The British historian George Macaulay Trevelyan said of the poet Wordsworth, "He could not realize God in the abstract. He had to see him in the Hills." I think many of us are Wordsworths in this regard. (For most of us, Wordsworth's "Hills" are a stand-in for other people. However there are many others of us who, like Wordsworth, are so disappointed in the sentient that we must start from the inanimate and then work our way up). From Moorman, *George Macaulay Trevelyan*, 40.

13. "[B]y such grace perceiving the Image . . . of the Word of the Father, they may be able through Him [Jesus] to get an idea of the Father . . ." Athanasius, *On the Incarnation*, part 11.

14. In his magisterial *A Secular Age*, Charles Taylor chronicles the replacement of the "porous self," which is open to the transcendent, with the modern, individualistic "buffered self," which is siloed off from both communitarian dependencies and transcendent, spiritual concerns.

15. Reynolds, Discourse no. 3, vol. 1, pg. 52.

What was needed, rather, was something superior to nature—something straight from the eminently tasteful mind of God, or from the imagination of one of God's chosen (Reynolds included). Art captured a perfection toward which all strove, and it was a product of high-status genius; it was not a humble tool for daily life.

Such lofty and elitist accounts, however, tended to be highly partisan and self-serving, and should be given limited credence. For example, Giorgio Vasari, the father of Renaissance art history and criticism, was himself an artist deeply invested in glorifying his own work and the products of his region (Tuscany, Italy). Naturally, he limited and socially elevated the role of art in keeping with his personal and political ambitions. Among other things, he used art as a tool for status signaling—something that unquestionably still goes on today (as we have seen, what oil tycoon *wouldn't* want to flaunt the "male *Mona Lisa*"?). This book, as I have noted, seeks to identify a role for "fine art" that is unrelated to the complex and intellectually-clouding status games that have gone on for centuries around artworks as luxury commodities, paradigms of glamor or trophies of national achievement.

Fortunately in the nineteenth century, influenced by groundbreaking insights in the realm of psychology, art historians and critics began to develop something akin to a "science" of artistic reception, or viewing. New vocabulary from the psychology of perception was accompanied by advances in transportation and print technologies that allowed scholars to compare artworks from all around the world. Thinkers like Heinrich Wölfflin and Alois Riegl began to engage in cross-cultural and cross-temporal studies that helped distill an essence for art somewhat different from the lofty perfection Vasari had so reverently described. Their insights were elucidated through the inductive process of "formal analysis," now a central (if rather unsexy) tool in art education for artists, curators, historians, and art critics everywhere.

Though the words "formal" and "formalism" today have many connotations in artistic circles, some of them very controversial and ideologically loaded, I am using those terms here in a purely descriptive, somewhat old-fashioned way.[16] "Formalist" methodology can be described as careful attention to the psychological effects of artistic *forms* (such as line, color, size, etc.) as opposed to the face-value "reading" of artistic subject matter. Formalists acknowledge that humans' psychological reactions to stimuli such as color, shape, and size can vary dramatically according to cultural context; nevertheless, they have identified certain configurations and

16. "Formalism" as an all-consuming art-ideology has been dismissed as racist and anti-historial. See, for example, Bois, "Whose Formalism?"

oppositions that seem to produce reliable effects. The kind of formalism I describe here is not interested in value judgments. It is no longer anchored to a particular "ideal" of beauty or perfection; rather, it simply investigates what the human organism sees and feels, on an instinctive level, when it encounters a visual object. Early formalist scholars like Wölfflin and Riegl were among the first to consider how the mind (in its roles of both creating and viewing) variously parses artistic forms—as superior, contemptible, elusive, self-sufficient, humble or seductive. They were also among the first to study our physical interactions with art objects and what that implies about our embodied, instinctive experiences. Finally, they were among the first to recognize and deeply analyze the highly personal perspectives, rooted in individual embodiment, that artists bring to their work.

An attention to this particular stream in art-historical scholarship shows that the artwork is essentially a location for physical, confrontational *contact*. Visual art can provide this experience of contact more effectively than any other art form, for it cannot be assimilated into the self in the same way that music, with its ephemerality, and literature, with its dependence on private imagination, can be. No matter how visual art is received or appropriated, it retains a stubbornly separate physical existence that is always "watching," always insisting on its independence; it can never be closed like a book or finished like a song. Indeed, most visual art can never be "used up" at all; even when we are done with it, it is still, obstinately, *there*. The theologian Deborah Sokolove has proposed something complementary in her book *Sanctifying Art: Inviting Conversation between Artists, Theologians and the Church*. For Sokolove, the beauty of art must indeed be redefined as "relational," lest it abdicate its claim to centrality in the spiritual life.[17]

In this book I hope to show that all true visual art, whether outwardly sacred or secular, is, like Bezalel's creation in the book of Exodus, a sort of tabernacle—a manufactured place where the viewer can reckon with other-personhood. The physical artwork creates a space where the viewer must confront something outside herself—something that, through its own existential claims, must transform her and move her out of the everyday, the sterile and the *automatic*[18] into a perilous and evolving dynamic of reckless, ascending give-and-take.

17. This perspective is echoed, in somewhat different language, in Deborah Sokolove's book *Sanctifying Art*. In chapter three of her book, Sokolove endeavors to deemphasize "beauty" as a metric for artistic quality in favor of what she calls "relational experience." See especially 51–64.

18. The Russian formalist critic Viktor Shklovsky, in his influential essay *Art as Technique* of 1917, explicitly condemned the sorts of "automatic," habitual, desensitized perception that keep us from noticing what is going on around us.

Accordingly, I will argue that the foundational value of art comes not from its subject matter, as many art theorists have contended,[19] but from its *substance*. The Ark of the Covenant is in this respect a great exemplar: far from picturing doctrine it manifested a *presence* and even framed at its center a throbbing but living symbolic void.[20] Art, as it has evolved in the West (and now globally) therapeutically and vicariously manifests the present-but-absent. Its monumental, timeless and anthropomorphic qualities make it a substitute "person" toward whom the ever-more fragile (because "awake" and sensitive) psyches of the third Christian millennium must practice habits of acceptance, attentiveness, and reconciliation, and ultimately sacrifice and love.

Art, therefore, is something that functions on a nearer plane than conscious belief or ideological position. Art is vital no matter what a viewer consciously holds in terms of doctrine. Acceptance of the totally separate "other" must always precede reliable intellectual formulation. Knowledge without such acceptance is nothing but desire or self-projection—a dangerous illusion that leads to atrocities and death. Visual art, because it forces us to confront otherness on the nearest plane of our consciousness, is a tool for making us fitting citizens of both Earth and Heaven—a tool just as necessary as clothing, shelter, or speech. We unconsciously utilize it constantly, even in ways artists do not intend. We even make into art things not meant to be art—rock formations, waterfalls, sunsets—out of our driving need for this guide, door, and adversary.

THE GAZE

As a visual vehicle of relationship art depends, in part, on the dynamics of *the gaze*, richly discussed by contemporary scholars and foundational to

19. This point of view is perhaps most strongly exemplified in H. R. Rookmaaker's famous *Modern Art and the Death of a Culture*. A major progenitor in this view was the influential British cultural critic John Ruskin.

20. Note the description of the "mercy seat" in Exodus 25: 17–22 (NASB): "You shall make a mercy seat of pure gold, two and a half cubits long and one and a half cubits wide. You shall make two cherubim of gold, make them of hammered work at the two ends of the mercy seat. Make one cherub at one end and one cherub at the other end; you shall make the cherubim *of one piece* with the mercy seat at its two ends. The cherubim shall have *their* wings spread upward, covering the mercy seat with their wings and facing one another; the faces of the cherubim are to be *turned* toward the mercy seat. You shall put the mercy seat on top of the ark, and in the ark you shall put the testimony which I will give to you. There I will meet with you; and from above the mercy seat, from between the two cherubim which are upon the ark of the testimony, I will speak to you about all that I will give you in commandment for the sons of Israel."

much recent visual theory. Our gaze—where and how we look—is central to our action in the world, central to our identity formation and central to our moral lives, insofar as it can be admiring, lusting, consuming or avoiding. Advertisers, censors, fashion designers and the Motion Picture Association of America know this. People who devote their lives to visual art may understand this best of all.

An influential thinker on the gaze was the celebrated French psychoanalyst Jacques Lacan, who in 1964 began speaking and writing extensively (and ground-breakingly) about humans' formative viewing experiences, including the early, shared gaze of mother and child. For Lacan, the early, mother-child gaze had the potential to set the stage for every human viewing experience thereafter, establishing patterns that could yield either (in healthy cases) confidence and fortitude or (in cases of deprivation) self-criticism and weakness. Artists and art theorists, inspired by Lacan's insight into the centrality of *looking*, seized upon Lacan's lectures and writings to formulate new approaches both to the understanding of earlier artworks (Meyer Schapiro is a famous art historian who deployed psychoanalytic insights) and to the making of art in the modern and postmodern periods (I think of artists like Robert Rauschenberg and Lee Bontecou, who made the action of the gaze a central theme). Later "the gaze" would comprise the linchpin of "attachment studies"—a psychological field devoted to the earliest childhood development. It would even be implicated in studies of conditions as diverse as bullying and drug addiction.[21]

Around the same time, some Christian theologians also pondered the centrality of the gaze. Perhaps the most profound thinker on the "gaze" in Christian theology was Hans Urs von Balthasar, the celebrated twentieth-century Catholic priest and theologian. Von Balthasar, with an expansive worldview that encompassed the heavens, sought broader implications than Lacan for the formative experience of infant sight.

Like Lacan, von Balthasar regarded the embodied experience of the gaze to be central to self-formation. And, like Lacan, he placed tremendous importance on the mother–infant exchange experienced at the beginning of life.[22] However, von Balthasar and Lacan understood the impact of this formative moment very differently. For von Balthasar, the gaze of the mother represented a moment of rich self-apprehension ("I am known and I am loved") that could be perpetually reinforced by the felt presence of a loving God. For Lacan, meanwhile, the mother–infant *frisson* provided a moment both so intense and so fleeting that it could create a life-long void, leading to

21. See, for example, Lewis, Amini, and Lannon, *A General Theory of Love*, 66 –76.
22. Von Balthasar, "A Résumé of My Thought."

decades of frenzied gazing upon inadequate substitutes.[23] Both thinkers interpreted that first gaze as the initiation of a quest, but where von Balthasar saw a journey buoyed by hope and beckoning love, Lacan saw an endless pull to regain something lost.

I believe that the uses of visual art through history show that both Balthasar and Lacan were correct. The Western Christian worldview, in fact, specializes in the paradox—in the simultaneity of the one and the many, the dead and the living, the present and the absent. Like the kingdom of God (as formulated by the theologian George Eldon Ladd),[24] the mirroring gaze of God is with us "already but not yet," even though it is understood to be foreshadowed in loving earthly eyes. As recent art (and theory) shows us, the longing described by Lacan indeed creates a void. But also, per von Balthasar, this void can be incrementally filled through the dynamic action of love received and given, always seeking deeper relationship, paradoxically at peace but never satisfied. Perhaps it is this dynamic action that makes time itself necessary, in the Christian scheme of things. And it also makes necessary the thing we call art, an echo-Incarnation and body-substitute, which receives and directs the questing gaze.

UNITY

The purpose of the artwork, therefore, is not mainly to provide pleasure or edification. The artwork is not meant, at least primarily, to figure a "perfect humanity," celebrate doctrinal truth, or alternately spur inspiration and guilt through the picturing of aspirational ideals. Rather, the purpose of fine art is to urge on the kind of loving unity promised by the infant-mother gaze, but deferred until a hoped-for eternity. We begin life gazing upon a yearned-for "other." Meanwhile, the stubbornly separate artwork figures "otherness" perpetually before us, helping us navigate the nuances of the self-other relationship. Gradually, we gain greater and greater comfort with the All that exists outside of us until we can accept all of space-time, which is nothing other than God's Providence enacted forever.

In this book, I suggest that the "All" (the universe of others) to which we have to be reconciled spans three levels, or inhabits three concentric

23. For fundamental Lacanian concepts about the gaze, see Lacan, *The Seminar of Jacques Lacan.* My reading of Lacan, here, is not the only one; his work has been productive of numerous, sometimes contradictory interpretations. It should be noted that Lacan did consider our experience of a supposedly divine gaze, but he believed it to be illusory.

24. See especially Ladd, *The Gospel of the Kingdom.*

circles. The first of these, perhaps surprisingly, is none other than the "all" of the unknown self—for our very selves are broken and divided, so that we "know not what we do."[25] According to von Balthasar, our internal divisions can one day harmonize into what he called a "unity of consciousness"—an ultimate form of self-knowing that can make us free and accepting of all that is within us. "Unity of consciousness" occurs when a person (an individual knower) encounters and integrates other views of herself so that she can gain awareness of her full potential. Though this is a unity *within* the self, it fundamentally depends on the gazes of others for its achievement. It can't develop without our acceptance of others' love and our painstaking assimilation of their responses in a process of flexibility and growth.

The first step toward this "unity of consciousness," not surprisingly, begins with the mother's smile—when the infant, with her dawning consciousness, perceives a fully separate, intentional, and acting "other" against whom she must define herself, but in light of whose love she also perceives her own meaning and worth. Later the gazes of others—siblings, lovers, friends—supply additional "views" that help the individual's self-awareness grow in nuance and fullness. Von Balthasar scholar D. C. Schindler uses a provocative simile to describe this "unity of consciousness": it is "more like the unity of a community of persons than like the unity of a geometric figure."[26] For Schindler (and, if he is right, von Balthasar), "unity of consciousness" is not closed and static like a hexagon with the same six, perpetual sides. Rather, it is capacious and expansive, like a society welcoming new persons ("personas," perhaps) with their talents and perspectives. *Adaptability* and *dynamic life* are thus necessary conditions for personal unity; this is a unity of movement rather than a mere juxtaposition of parts.[27]

The personal "unity of consciousness" discussed by Schindler and von Balthasar—enabled through mutual gazing and resulting in individual growth and perfection—is, meanwhile, a type or echo of two higher forms of unity. The first, the next larger of the concentric circles, is the hoped-for unity of the church as articulated in Christian thought, itself both a community of personalities and a single "person" (the Body of Christ) with many members. ("We were all baptized by one spirit so as to form one body," says Paul in 1 Corinthians 12.) As the Bible asserts, God wishes that all people could be a part of this unity—could be joined as brothers and sisters,

25. Luke 23:34 (KJV).

26. Schindler, *Hans Urs von Balthasar and the Dramatic Structure of Truth*, 142.

27. This formulation bears some similarity to the psychological idea of "Internal Family Systems" developed by Richard C. Schwartz, according to which the individual is understood as a collection of roles or personas. See Schwarz, *Internal Family Systems*.

accepting and loving.[28] It is the mission of the church on Earth to effect this unity as far as it is able, both by gazing with loving eyes upon those without, and by fully recognizing and accepting those within. Only then can humanity as "Christ's Body"—such an enigmatic formulation!—be one.

Finally the largest of the concentric circles, because it encompasses infinity, is the unity of the church with the Godhead itself: at once Father, Son, and Holy Spirit. Upon achieving this unity with the Godhead, the church (that is, humanity) will attain its eternal glory, for it will share in the Godhead's life and harmony. It should be noted: the Godhead alone possesses the ability to generate its own self-unity due to its trifold, perpetually distinct personhood, locked eternally in a loving, reciprocal gaze. By reaching out to humankind, by interacting with and gazing upon it, the Godhead beckons all other persons into the ultimate sharing of a fully-knowing gaze that is ecstatic, timeless, and endlessly meaning-giving.

The end of all persons, therefore, is to share the Trinity's complete integration-in-individuality by ascending through the first two layers of unity (personal unity and corporate or ecclesial unity) to a unity with the Godhead itself. (Indeed, the fulfilled "Personhood" discussed by the Orthodox theologian John Zizioulas in his consideration of the Trinity is similar to the very type of "unity in difference" that von Balthasar and Schindler describe.[29]) The Godhead has reached out to make us a part of its beatifically self-knowing life, and this will happen not through assimilation or annihilation (as in a state of nirvana) but through a unity of consciousnesses that can come *only* through differences perpetually juxtaposed, accepted, and reconciled. The artwork, as a mute point for the practice of contact, is a humble tool through which this dynamic of unity can be initiated, so that the recognizing gaze may ricochet upward, "mirrored and reflected infinitely."[30]

THE CHALLENGES OF RECONCILIATION

The early twenty-first century—perilously interconnected via both transportation and communication technologies—is rife with divisions that can explode suddenly into episodes of psychological and physical violence. The modernist and postmodern periods, characterized by distance-bridging

28. See 1 Tim 2:1–7.

29. See Zizioulas, *Being as Communion*.

30. This phrase is inspired by the title of artist (and MacArthur Grant winner) Josiah McIlheny's famous piece, *Modernity, Mirrored and Reflected Infinitely* of 2003. I discussed this piece in my essay "Night Vision."

technologies and rapid globalization, have experienced special challenges (and raised stakes) in the quest for human peace.

Art can address these challenges by putting the individual in mind of a transcendent other, to be sure (in the manner of the ancient Israelite Tabernacle), but more often art must help the individual grapple with the physical, human "otherness" that threatens it daily, whether that "otherness" is powerful or humble, delightful or disgusting, comforting or threatening. Indeed, the Bible seems to suggest that we must reconcile psychologically with the concrete threats, lusts, insults, and challenges that beset us before we can truly reconcile with that ultimate challenger we call God.

Human beings have always struggled mightily with all kinds of Otherness, but we became especially conscious of that fact at the beginning of the modern period. The philosopher Victor Cousin, summarizing in 1854 the insights of Immanuel Kant, wrote,

> Copernicus, seeing it was impossible to explain the motion of the heavenly bodies on the supposition that these bodies moved around the earth considered as an immovable centre, adopted the alternative, of supposing all to move round the sun. So Kant, instead of supposing man to move around objects, supposed on the contrary, that he himself was the centre, and that all moved round him.[31]

Cousin here described the so-called "Second Copernican Revolution"—a modern movement resulting in unprecedented self-absorption or solipsism. But surely this radical self-centeredness, leading to disordered relationship, has been a feature of human life from the beginning. How else can we explain Cain's inability to cope with the "otherness" of his brother Abel, who gave a different offering and received different praise? But perhaps the too-subtle psychological wisdom of modernity has made us over-aware of our perpetual human tendencies. And perhaps the challenges of a suffocating modernity have made self-absorption an ever-more-appealing refuge. Beset by overwhelming stimuli on all sides, we retreat into the caves of *ourselves*.

Thus today's artworks, as stubbornly physical *others*, must begin by pointing not primarily toward a God posited by ancient religion, but toward hated or worshiped things right in front of us—alien persons that challenge our sense of individual centrality. Much art today points toward the feared "foreigner," the objectified sex symbol, the despised scapegoat, and the revered hero. And it does this not merely through summoning pre-existing concepts (as words do), but by actually *manifesting* otherness in a way that

31. Cousin, *The Philosophy of Kant*, 21.

is immediate, confusing and even confrontational. This role of manifesting otherness so that we can exercise ourselves upon it recalls—for good reason—ancient rituals like animal (or even human) sacrifice, idol worship, the burning of effigies, and the Old Testament raising of the golden calf and the bronze serpent.[32] Art performs perennial human functions under a distinctive guise, and its contribution is especially important in an era perhaps best characterized by the siloed, independent self.

Christianity, with its clear emphasis on the person of Jesus alone as sacrifice, healer, and God, stripped the ancient visual tools (idols, effigies, public sacrifices) of their magical significance and, under the sign of the Incarnation, formulated art in their place. In the early Christian centuries, therefore, "art," as we call it, began to provide a new way of vicariously interacting with both other souls and a relational God. Today, when advances in psychology reveal ever more clearly our consciousness-warping subjection to subtle, widespread traumas, and when a crowded and cacophonous world forces us to confront otherness at a breakneck pace and with global stakes, we should not look askance at that gift.

THE STORY OF THIS BOOK

This book will tell the story of the needfulness of art in the years *Anno Domini*. There are limits to what word-based media can do, and art provides a necessary supplement to the learned discourses of moralists, philosophers, and theologians. Therefore, this book is not only directed toward art specialists (artists, critics, theorists, collectors, theologians of the arts), but toward everyone committed to personal healing and growth. In an age increasingly dominated by dematerializing digital technologies, ideological echo chambers, and a rhetoric of perpetual threat, the lesson of the physical artwork is crucial. To deploy our eyes and bodies in the way art bids us is to experience an adventure in the *knowing* of others, and by extension the ultimate other, God.

Thus this book also articulates a kind of religious epistemology (or knowledge theory), suggesting that word-knowledge must be supplemented by the kind of relational wisdom that the thing called art can best facilitate. Of course, human relationships are the richest founts of such knowledge, but they can also be over-rich and fraught with real-life peril. Art, on the other hand, unfolds in a relatively low-stakes and contemplative context,

32. In Numbers 21 Moses, at the Lord's command, erects a bronze serpent that, if gazed upon, can heal sufferers from snakebite.

giving us the space to model, imagine, and adjust so that we may interact with each other and the universe more fruitfully thereafter.

Finally, I submit that visual art radiates a quality almost impossible to grasp during encounters with other humans, and that quality is *timelessness*. Or put another way, it is a quality of *freedom from circumstance* that allows otherness to shine forth on its own terms, unencumbered by the pressures of daily need and desire. As we will see in later chapters of this book, fine art acquires its "artness" precisely when it manages to step outside of the realm of give-and-take, negotiation and compromise, and into a realm of *pure existence*. Art symbolizes *what things are*, and not what they can *do* for us. This is a formidable power, indeed, for the selfish calculus of utilitarianism (which considers only how *useful* things are) pervades our consciousness more than we know.

I have leaned so far on ideas from Hans Urs von Balthasar. Von Balthasar, in creating his greatest works, strove to abstract and operationalize the experiences of the Catholic mystic Adrienne von Speyr. It is therefore no accident that von Balthasar's formulations—based as they were on the tracing of a spiritual relationship—lend themselves especially well to the consideration of a relational thing like art. Von Speyr's insights have latterly been called a kind of "experimental theology,"[33] and it is precisely this kind of experimental theology-through-recognition that art can provide for everyone. Though art is not, perhaps, equipped to codify overarching doctrine or moral precepts, it can help every person of conscience develop an understanding of the meaning of relationship—with God, with others and with the self.

This book, therefore, is in part a call to reconcile many worlds: the so-called art world, the popular Christian world, the theological world, a host of intellectual and aesthetic subcultures, and the many traditional worlds preserving redemptive practices that speak prophetically into our post-modern din. There are deep principles and dynamics that all of these worlds share and have shared for hundreds or thousands of years. It's time we recognize that. In keeping with the three levels of unity described above, then, this book is a plea for the reintegration (or integration) of selves, society, and people-with-God.

33. See, for example, Dietlind, et al., *Gottesfreundschaft*, 259, where von Speyr's method is dubbed "experimentellen Dogmatik."

THEMES

This book will unfold in five chapters. The first chapter, "**All or Nothing: Otherness in the Christian Story**," will examine biblical passages toward the end of defining and categorizing the dangers of what I am calling "otherness." With its bald, realist prose that focuses more on recording than interpreting, the Bible is an invaluable document for the mapping of perennial relational habits. The biblical authors strive to place human nature before us in all its nakedness and equivocality to make clear the pitfalls humans face in their quest for unity and peace.[34] In narratives spanning thousands of years, biblical writers show "heroes," "villains," and anti-heroes circling each other in uncertainty and fear, negotiating, lusting, ignoring, and fixating, sometimes rising above their circumstances but usually making mistakes. Cain could not bear his brother's unique and favored "otherness." Joseph of Egypt was "othered" by his brothers, but this sin redounded to God's glory. And, of course, Jesus himself was the Other of others, both diminished and lifted up. This chapter will combine biblical insights with both art interpretation and sociological reflection toward an understanding of the core "othernesses" that the Bible dispassionately reveals.

My second chapter, "**New Wine**," will trace the birth of a distinctive Christian visual experience by comparing art-historical evidence from the ancient world with more recent art-theoretical insights. I will contend that the vicarious otherness conjured by Early Christian artists and inspired by the Incarnation gave believers the tools to understand healthy *relationship* (both human–human and human–divine) as a central dynamic of the hoped-for Kingdom of God. Rather than relying on the explicit doctrine surrounding Early Christian image formulations, this chapter will focus on evidence of worshippers' (and to a lesser extent, artists') *experiences* with and around early Christian and medieval visual culture. These early experiences will then be compared with the experiences of modern and postmodern critics who have uncovered bedrock psychological functions for art, using the formalist method I alluded to above. In all, this chapter will lay the foundations for a definition of art that organically emerged from the Christian worldview, that is still "hardwired" into the culture of the post-Christian west, and that had scant parallel anywhere else in the pre-modern world.

My third chapter, "**Private Worlds**," will spell out the dangers of a highly-developed sensory life bereft of the "othering" that art can provide. I contend that the Western visual environment, thanks in large part to the

34. This has been ably shown by, for example, Erich Auerbach in his landmark *Mimesis* and Robert Alter in his *The Art of Biblical Narrative*.

constant development of new information technologies, can be character-
ized as a kind of image-pandemonium to which individual "knowers" are
psychologically and morally ill-adapted; this can result in coping mecha-
nisms of considerable harm to both knowers and known. For example, the
phenomenon we call "information overload" can lead to a vicious cycle con-
sisting of: 1) a reactionary blocking or suppression of stimuli; 2) a resultant
atrophying of receptive "sensors"; 3) a consequent increased psychological
fragility; and finally 4) even more dramatic blocking and suppression. One
coping mechanism I will discuss, the *zone of subjectivity*, shields knowers
both individually and collectively from real existential challenges; contem-
porary manifestations of these zones include modern cultural temples like
museums and (to some extent) research universities, hoarders' collections,
eccentric subcultures, and the fragmenting media's ideological echo cham-
bers. Mystical Christian writers like C. S. Lewis and George MacDonald
(both operating within a Romantic-philosophical framework) popularly
identified and metaphorically figured this tendency. Reaction to this ten-
dency is also clearly present in the work of Romantic-era figures like Søren
Kierkegaard. Needless to say, contemporary visual culture, from film to tele-
vision to the internet, reinforces zones of subjectivity and cultivates a visual
vocabulary that can be immensely damaging. Fine art has largely striven to
resist this kind of "cutting off."

My fourth chapter, "**The Theater of the Self**," will demonstrate what
happens to others when we do not avail ourselves of art's reconciling power.
Today, the people who feel most reduced by our "zones of subjectivity"
flagrantly own their new status as *objectified*—in prophetic protest, they
embrace their identities as new types of "human sacrifice." (Bereft of vicar-
objects upon which to exercise our impulses, our human brothers and sis-
ters become vicar-objects instead.) This results in what the art critic Jerry
Salz has labeled the present "theater of the self," characterized by an ironic
mode of identity performance that simultaneously embraces and exposes
the deifying and scapegoating of millions of real people. We see this most
among feminist artists, minority artists, and LGBTQ artists. I will show how
these prophet-performers have in many ways *become* artworks as a way of
highlighting their objectification. In recent years, this paradigm has come to
dominate the production of almost all artists (whether minority or not)—all
artists (and increasingly all people, thanks to social media) must become
"brands" through which cohesive, innermost "selves" are offered up for
scrutiny, judgment, and, ultimately, ownership. *Everyone* thus becomes a
perverse kind of human sacrifice. Andrea Fraser's controversial *Untitled*, a
performance in which a collector pays to have sex with Fraser herself, is a liv-
ing metaphor for this dynamic of person-collection and self-objectification.

My fifth chapter, "**Glory (Lover, Scapegoat, King)**" will suggest concrete ways that art can act redemptively and therapeutically toward the end of reconciliation with self, society and God. Before we can experience the manifold facets of the supreme other (i.e., the immanent and transcendent God), we have to reckon with the presence of "the other" as such. But the more embedded we become in our zones of subjectivity, the more difficult this gets, and the more lurching and violent our efforts become. Consequently, art today must in some ways reenact some of the earliest ritual purposes of human image making. Art must be "put on a pedestal" (to absorb impulses toward abject worship), it must be yearned after (to absorb impulses toward self-immolation), and it must be scapegoated (to absorb impulses toward blame). Yet in each case, the artwork must also be self-subversive so as to avoid a shift from vicarious tool to genuine fetish or idol. The art-experimentation of Christendom and post-Christendom has given us the potential to create and interact with objects that can receive and then slough off these unbalanced impulses and leave us with a serene apprehension of God's presence-in-otherness. This is like the "exorcism" to which the artist Pablo Picasso famously referred.[35] This chapter will include in-depth art-critical analysis of certain contemporary and ancient objects that have performed relationally redemptive functions and can still perform them. Methodologically, this chapter will model a new kind of art criticism that evaluates works not for their stylishness or originality, but for their spiritual utility in the modern quest for von Balthasar's "unity."

ONE ARTIST TRIED

The frontispiece to this book shows James Hampton's mid-twentieth-century assemblage *The Throne of the Third Heaven of the Nations' Millennium General Assembly*, currently in the collection of the Smithsonian Museum of American Art. An African-American veteran of World War II and the son of a Baptist minister and a gospel singer, Hampton was raised in South Carolina and later moved to Washington, DC, where he worked as a night janitor for the General Services Administration. Humble and quiet, Hampton never married, though he long dreamed of a "holy woman" to share his life. He died of stomach cancer at the age of 55.

Hampton's *Throne of the Third Heaven* assemblage consists of an array of 180 objects grouped symmetrically around God's throne—itself an ordinary cushioned chair meticulously decorated with gold and silver foil,

35. See Pablo Picasso, "Discovery of African Art," as told to Andre Malraux, reprinted in Flam and Deutch, *Primitivism and Twentieth-Century Art*, 33–34.

cardboard and lightbulbs. The total installation once occupied the entirety of Hampton's garage and is now positioned in a specially-designed niche at the Smithsonian American Art Museum, where its monumentality and solemnity can be better appreciated. It likely bodies forth one of Hampton's mystical visions (several of which he recorded), in which a unified heaven and earth wait to receive the ineffable God who will rule over them in splendor and benevolence forever. Like the void atop the Ark of the Covenant, the void at the center of Hampton's richly symbolic and impressively monumental installation figures a condition of "already but not yet"—of hope simultaneously fulfilled and deferred. This hope is deferred because of the throne's emptiness, but it is partly fulfilled through the opulence, majesty, and profundity of the assemblage itself, lovingly produced over fourteen years by a janitor-mystic repurposing trash.

This masterpiece of so-called "outsider art" shows not only that the individual human soul craves the bodying-forth of its relationship to the divine, but it also shows the potential of the human imagination to invoke divine otherness toward the end of confronting it, grasping it and ultimately reconciling with its claims of majesty. In Hampton's case, this was done through the sheer number and size of objects he created, through his panoply of visionary forms, through his wide variety of luminous surfaces and textures, and through the assertive humility of his materials coupled with the paradoxical grandeur they evoke. This is an expression of human brokenness and diversity reconciled in heavenly fashion to become a lavish temple to a mysterious, triune God.

To encounter Hampton's *Throne of the Third Millennium*, then, is to grasp the otherness-and-presence of the divine other in a way inaccessible through words. It is an experience of the *looming*, the *manifold*, the *embracing*, the *elusive*, the *awesome*. It helps us understand what it means to viscerally apprehend God. For it is not enough to verbally insist on God's Otherness. As Jesus affirmed, "the spirit is willing, but the flesh is weak."[36] No matter what verbal doctrines we assent to, our bodies—our flesh—will react in lust or fear to physical manifestations of true majesty, true autonomy, true separateness. It is this bodily action, and its impact on both the subconscious psyche and the conscious mind, that visual art strives to nudge, guide and redeem. It is this bodily action that art can help tame and channel toward the achievement of unity in love.

And there is one more thing Hampton's *Throne of the Third Heaven* can teach us. It can teach us about the death of God. I have already posited that death symbolizes (and enforces) the distance necessary to maintain an *axis*

36. Matthew 26:41.

of otherness. We need this distance to set our consciousnesses right. Christ's ascension was the living seal on that distance—it's true meaning and function made clear. It proclaimed communion across distance, with a dynamic of vibrating, mirroring otherness anchored in ecstatic love.

But there is another aspect of death that Hampton's work captures. James Hampton's own tabernacle, his *Throne of the Third Heaven*, is built of the discarded and spent, the dead and cast out. In this way, it taps into ancient wisdom. In old Norse mythology, the world was built from the flesh of Ymir, a primeval god (the first god) slain by his children. In Aztec mythology, meanwhile, the earth was formed from the body of a water goddess with many heads. And in the *Enuma Elish* of Mesopotamia, the goddess Tiamat is shown to be slain by the hero Marduk, who divides her body into earth and sky. The Bible, for its part, deals Christ a similar punishment with a much higher dignity. "For in him all things were created," says Colossians 1:16. And 2 Corinthians 5:15 says that Christ "died for all." For this reason, Christ "was exalted to the highest place and [given] the name above every name."[37]

Thus Christ's death, and our resulting life, was not the zero-sum transmission of energy from one place to another, like Ymir's blood fueling a nascent earth. Rather, it was energy realigned to spark eternal participation and relationship, like a perpetual-motion machine driven by unquenchable, spiralling love. All art, like Hampton's *Throne*, destroys to make. In this way, all art is like food and like the primordial slain gods. Yet art, like Christ, also transmutes death to life. The spent and cast out (whether marble chipped from living rock, or mud, or charcoal, or trash) is resurrected into relationships meant, in hope, to vibrate for eternity.

37. Phil 2:9.

I

All or Nothing

Otherness in the Christian Story

The Judeo-Christian account of the universe's origin can be understood as a cascading multiplication of *othernesses* flowing from God's joy in his own, internal diversity. "Let us make mankind in our own image," the Hebrew God said, whereupon he created Adam and later, Eve, the first man and woman. Of course before this, God had created majestic biomes and a dazzling variety of animals, in the sea, on the land and in the air. Into the "formless and void" universe biological complexity burst forth, and it was "good." It was delightful. When humans make art, perhaps they mimic God's process by bringing even more otherness—scintillating, lovable otherness—into the world.

Out of all the things God created (the landscapes, the fish, the birds, the mammals), it was humankind alone that was made in what God called "*our* own image" (emphasis mine). Surely this "our" signaled God's internal diversity from the very beginning. But what did it mean? Was God one or many? Did this "our" include the angels? Was it a royal "our" suggesting God's leadership over—or representation of—everything? Around one thousand years after the book of Genesis was written, Christianity would interpret this pronoun "our" in light of the Trinity: the three, united persons of God. But the trinitarian concept was inherently paradoxical and therefore dangerous, sparking every major heresy of the Early Christian period (Arianism, Docetism, Modalism—all of them struggled with the concept of "three in one"). Even the orthodox did not settle on the term "Trinity" as we know it until the third century AD, when the Roman theologian Tertullian

gave it something like its present form: three persons and one substance, consisting of the Father, the Son, and the Holy Spirit.[1]

This chapter is subtitled "Otherness in the Christian Story," and it will trace experiences of "otherness" in the Bible and how they reflect (or deny) the "otherness" at the heart of God. Specifically, this chapter will examine how the drama of individuals' contact with *wholly separate* "others" (loved, feared, mysterious) is central to the Bible's anchoring narratives. Through an attention to scriptural passages and their implications as explored by visual artists, I will show that many of the conflicts mapped in the Bible can be understood as instances of this single, universal dynamic: that of individuals coming to terms with the fact of *other beings* that cannot be controlled and that have an equal claim to dignity. When this "coming to terms" is accomplished, a godly (as in *god-like*) relationship is established—a relationship that echoes the respect, welcome and graciousness practiced in the Trinity.

As obvious as the notion of "human equality" might sound in our twenty-first century, and as easy as it is to state, our psyches have a very difficult time accepting its bedrock truth. In a way, the human lifespan is one long adventure in coming to terms with the fact of *others*. This is another part of what Jesus meant when he said that "the spirit is willing but the flesh is weak."[2] In can take decades, a lifetime, or more (if notions of purgatory hold any water), to bring the whole self in line with a truth obvious to the mind. This brings me to the main title of this chapter: "All or Nothing." For as the next several pages will show, to deny *otherness* may ultimately be to deny all of God's creation. If the Genesis account of origins is any indication, then God has vehemently willed diversity and plenty, and that condition—that dazzling, glorious, riotous state—demands the humble limitation of the self.

THE OTHERNESS AT THE HEART OF GOD— GENESIS 1 AND 2

Since early Christian times, orthodox theologians have insisted that the three members of the Trinity are equal. The sixth-century Athanasian Creed, a landmark document of huge influence, framed the Trinity as a perfect equilibrium among persons:

> Nothing in this trinity is before or after, nothing is greater or smaller; in their entirety the three persons are coeternal and

1. See Tertullian, "Against Praxeas," chapter 3.
2. Matthew 26:41, KJV.

coequal with each other. So in everything. . .we must worship
their trinity in their unity and their unity in their trinity.[3]

In *Mere Christianity*, the literary scholar and Christian apologist C. S.
Lewis likened the Trinity to two, equally-sized books lying stacked together
since the beginning of time. In Lewis's metaphor, the bottom book literally
supports the other without existing before the other—the books have simply
been that way from the beginning, eternally fused. For Lewis, this was a way
to understand divine Fatherhood and Sonhood: it was not about the Father
coming first in *time* or *rank*, it was more like *relative geometric position*.[4]
A similar metaphor might be that of a cathedral whose foundation and
tower have stood together forever. The tower depends on the foundation
for support and always will, but both tower and foundation have their own
special roles (invisible vs. visible; deeply rooted vs. lifted high; sustaining
vs. beckoning). If we extend the metaphor, we can imagine the Holy Spirit
proceeding from the cathedral as light streams from a stained glass window.
Part of the deep mystery of the Trinity, after all, is its demonstration that
relationship itself is generative. Love produces life. Since the Father and Son
have dwelt in Love for eternity, the outpouring of their Love (the Spirit, like
fractured, rainbow-rich light) has also existed forever.

By the third century, then, orthodox theologians agreed that God is
a social being. Of course, their conclusions were based on Scripture: the
narrative in Genesis 18 describes the so-called "Old Testament Trinity," for
example, when God seemed to appear as three men to Abraham and Sarah.
Later, the author of the New Testament gospel of John stated that the Father
and Son had been together "in the beginning," before Creation. Meanwhile,
Jesus himself had promised to send the Spirit, a version of himself, to guide
his followers: "I will not leave you as orphans; I will come to you."[5] These
verses showed that God was a community by nature. It must have seemed
inevitable then, that at the beginning of history God would reproduce him-
self by making another community—the human community. Because God
was not alone, "it [was] not good for the man to be alone," either.[6] Thus God
made Eve from the substance of Adam (a rib), just as the Son and Spirit
share the same essence as the Father.[7]

3. The Athanasian Creed is available from many sources online. See, for example,
the website of the Christian Reformed Church: https://www.crcna.org/welcome/be-
liefs/creeds/athanasian-creed, trans. Faith Alive Resources, 1988.

4. See Lewis, *Mere Christianity*, chapter 26.

5. John 14:18.

6. Gen 2:18.

7. The metaphor of an "earthly trinity" is supported by Aelred of Rievaulx

With Adam and Eve, an earthly dyad was formed—a godly relationship, even if it went only two ways. But God did not stop there—he wanted to make another trinity. Therefore God came and "walked" with Adam and Eve.[8] God's completion of the earthly triad with *himself* made two things clear. First, it showed that earthly relationships were meant to be connected to the God-relationship through a mediator: an incarnation that occupied two spaces at once, like a golden ring connecting two separate chains. Second it showed that human relationships are *supposed* to have trinitarian structure and are *supposed* to echo the Godhead down through time, like beautiful fractal shapes eternally unfurling from the Great Shape at their origin.[9] For in addition to making all the other creatures, God commanded Adam and Eve to "be fruitful and multiply."[10] They were to enjoy a love-process that (similar to the Father-Son union) would produce *even more persons*. This would go on through the generations until the fulfillment of all things.

Like C. S. Lewis's stacked books, Adam and Eve were complementary but equal. The earthly community they formed with God shows a merry confusion of overlapping roles, so that each echoes all. Adam, for example, was declared to be "alone," and so God rushed to give him trinitarian experience. He did this by creating Eve out of Adam, making Adam like the heavenly "Father" who "begets." This made Eve like the Son proceeding from the Father. But Eve had also emerged from the relationship of God and Adam, making her like the Holy Spirit—a product of shared love. Meanwhile God, who had created Adam and Eve for each other and who descended to them once in a while, was sometimes himself like the Spirit ("coming and going"[11]), and sometimes like the earthly Jesus, an incarnate blessing to a couple matched by God. The whole account of human origins is like a song with echoed refrains, or a dance with answered steps. Each new relationship ties back into the First (that is, the God-community) in many ways and at many points.

(1110–1167). See Aelred, *Spiritual Friendship*, trans. Dutton and Lawrence, 1.57–58.

8. Gen 3:8.

9. Fractals are a mathematical and natural phenomenon that consist of identical shapes repeated across a range of scales (from larger to smaller). Common examples of fractals in nature include snowflakes, nautilus shells, fern fronds and peacock tails.

10. Gen 1:28, KJV.

11. Paraphrase of John 3:8: "you cannot tell where it comes from or where it is going."

TRINITIES IN ART

Words—even Scriptural words—are among the most abstract of human signals. More often than not, they suggest big categories of things (a tree, a face, a book) rather than specific things in their uniqueness. Words can't really tell you what something looks or feels like, for example, even when adjective is piled on top of adjective. This is one reason why people say that "a picture is worth a thousand words." But it's not just concrete details that words leave us wondering about. Words also struggle to represent *relationships*, because relationships operate on so many different levels at once. Again, if you pile adjective onto adjective and chapter onto chapter, you might start getting somewhere, but then you've got a new problem. A multidimensional, living relationship has been chopped up and stretched out over hundreds of pages and hours upon hours of reading. It has become like a ball of yarn that reveals itself one, tiny, unraveled inch at a time.

Visual art, of all expressive forms, specializes in capturing multi-level relationships in an instant. Artists can explore many things simultaneously (such as, for example, the implications of "sonship" or "lordship") like no one else can, because they are working in three dimensions. C. S. Lewis asked us to imagine a *picture* in his explanation of the Trinity. This is because pictures can evoke so many relational qualities at once—height and breadth, darkness and light, smallness and bigness, and everything in between. Artists can summon a universe of metaphors at a single glance. Their interpretations can seem to spin doctrine (dry words) into personal, embodied significance, just as the wily Rumpelstiltskin spun useful straw into eye-catching gold. Jesus himself bore witness to the power of metaphor in his reliance on parables: brief expressions of relationship that often conjured pungent images for his audience.

But ordinary human artists are of course not infallible. So perhaps their job is best understood as beautiful *hypothesizing*—as the experimental application of principles in controlled, three-dimensional fields. Art offers a *version*—an interpretation—of the truth to be tested by viewing communities. It becomes great only when its hypotheses have been validated through generations of lived experience. Masterpieces like the Sistine Chapel, the Isenheim Altarpiece, or Raphael's Madonnas have been tested again and again, through hundreds of years, and still ring true. They teach us indelible things about (respectively) human dignity, Jesus's suffering (and all human suffering), and the authentic fleshiness of Christ's incarnation.

Visual representations of the Trinity (both the heavenly and the earthly ones)—have also been powerful tools of Christian experience through the ages. In fact, since the Bible does not hold a clear account of the Trinity,

visual art has often stepped in to shoulder the load. One image of the Trinity—really, a sort of hieroglyph—is a glowing, equilateral triangle surrounding the "Eye of Providence." It is one form with three equal components, and it reaches toward humankind because it *gazes outward*. The eye is the hinge that unites God with the human community. (In recent centuries, this formula has been adapted into the occult "all seeing eye" as it appears on the U.S. dollar bill.) Other times, the Trinity appears in its so-called "mercy seat" form, where God the Father, seated on a throne, holds up the crucified Christ by his arms. A dove, representing the Holy Spirit, is perched between them, facing outward. The term "mercy seat" was not only Trinitarian; it also referred to the Ark of the Covenant, upon which God's presence rested in the Old Testament. Thus the Christian "mercy seat" was a self-conscious update of that first location for structured human–divine contact. It showed that Christ himself (like the Ark) was the physical matter upon which (or within which) the spirit of God had come to dwell, creating a *locus* where unity with the divine could be experienced.

Fig. 1.1. *The Trinity (Mercy Seat)*, historiated initial from *Die Dietsche Doctrinale* of Jan van Boendale, circa 1374, about 9 x 8 cm. Photo courtesy of the Koninklijke Bibliotheek.

Artistic interpretations of what I have called the "earthly trinity" (that is, Adam, Eve, and the God who "walked with them") are relatively common in the history of art. The most famous example is probably Michelangelo's "Creation of Eve" from the Sistine Chapel ceiling. Here, Adam lies on the ground with God standing alongside, as Eve rises diagonally from Adam's rib. Michelangelo has made Eve the hypotenuse of the Edenic triangle, and she emerges into a barren, empty landscape as if she is the key to populating the world (which she is). Her hands are clasped in prayer from the moment of her "birth"; she completes the relational triad instantly, lunging toward God to cement the connection.

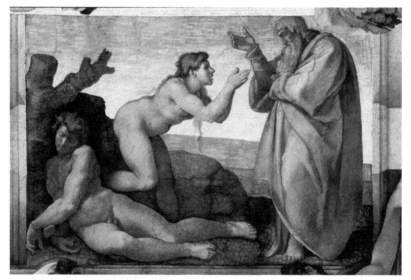

Fig. 1.2. Michelangelo Buonarotti, *The Creation of Eve* from the Sistine Chapel, 1508–1512, 170 x 260 cm.
Photo courtesy of the Vatican Museums, Erich Lessing/Art Resource, New York.

Three hundred years later the British mystic William Blake depicted the "earthly trinity" at a different moment: when God, recognizing the humans' shame, gave them clothes of skin to wear. Serene and unperturbed, Blake's gigantic, bearded God encompasses Adam and Eve in his arms; his body makes a great triangle in which the man and woman are wholly contained. This suggests God's continuing protection and providence even after the indignity of the Fall.

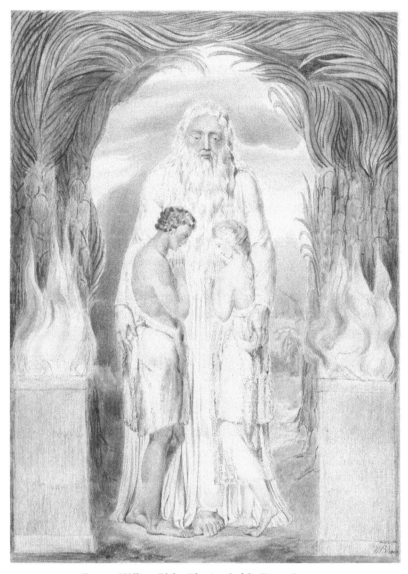

Fig. 1.3. William Blake, *The Angel of the Divine Presence
clothing Adam and Eve with coats of skins*, 1803, 39 x 29 cm.
Photo courtesy of the Fitzwilliam Museum, Cambridge, and Art Resource, New York.

But perhaps the most interesting visual version of the Genesis "earth trinity" appears in Hieronymus Bosch's *Eden* panel from his triptych *The Garden of Earthly Delights*. Here, a youthful, ruddy, round-faced God stands placidly between a naked Adam and Eve. Just behind him, a bulbous and complicated fountain rises from a pond. Pink like the figures' skin and lobed

with forms that resemble human organs, the fountain is oddly—maybe un-comfortably—fleshy and fertile (even phallic), as if its life-giving water is generating the diversity around it. Meanwhile Bosch's God figure, his slen-der body robed in pink, mimics the shape of the fountain. (Or maybe the fountain mimics the shape of *him*). This juxtaposition shows that *God* is the true life-giver—the inseminating force of the earthly creation. For Bosch, the physical God who walked with Eve and Adam was both builder and building at once, both designer and sower, begetting and begotten, foun-dation and pinnacle. Very much "in the flesh," Bosch's God was also Jesus of Nazareth prefigured—the physical wedge of the Trinity. To extend the metaphor (as the biblical authors themselves did in books like Ephesians and Revelation),[12] Bosch's Eve, rising diagonally like Michelangelo's, prefig-ures the Virgin Mary, and the seated Adam prefigures Joseph (who is often shown in art seated next to his wife). Here, like in Michelangelo's painting, Eve completes a trinitarian urge. As God looks at Eve, Eve looks at Adam, and Adam looks back in wonderment at God, their gazes become locked in propulsive, triangular movement. It was this eternal togetherness, Bosch shows us, that gave meaning to humankind's creation: male and female, not one but two.

12. See, for example, Ephesians 5, with its theology of marriage, and the "woman clothed with the sun" of Revelation 12.

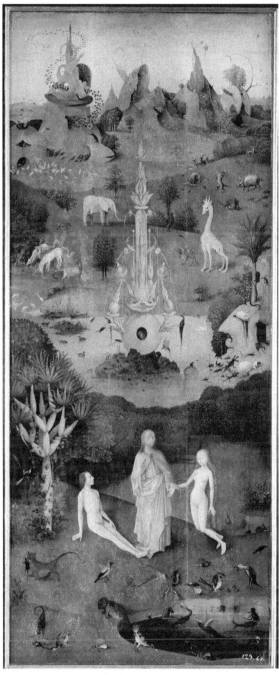

Fig. 1.4. Hieronymus Bosch, *The Garden of Earthly Delights*,
left panel (Eden), 1515, 389 cm high.
Photo courtesy of the Museo del Prado, Madrid,
and Erich Lessing/Art Resource, New York.

THE FALL—GENESIS 3

But, as we know, the earth trinity was doomed to fracture. The so-called "Fall of Man," when Adam and Eve were cast out of the garden and away from God's presence, occurs only one chapter later in Genesis. The new paradise did not last. Among Bible commentators, the deep sin of the Fall has usually been framed as a sin of disobedience; this interpretation goes back at least as far as the second-century Church Father Irenaeus.[13] God issued a command, and Eve and Adam disregarded it. Then, as always results from lawbreaking (or old-fashioned parenting), there was instructive punishment. Adam and Eve were cast from the garden, forced to work, and ultimately condemned to death. (Generations of Christians have wondered, sometimes embittered, at the severity of this first and most destructive penalty.)

Laws and rules, however, are only frozen forms of deeper, richer dynamics, and Adam and Eve walked with God in a halcyon time before Law. Perhaps, then, we can think of the biblical Fall in terms of *relationship*. The eating of the fruit was not really a matter of law broken, but of an *other* offended and denied their right. This was the beginning of humankind's failure to mirror the trinitarian community of God. Thus it was not so much that our first parents disobeyed God, but that they *betrayed* him. They did not trust their lover or take him at his word. They did not see him truly and honor his self-evident ontological demands (e.g., the calling out of relationship latent in his nature, or his essence of abiding in reciprocal love). Moreover, after going behind his back, they even believed tawdry gossip about him. ("God knows that when you eat from it . . . you will be like God," Satan had said, implying that God purposely hoarded good things away from his beloveds.)[14] Finally, when confronted by the one they betrayed, Adam and Eve hid. It is no coincidence that in his *Divine Comedy*, Dante Alighieri placed the sin of betrayal in his deepest circle of Hell. Dante's Judas was the doomed re-enactor of humankind's original sin.

It is worth noting here that *trust*, predicated on the true recognition of a loving and beloved other, and therefore resting in the outflowing of that other's nature, is "the *sine qua non* of communal life."[15] There can be no true community without trust, and there can be no true building outward and forward without the same. Indeed, psychologists have shown that the most well-adapted children, the ones most poised to fulfill their potential

13. See, for example, Irenaeus, *Against Heresies*, book V, chapter 23.

14. Gen 3:5.

15. Thanks to Dr. Richard Steele for this formulation.

and go fearlessly into the world, are the ones who learned early to trust.[16] Meanwhile in evangelical religious traditions—traditions that have used simple language to reach the alienated, the oppressed, and the broken (that is, those betrayed by life)—a common refrain has been to "trust in God." One thinks, for example, of hymns like "Tis So Sweet to Trust in Jesus," written by the nineteenth-century missionary Louisa M. R. Stead, or "Trust and Obey," inspired by a testimony at one of Dwight L. Moody's turn-of-the-century revivals. This evangelical message of trust was instrumental in the rebuilding of fragmented communities during an age of major upheaval and rapid industrialization.

Adam and Eve's betrayal of God, stemming from the denial of God's intrinsic rights and committed at the very beginning of the Christian drama, is familiar to everyone—everyone has been stabbed in the back by a beloved friend, disappointed by a trusted parent or disobeyed by an adored child. These betrayals are both heartbreaking for the wronged parties and psychologically corrosive for the "traitors," who struggle to accept what they have done. In fact, Genesis pinpoints this corrosion as the real source of the earth-trinity's splintering. It was not God, after all, who initiated the fateful estrangement of the human and divine. Rather, it was *Adam and Eve themselves*, who ran and hid when they heard God's voice. ("Where are you?" God had to call in Genesis 3:8, unable to join his earthly community.) Poisoned by shame and self-deception, Adam and Eve had become incapable of receiving (and answering) God's friendship. They pre-emptively separated themselves from him, breaking the sacred circuit depicted by Bosch and Michelangelo.

The fracture of the earth-trinity in Genesis 3 was symmetrical—not only did humankind separate from God, but man and woman separated (at least spiritually) from each other. This point is hammered home in Genesis 3:12, when Adam alienates both of his beloveds with a single, halting declaration: "that woman you put here with me—she gave me fruit from the tree." With the phrase "that woman," Adam minimized—ontologically diminished, or *betrayed*—his partner, denying her presence before God and her ability to speak for herself. At the same time, Adam diminished himself; by shifting blame to Eve, he denied his own autonomy and responsibility. Worse, however, was the following word "you," directed to God ("that woman *you* put here"). With this word, Adam blamed God for having foisted such a temptress upon him, as if he had been primed for failure in a rigged game. This showed fundamental blindness to God's nature and providence. And indeed, such petulance has infected the world's heroes from the

16. See Lewis, Amini, and Lannon, *A General Theory of Love*.

beginning of history, as they shake their fists and insist on their value before God, often blaming woman (the *femme fatale*) for their shortcomings. God's gift is thrown as a weapon back at its misunderstood and disrespected giver.

Adam's resentful words also revealed a second thing about the fragility of the human. When the eyes are turned away, when fellowship is denied, the gaze turns destructively inward in self-pity (think of Adam's blaming and complaining). Yet it is precisely the beckoning gaze of God (and by extension, the gaze of the human other) that pulls us into the shared life of which God is the fount—the eternal life of the Trinity's ceaseless mutuality. When Adam and Eve fell out of fellowship with God, therefore, they renounced the exchange that gave their lives meaning, dynamism, and longevity. They risked a slow petrifaction into lifeless stone—the inert prison of the isolated self.

THE THREAT OF THE MONOLITH

The opposite of cascading otherness—of the Trinity and all its children—is monolithic consolidation; the crushing weight of infinite gravity; the destructive, lightless density of the black hole. The monolith encroaches when otherness is denied, and otherness can be denied both symbolically and actually, both in word and in deed, where word precedes deed or deed precedes word, until all difference is obliterated and what remains is a single, hungry will. This, we could imagine, is what the biblical Satan seeks, with dim and uncomprehending sight.

Jesus famously declared in the "Sermon on the Mount":

> You have heard that it was said to the people long ago, "You shall not murder, and anyone who murders will be subject to judgment." But I tell you that anyone who is angry with a brother or sister will be subject to judgment. Again, anyone who says to a brother or sister, "Raca," is answerable to the court. And anyone who says, "You fool!" will be in danger of the fire of hell.[17]

Here Jesus suggests, in surprising harmony with twenty-first-century psychologists and theorists,[18] that the merely *symbolic* denial of a fellow's

17. Matthew 5:21–22.

18. A rich scholarship on "language as violence" spans multiple disciplines, going back decades. The notion of "language as violence" has become particularly influential in the last several years. Some psychological research supports hypotheses that degrading language can be physically debilitating, though the "reproducibility crisis" in the discipline of psychology has thrown some conclusions into doubt. For an example of these discussions and the controversy surrounding them see Lilienfeld, "The Science of

personhood—even when not acted upon—is deeply destructive. To verbally or imaginatively deny a fellow's humanity is to commit heart-murder—to perform grave sin against a God-given meaning and ontology. These actions obliterate *otherness* (whether physically or "merely" consciously), spreading the blackness of the monolith—the monolith that devours all beauty, detail, complexity and light.

But otherness, according to Jesus, must never be denied—only taken up and enriched. Thus Jesus said earlier in the Sermon on the Mount,

> Do not think that I have come to abolish the Law or the Proph-
> ets; I have not come to abolish them but to fulfill them. For truly
> I tell you, until heaven and earth disappear, not the smallest let-
> ter, not the least stroke of a pen, will by any means disappear
> from the Law until everything is accomplished.[19]

"Not the least stroke of a pen," Jesus said. In a way most confusing for the puritanical mind, Jesus described in his Sermon on the Mount an ethic of *allness*—of accretion, multiplication, and abundance. Of embarrassing, mind-boggling, voluptuous, and almost grotesque accumulation. The Jesus of the Sermon on the Mount is not a Socratic dialectician who seeks a "pure" middle way, nor is he an iconoclastic reformer sweeping away the corrupt and outdated. He does not take sides in a zero-sum battle; instead, he is for everything and everyone. He does not abolish anything, but he takes it up into himself to *fulfill it* so that it will no longer strain against, or spin independently of, the communitarian energy he directs. He will have and keep distinct everything in space-time, to the last utterance, the last secret, the last penny, the last mote of dust.

CAIN AND ABEL—GENESIS 4

But in the book of Genesis the monolith continued to encroach, spreading its dark vapor to God's other creations. In the story of the next two human beings, Cain and Abel, we see the beginning of real, *physical* obliteration—the monolith in action. The dynamics are complicated. Cain, the elder brother, burns in jealousy toward the younger Abel, whose offering to God is preferred, and so Cain kills his brother with chilling premeditation. According to tradition, Cain did this with an ass's jawbone, since humankind had not yet seen weapons or war.[20]

Microagressions: Its Complicated."

19. Matthew 5:17–18

20. For more on the (extra-biblical) attribution of this strange weapon to Cain, see

How did Cain imagine he could get away with this crime, the astute reader might wonder? In this time of newness, when God had humbled himself to walk with Adam and Eve, slowly coaxing them into conscious-ness of the universe, perhaps Cain did not yet understand that God could *be everywhere* and *see everything* all at once. Thus God had to explain to Cain, "Your brother's blood cries out to me from the ground."[21]

Yet God's invocation of Abel's blood was not just a sign of omniscience (like God's "all seeing eye"), it was also a sign of God's commitment to *all-ness*. By speaking of Abel in the present tense, as one still "crying out," God showed that Cain's effort to erase his brother had failed. Somehow Abel still *was*, even in death, so that not even murder could stop the chain of God's self-proliferation. But God did not raise Abel again to physical life. For just as Abel could not be erased, neither could the actions of Cain. Both Cain's sin and Abel's death would redound through all the millennia, Abel's blood forever "crying out" as his spirit dwelt with God. God's work, which is also the work of history, cannot be undone.

Visual interpretations of the Cain and Abel story are relatively un-common in art history, perhaps because the episode is deeply depressing. The Puerto Rican artist Augusto Marín is one of the few to have tried it in recent centuries, and he has found in the story meanings suited to our hard-bitten modern sensibility, which daily beholds (in reality or through mass media) horrors like torture, genocide, and war. In Marín's version of the Cain and Abel story, Cain looms above his brother, his arm captured in a rictus of violence.[22] The jawbone he used in the deed is still raised above his head. His disfigured body seems to pulse and sag in anticipation of its own mortality; he bears the seeds of his own destruction. But most telling, Cain stares ahead with his mouth agape, vacant-eyed. Having destroyed his brother, his own self seems likewise (if temporarily) destroyed in the blind-ing flush of triumph—of power seized and possessed. The monolith yawns from his dark, unfocused eyes. If God's favor was equivalent to power, in this moment Cain seemed, by eliminating his rival, to take that power for himself. But of course he did not win God's favor at all. Instead, his attempt to seize love can be understood as a kind of primordial, spiritual rape. This destructive impatience—taking forcefully what you might have earned—is perhaps the most senseless of imaginable crimes, lying at the heart of the

Schapiro, "Cain's Jaw-bone That Did the First Murder."

21. Gen 4:10.

22. Unfortunately, Marín's *Caín y Abel* (1971–72) was not available for reproduction in this book. The curious reader can view the painting at the Museo de Arte de Puerto Rico website: http://www.mapr.org/es/arte/obra/cain-y-abel.

most tragic stories in world mythology: consider the opening of Pandora's box, the torture of Prometheus, or the launch of the Trojan war.

For the heart of the Trinity's cascading delight-in-otherness is love freely given and received; gracious and courtly consent. Cain tried to seize God's love, and his grasping echoed that of his parents, whose seizure of fruit was also a seizure of favor (Satan had promised "you will become like God," after all). In each of these cases, in a way that may seem counterintuitive in light of God's power, *God* was the victim whose love was violently demanded. His wounded creatures (the slain Abel, the plucked tree) were collateral damage. In these two, earliest sins recorded in the Bible, something of God himself is taken into the monolith and swallowed, vainly and greedily. How apt that each story involved food, whether as offering or spoils. For Adam, Eve and Cain, each in their own way, all tried to consume a part of God (his knowledge, his favor), bringing him within their energy and control.

Much later in the Bible, the Resurrection would be the means by which this consumed God—this *eaten* God—would break free of the gnawing cycle, bringing everything back with him through the collapsing cascade of time. Christ the God-man, through his resurrection and ascension, eluded seizure; meanwhile his life modeled favor *earned*. The Christian life, in its own way, must be the same. The Christian path is the humble patience of the long wait. There can be no seizure, only submission. No prediction, only adventure.

THE TOWER OF BABEL—GENESIS 11

The book of Genesis recounts how, in the early ages of humankind, all of the people joined together to seize and to rape—to take what was unearned. Having assimilated together in paranoid unity, they wished to assimilate even the heavens. They resembled a sort of "monolith" in their oneness of mind and their shared logic: "Now the whole world had one language and a common speech," Genesis says. And so the people of the world said to one another, "let us build ourselves a city, with a tower that reaches to heaven, so that we may make a name for ourselves; otherwise we will be scattered over the face of the whole earth."[23]

How strange that "making a name" should prevent "scattering," as if fame and honor was an antidote to conflict. And how strange that "scattering" would be feared above all—above war, or famine, or storm. But these people of Shinar (Shinar is the plain where they settled) knew the ancient power of "making a name"—that is, staking one's place before the

23. Gen 11:4.

meaning-giving God. As Cain had wished to prove himself with a better offering, these early folk would prove themselves with a grand city and a tall tower—an offering to the ages. By this means they would be united in God's eyes under the sign of their accomplishment, never again to fear the unpredictability and distension of time, which is God's chisel for cutting and shaping his multitudes. With the tower, the people of Babel would say their own shaping was finished and their destiny secured.[24]

To declare one's own destiny is the greatest of comforts, and to submit to the shapings of time is the greatest of challenges. This opposition lies at the core of all human experience. For ultimately, to accept the other is to accept one's own distension (stretching, bending), and to accept bending to the utmost is to accept death. Therefore it is not wrong to say that death *is* the other and the other *is* death. Both death and otherness proclaim the right of God to shape as he wills; both death and otherness embody our own, infinite helplessness. Which of us can blame the Shinarites' drive to take God's place in this shaping and declaring? Which of us doesn't try to do the same a thousand times every day?

Thus the tower's height was not meant to demonstrate worthiness only, like a crass lump of propaganda. It was more fundamentally meant to *collapse the distance between knower and known*. It was meant to bridge the gulf between God and humans, so that humans, too, could exercise ontological, meaning-giving judgment (and also prove to God that their judgment was good). Indeed, though the biblical text does not say as much, many commentators, including visual artists, have viewed the tower as a way of competing with God—like a declaration-in-brick that humanity could assume God's role. A tower that reaches the heavens, after all, can afford one a godlike perspective, looking down upon and judging the whole earth. And this judgment is really just a declaration of finished shaping. What is the book of Revelation's "Last Judgment," after all, if not a seal of ontological completion, followed by a sorting of who goes where in the final organization of things?

Instead of accepting God's shaping, then, the Shinarites re-enacted the taking of the fruit and the primordial Fall. Satan had promised to Adam and Eve: "you shall become like gods," not least in their ability to "know good and evil," giving meaning to what they encountered and declaring its true

24. It is worth mentioning that the biblical author probably had something like a Mesopotamian ziggurat in mind when this passage was composed. Ziggurats were stepped, slightly tapering structures that, among human edifices, rose to unprecedented heights; they were explicitly intended to bring the worshipper nearer to the dwelling of the gods in the sky. A good surviving example is the Great Ziggurat of Ur in Muqaiyir, Iraq; see a photo and description at: https://en.wikipedia.org/wiki/Ziggurat_of_Ur.

shape. (Satan was not wrong: naming the animals, as God had commanded Adam to do, can be understood as practice for a greater glory at the fulfillment of all things.) But to *seize* this godlike perspective was something else altogether—it was self-destructive and a rejection of true life. For as Adam and Eve had learned to their despair, to grasp toward "the heavens" was also to pivot out of God's sight line. And this pivot was equivalent to an exit from the divine dance, a fall from the life-giving circuit, so that the flow was broken and its energies were stanched. Adam, Eve, and the Shinarites, by seizing and usurping instead of gazing and receiving, blocked the flow of life and diversity that unfurled from God.

Yet God's proliferation will not be stopped. For Adam and Eve, the punishment was toil and mortality: subjection to a timeline that would bring innumerable diversities into the world through recurring processes of birth and death. For the Shinarites, the punishment was different: it amounted to the very same fragmentation and dispersal ("the scattering") that the Shinarites had feared. God exercised this punishment through a "confusion of language"—that is, through the invention of many tongues—so that the builders could no longer communicate and could thus no longer authoritatively *name*. Frustrated, they quit their endeavor and separated into tribes. This was how God's cascade of otherness was renewed in Genesis 11. The human monolith of Shinar had been splintered into shards so that each one (that is, each person) could resume her experience of ordained, unique shaping by the hammer of suffering and history.

In the 1500s, a generation after the Protestant Reformation (itself a sort of latter-day "scattering" into many different denominations), Pieter Brueghel the Elder painted three versions of the Tower of Babel. The version now in Rotterdam, measuring about two feet by two-and-a-half feet, is perhaps the most haunting. This is chiefly due to its atmosphere of anonymity: at first glance, not a single person can be seen. Later, upon inspection, hundreds or thousands of tiny figures become visible, but they appear as mere daubs of white ash with scarcely any human features. Above these tiny workers, the tower rises absurdly from a countryside of fields and farmsteads, spreading grotesquely and precariously over beautiful shoreline and arable land. (The peoples' boats and cottages are fantastically small in comparison.) The tower reminds one at first of an elaborate anthill, but it is more quiet than that, more sinister. For with its apparent absence of life it feels like a ruin even before its completion. It *is* already useless, after all, without function or benefit. But even worse, it actively squeezes or stamps out the life around it, encroaching on fruitful resources. In the end, Brueghel's Rotterdam *Tower of Babel* feels like a monument to collective suicide, blindly

undertaken but still rhetorically powerful. It shows the cancerous effect of life rejecting its life-giving source.

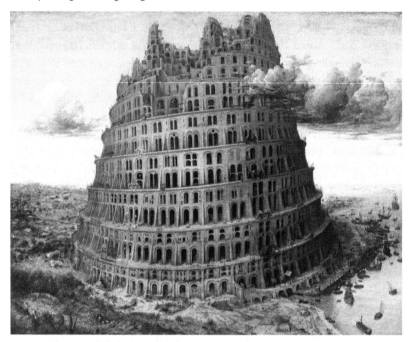

Fig. 1.5. Pieter Brueghel the Elder, *The Tower of Babel*, 1568, 60 x 75 cm.
Photo of courtesy the Museum Boijmans van Beuningen, Rotterdam,
and Google Art Project.

Brueghel's inspiration for his *Tower of Babel* was the Roman Colosseum, also known as the Flavian Amphitheater, erected by the emperor Vespasian in the last decades of the first century AD. The Colosseum is perhaps the most spectacular monument remaining from the ancient world, but there was more behind Brueghel's choice, I think, than the Colosseum's great size or stately complexity. By Brueghel's time, after all, architects had again rivaled the scale of the ancients with their works, and had maybe even surpassed the ancients in flagrant opulence. If it was not the Colosseum's size, then (at least by itself), that inspired Brueghel's *Tower of Babel*, then how else do we account for the artist's choice? I believe Brueghel was fascinated by the Colosseum's layered, modular organization—its capacity to impose hierarchy and meaning onto multitudes. For the Flavian Amphitheater showed in its very structure the human drive to *sort*, to *rank* and to *organize*: to assign ontological meaning in the place of God.

All sorting begins with the crude dichotomy, or set of opposites (good and evil, black and white, high and low), and later reflects out into greater subtleties. We all instinctively know this; thus we begin by fretting over the bald conditions of good and bad, worth and non-worth, saved and damned, until the complexity of life confounds our ability to track. This insurmountable frustration gives rise to our drive to impose self-made structures: the boxes of our own ontological sorting, comforting in their boundedness. The Roman Colosseum, of all ancient structures, displayed and enacted this need to sort, and Brueghel's *Tower of Babel* does the same. With their many tiers, both structures show ambition to judge and to rank—to bind life into hierarchy. In real life, the Flavians delineated levels of the Colosseum for specific classes and genders; naturally, the most beautiful ornament was reserved for the highest class. Brueghel extended the Colosseum's levels threefold (and implicitly more) to achieve even more subtle ranking—like a parody of the choirs of angels arrayed around the throne of God.

Brueghel's tower (like the biblical tower it pictures) is thus incredibly multivalent in its indictment of humanity: we try crudely to reach God with extravagant effort and sheer expense, but at a deeper level our reaching takes a different form. It is a reaching of knowledge and meaning that takes God's place by taking God's *voice*. To escape the other-as-death, we must make everything our *mental* possession, subject to *our own naming*, so that the "monolith" is not only a phenomenon of space, but also of knowledge and mind.

SIBLING RIVALRY: JOSEPH IN EGYPT— GENESIS 37–47

It is not enough to simply take for one's self God's meaning-assigning role. This is not satisfying. A mental shift from God's declaring to *my* declaring, after all, would be simple enough—it would not require the building of a gargantuan tower. So it must not be the mere usurpation of power that we seek. Instead, whether we admit it or not, we want rather to *impress* the gazing God-parent, to wrest admiration from his eyes, so that he will agree with our attempts to redefine. In Genesis 11, the Shinarites seemed to replace Cain's whining resentment with puffed-up self-sufficiency, but they were still motivated by a subtle and sidelong jealousy. Context tells us this. For the Babel account in Genesis 11 is immediately preceded by the dispersal of Noah's sons, repopulating the earth after the Flood; the Shinarites represent one branch of this dispersion. In light of these events, the Shinarites' desire to "make a name" takes on another aspect, resonant with the struggle of Cain:

they hope to surpass Noah's other bloodlines, securing a permanent gaze of validation. They hope to be the favored ones in God's new dispensation.

The Bible shows repeatedly that the "older will serve the younger,"[25] from the preference for Abel over Cain, to the story of Jacob and Esau (from which the phrase comes), to the story of King David, who was the youngest of brothers and protégé to King Saul. In the New Testament, this principle extends to the radical assertion in the book of Hebrews that "[humankind] will judge the angels."[26] Thus fear of the other, in its outlines, was endemic to the very first sibling rivalry, and it rears its head again and again with the birth of every second child (or third, or fourth), re-speaking the perils of community into the world at the foundation of each new human experience. All of us, again, are Abel or Cain.

There is tender pain here. For it means that even the hardness of Monoliths (all Babels singular and collective) must harbor faintly beating hearts at their centers. The adamantine scar-tissue of the shielded self, and its grand armor, must protect something, and that something is at least a glimmer of love desperately grasped. This must have been the case with Cain: he desired God and wanted God to himself; he did not want to share. This must have been the case with the Shinarites too, whose tower was a desperate effort to hold onto God's favor at the expense of all other claimants (as if God's favor couldn't be spread around). This may even be the case with the so-called "demons." The book of James declares, after all, that "even the demons believe,"[27] and in the book of Mark, a demon-possessed man says grandly, "what do you want from me, Jesus, Son of the most High God?"[28] Perhaps the demon-impulse itself is just love-fascination corrupted by jealous hoarding, erecting bulwarks against unworthy human rivals made of clay.

An early modern artistic metaphor might help us grasp this last idea more clearly. Constantin Brancusi, the Romanian sculptor, fervently attempted to capture primordial truths in his simple works. From the existential terror of his *Newborn* (a white marble ovoid pierced by a screaming mouth) to the melting lightness of his *Bird in Space* (a reflective, aerodynamic spear), Brancusi sought distilled expressions of universal principles. His 1908 limestone sculpture *The Kiss* shows two squat figures, only barely discernible as male and female, locked in a permanent embrace. Oddly rectangular with flat sides pressed against each other, their foreheads, lips and even eyeballs meet. The result is something uncomfortably monomaniacal (and literally

25. Gen 25:23.

26. 1 Cor 6:3.

27. James 2:19.

28. Mark 5:7.

mono-lithic, having been carved from a single stone). The lovers see nothing but each other, and the intensity of their intimacy seems unsustainable. Brancusi executed at least ten versions of this favorite theme, in various sizes and materials, including the famous version atop the grave of a suicidal lover in Paris. Is this what it's like when we deny community and try to keep the pleasure of the divine to ourselves? Smothering and ecstatic, Brancusi's *Kiss* figures a consuming love that has no room for other glances.

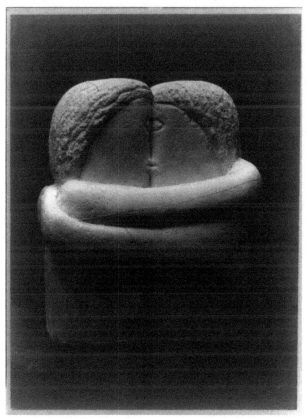

Fig. 1.6. Constantin Brancusi, *The Kiss*, 1908, 28 x 26 x 22 cm.
The pictured sculpture, photographed at the New York Armory Show in 1913,
is probably a plaster cast of the 1908 original.
Photo courtesy of the Library of Congress and ARS New York/Brancusi Estate.

The Pharaohs of Egypt spread lightless towers over flat deserts—thick bastions within which their essence-bodies were protected and hidden. They were said to have destroyed their communities in order to erect these monuments (Khufu, the first pyramid builder, is called "evil" by the Roman historian Herodotus, even prostituting his daughter to finance his

monument[29]). Also, by remarkable coincidence, the Pharaohs wore shining serpents on their crowns—serpents that symbolized the Pharaoh's dominion over the land while unwittingly echoing Satan, the serpent of Eden, called "god of this world."[30] One pharaoh's jealous cruelty spurred the Israelites' flight to the Promised Land. In Exodus, through a single God-gesture, this very same pharaoh's power was crushed, leaving a desperate self, bereft of defense, on the shore of a sundering sea.

Joseph son of Jacob was the regent of one such Pharaoh, and many artists have placed the Pharaoh's serpent-crown on his head. In Eastern Orthodox icons, in fact, Joseph is identified by this crown (in distinction from other Josephs), for it was in his passage through symbolic, glorified death that Joseph showed the way to salvation. Joseph, after all, had "died" at the hands of jealous brothers, sent to the death-land of Egypt, where he would find his proper destiny. And in his rediscovery by the clan of Jacob, Joseph became a resurrected Abel: a "slain" brother now restored to his deserved place.

In the Joseph story, and in the Exodus story that would follow, there was much death: the death of fathers, the death of the firstborns, the death of armies, and later the death of Joseph's successor Moses (estranged from his family, adopted by the serpent-pharaoh) who would never reach home. There was also God's separation of the Red Sea; and as I have argued, separation is the meaning of death. But it was precisely through all of these deaths and separations that a proper God-to-human axis began to be restored. After Abel, the story of Joseph and his descendants continued a pattern of enduring, beloved difference—proliferation and restoration through separation—that would become clearer and clearer, more obviously inevitable, more concretely acted-out, as salvation history unfolded. If Joseph was Abel squared, then Jesus would be Joseph cubed, his triumph redounding in all known dimensions.

Brancusi completed his first version of *The Kiss,* his monolith, in Paris in 1908. In 1909, the sanguine French artist Henri Matisse would also discover a favorite theme: *The Dance.* Like Brancusi, Matisse was trying to evoke something primordial; thus, like Brancusi, the French artist used simple forms and Edenic nudity to put one in mind of a sort of primitive innocence. But in his favored theme, Matisse tried to evoke something beyond smothering eroticism. He tried instead to conjure a joyful state in which a community of people could join their gazes around the circumference of a circle, dancing together full of joy and without shame. If Matisse's figures had been more conventionally beautiful or realistically detailed, the effect might have been pornographic or cloying, but there is just enough awkwardness here, and just

29. Herodotus, *Histories,* vol. I, book II.

30. 2 Cor 4:4, ESV.

enough folkish anonymity, that the sentiment is at once bracing and sweet. *The Dance* is a sort of update of Matisse's 1906 masterpiece *Le Bonheur de Vive* (*The Joy of Life*), in which amorous couples lounge in front of a distant circle of dancers. In *The Dance*, then, what was once background has been pushed into the foreground, in acknowledgment of its importance. In the years between 1906 and 1909, in a Paris art world that probed the universal roots of human meaning, Matisse learned that the greatest purpose came not from ownership and exclusivity, but from the propulsive, unpredictable energy of the collective give-and-take. The divine dance. Works like Matisse's *Dance* exhibit a double looking-outward: first, a looking sidelong toward human others, and second a radial looking inward toward a shared center around which all movement and knowledge must spin.

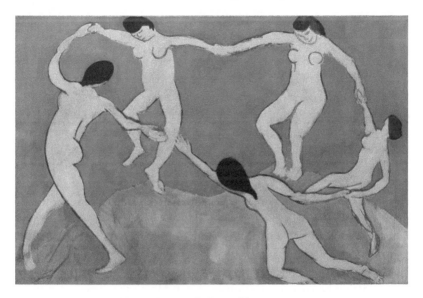

Fig. 1.7. Henri Matisse, *The Dance (I)*, 1909, 260 x 390 cm.
Artwork copyright Succession H. Matisse, 2019
and Artists Rights Society (ARS), New York.
Photo courtesy of the Museum of Modern Art, New York,
and Scala/Art Resource, New York.

JUDAS

The Gospels recount the mysterious sin of Judas—Judas who had seen Christ's miracles, but who betrayed his master for thirty pieces of silver. Why would he do such a thing—something so momentous for such a trivial

reward? His sin amounts to murder, like Cain's primordial murder of Abel. And indeed there is something here of Cain's jealousy. (Judas could not abide the pouring of perfume on Jesus's feet.) But is there also something here of seizure—of Adam's and Eve's seizure of the fruit, or the Shinarites' seizure of the very heavens? Did Judas wish to seize Christ's place as a moral authority, at least in his own mind? In a way, but not exactly. More accurately, as with the Shinarites' self-immolation before their tower, Judas's error was one of structure over individual. He believed the fledgling Christian movement could transcend the man who began it; this made the "movement" just another, more ephemeral version of the monolith. It was a monolith of ideology rather than a monolith of nation, or of individual power.

The woman approaches to pour the perfume. In his heart, Judas is envious. "This violates why I have chosen this path," he thinks to himself, "for in our Way, we should all be treated the same!" But out loud, Judas voices something different: "Why wasn't this ointment sold for three hundred denarii and given to the poor?"[31] he asks. Jesus, in his wisdom, answers a different question. He addresses Judas's secret demand for sameness: "the poor you will always have with you, but you will not always have me."[32] Though he preached community, sharing and self-renunciation, Jesus also insisted upon his own uniqueness. One imagines Judas's reaction unfolding in two steps: first as a pang of jealous anger, and then as rational self-justification. "He preaches service but he says he's better than the poor—than me?," is the first thought. And second: "He implies there are no general rules to follow—that there are exceptions! But this is chaos! Are we not supposed to fulfill the Law? This is no law at all!" Judas would not admit that Jesus's Way was based on the clear sight of every person's true dignity, and not on comforting rules. For his pride's sake, Judas wanted leveling abstractions that could be mentally owned and contained.

Whether he knew it consciously or not, I think the early Renaissance artist Giotto di Bondone had an intuitive sense of Judas's motivations. In his fresco version of the *Kiss of Judas* for the Scrovegni Chapel in Padua (one panel of an encyclopedic masterpiece that shows the entire life of Christ), Giotto shows Judas approaching Christ with the fateful kiss that would signal the latter's identity to the Roman soldiers. Giotto's approach to this subject is absolutely novel in dozens of ways—not least in the artist's choice to completely obscure Jesus's body beneath Judas's yellow cloak. This is the monolith visualized: covering, swallowing, assimilating—denying the right of the other to live or even be known. Yet in this crucial moment, Judas

31. John 12:5, ESV.
32. John 12:8, ESV.

realizes his assumptions have been wrong. As he looks into Jesus's face, his brow furrows in confusion and dismay. Jesus gazes back calmly with acceptance and recognition. One imagines that this is the moment when Judas's world collapsed. From here, he would frantically attempt to undo what he had done, scattering his silver coins like tribes on the plain of Shinar and destroying his own body, the monolith-body, that had attempted to seize and consume too greedily.

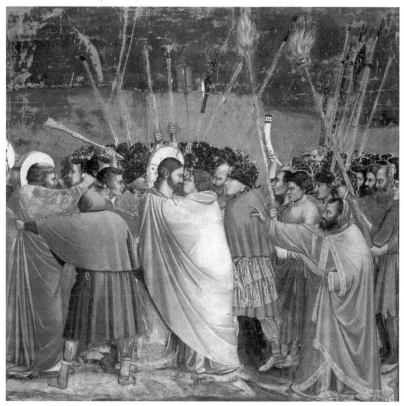

Fig. 1.8. Giotto di Bondone, *The Kiss of Judas*
from the Scrovegni Chapel, Padua, 1305, 200 x 185 cm.
Photo courtesy of Geoff Wren.

THE TABERNACLE AND THE THRONE OF GOD

Contemporary scholars and activists warn against forms of "othering" that project menace, inferiority, or evil onto "others." In fact, the very word "othering" has assumed distinctly negative connotations; consider, for example, the Othering and Belonging Forum at the University of California at Berkeley, which produces an eponymous journal and biennial conferences.

The OBF, in its very title, constructs a dichotomy that seems to oppose otherness with community, as if difference and "belonging" are incompatible. I'm sure the forum's founders did not mean to suggest that harmony amidst difference is impossible, but the forum's name brings to mind conflict. Our society today is still not sure how to find unity in diversity.

Thus in our fight against "othering," we must avoid certain obvious but damaging correctives. Dis-othering, for example, must never be transformed into "same-ing" or pure "identifying." (The Bible's preoccupation with naming and genealogy is a deep indicator of the Judeo-Christian focus on individuality and difference.) "Same-ing" is a pathway to a collectivist sort of Monolith. Meanwhile, the Trinitarian character of God shows us that absolute distinctness must be preserved for true love and fellowship to flourish. The deep meaning of the Trinity rests on its internally complementary character, and this extends to the whole earthly Body of Christ.

Judeo-Christian sacred space then, from the days of the Tabernacle, has been a place of separation, both in its rigorous separation of the holy from the earthly, and in its implicit separation of every earthly thing from every other. This is powerfully described in the Bible. The ancient Israelites could look upon the Ark of the Covenant, for example, but they were not allowed to touch it. (In 2 Samuel 6, the hapless Uzzah was struck dead for steadying the Ark on a cart.) Later, in the Temple, a veil separated the Holy of Holies from the place where ordinary laypeople could worship. Christian architecture, too, has usually insisted on the separation of holy and profane spaces, though in recent centuries those distinctions have been questioned and have almost been lost.

The insistence on absolutely separate sacred space is not unique to the Judeo-Christian tradition, of course. In the ancient Middle East, from Sumeria to Athens, pagan worshippers placed their temples on hills. Dark interiors lit by flickering candlelight suggested that temple space was mysterious and set apart (a famous example is the interior of the now-ruined Parthenon). In the Far East, certain cult statues were—and still remain— unapproachable and unseeable, hidden and separate forever (consider Japan's famous "invisible Buddhas"). We tend to view such efforts as tainted by superstition, but they can be understood as time-tested responses to an authentic psychological need. Humans *need* to walk up hills to encounter the holy; they need to experience the effort and the quest. Similarly, humans *need* to feel mystified and frustrated by the hiding of a deity. The practices that meet these needs are not manipulative shams—they are rather organic responses to a living dynamic. There must be a reason *why* we need these things. There must be something toward which to look or climb.

Interestingly, Early Christian space might at first glance seem to buck this trend toward separation. Early Christian churches were remarkable for their openness, light and permeability. The first Early Christian churches, for example, were modeled after law courts rather than pagan temples: these were vast enough to accommodate large congregations worshiping together, bright enough to allow complex communal ritual, and so airy that no place remotely like the ancient *cella* (or "cell" for a cult statue) could be found. Instead all was open and light. So how was the principle of separateness and uniqueness upheld—even made central—in these spaces? As we will see, it happened in genuinely novel ways.

In the book of Revelation, the author recorded the following vision:

> there before me was a throne in heaven with someone sitting on it. And the one who sat there had the appearance of jasper and ruby. A rainbow that shone like an emerald encircled the throne. Surrounding the throne were twenty-four other thrones, and seated on them were twenty-four elders. They were dressed in white and had crowns of gold on their heads. From the throne came flashes of lightning, rumblings and peals of thunder. In front of the throne, seven lamps were blazing. These are the seven spirits of God.
>
> Also in front of the throne there was what looked like a sea of glass, clear as crystal. In the center, around the throne, were four living creatures, and they were covered with eyes, in front and in back. The first living creature was like a lion, the second was like an ox, the third had a face like a man, the fourth was like a flying eagle. Each of the four living creatures had six wings and was covered with eyes all around, even under its wings.[33]

This is an astonishingly rich image, recording detail upon detail. In fact it is so rich that it is difficult to picture in the mind. There are bright colors, flashing lights, beings of all kinds (some humanoid, some beastly), and even a crystal sea. If one imagines this sea as reflective, then the lights and colors might appear to multiply endlessly, as in one of the artist Yayoi Kusama's famous, mirrored "infinity rooms." Before the throne of God, the biblical author relates, there is enormous and category-spanning aggregation and diversity. Christian architects, once they found their footing, embedded the same kind of aggregation and diversity into their houses of worship.

The very first Christian churches to emerge after the Edict of Milan (when Christianity was made legal) embraced the vision of Revelation in their own way. Specifically, they showcased an art form that clearly

33. Rev 4:2b–8a.

celebrated the part-within-the-whole: the mosaic. During pagan times, mo-
saic tilework was a durable solution for paving floors, as many surviving
examples attest (consider the famous Alexander mosaic at Pompeii). In
Christian times, however, mosaics suddenly made an appearance all over
walls and ceilings, illustrating the grandeur of the heavens and (sometimes)
the majesty of God's throne. Embedded in the art form itself was an insis-
tence on the preservation of multitudinous diversity.

But perhaps the crowning achievement of Christian architects was the
structure we now think of as the "Gothic" cathedral (the term Gothic was
not coined until hundreds of years after many of these churches were built).
In these churches, a modular building technique was employed from floor
to ceiling, so that gigantic piers were often aggregates of smaller columns;
enormous doorways were an aggregation of frames; and supports climb-
ing to peaked ceilings were aggregations of smaller lengths layered upon
each other in orderly patterns. In many churches, even the capitals of the
columns lining the main sanctuary were each utterly unique and dizzyingly
detailed. The nineteenth-century artist, critic, and designer A. W. N. Pugin,
famous for his neo-Gothic churches, stressed and trumpeted the theologi-
cal meaning of this complexity in his many writings. He feared Christian
thoughtways were receding before modernist values of simplicity and ef-
ficiency—before, in other words, a new sort of monolith.[34] His lesson is
still worth heeding today. For Pugin, Christian space would only remain so
when it continued to echo the majesty of John's Revelation.

In Genesis, God set his plan of cascading otherness on its course; but
humankind grew impatient, and seized, and killed. Through the life of Jesus,
the broken pieces were taken up to be polished off and fused into a new,
still-unveiled collage of stunning complexity. Indeed the Crucifix-form, like
Joseph's uraeus crown, shows that God will take and keep all things—even
modes of execution—and transfigure them. (This is another meaning of the
phrase, "Not the least stroke will disappear.") The Bible traces the perils of
othering, but it also insists on God's determination, from the beginning, to
hold onto all "otherness" and lift it up, so that in the end, God's kingdom will
shine forth in mind-blowing, manifold splendor. Fine art is an embodied
metaphor for otherness, and it is lifted up that our eyes might be opened—
opened to what surrounds us, and then, opened to what transcends.

34. See for example, Pugin, *The True Principles of Pointed or Christian Architecture*.

2

New Wine

Art in the Christian Era

This chapter tells the story of the birth of art in the Early Christian world. Because this book is concerned with how people have psychologically engaged with the visual (rather than with how theologians have discussed the visual), we will sometimes have to approach our story from sideways or behind, intuiting the unexpressed dimensions of ancient experiences. Modern visual theory can help us in this process. That's because modern, abstract art, with its laser-like focus on pure forms and their psychological potential, forced scholars to reckon explicitly with art's hidden, sensory effects. Modern art caused a new descriptive vocabulary, and a new awareness of perennial forces, to emerge.

Thus I'll begin this chapter with a modernist case study. In the late 1960s, when the rules of abstract art were being upended, one art critic used the turmoil to define, once and for all, what "art" meant for him. As is often the case in human experience, challenge and struggle were bringing clarity. This critic's thoughts can help us understand the psychological power of Early Christian objects, as well.

DEFINING THE THING CALLED ART

In 1967, the art critic and historian Michael Fried wrote his landmark essay "Art and Objecthood," in which he contrasted what he considered to be "authentic" art with the work of artists from the Minimalist movement like

Tony Smith and Donald Judd.[1] (Donald Judd, a leader of the movement, is famous for his warehouse of identically-sized silver boxes in Marfa, Texas—among other things. His artistic language consisted of pure geometry and rigid repetition.) In his essay "Art and Objecthood," Fried identified an important tension developing in the art world, exemplified by the contrast between work like Judd's and work by famous painters like Jackson Pollock. In the end, this tension revolved around opposed qualities we might call *self-sufficiency* and *dependency*. Was an artwork really an artwork if, like one of a dozen silver boxes, it had no meaning and no inner life? Was it enough for an artwork to operate on the senses alone? And if art *did* operate only on the senses, didn't it need viewers to complete it? This problem can be illustrated through an example that Fried himself discussed at length: Tony Smith's *Die* of 1962, which consists of a dark steel cube, around 6 x 6 x 6 feet in size and oiled to prevent reflectivity. Across all of its versions (four have been manufactured) *Die* is displayed in the same way: resting on the ground without pedestal or barrier, so that viewers can walk right up.

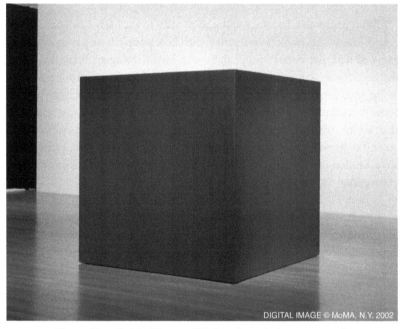

Fig. 2.1. Tony Smith, *Die*, 1962 (fabricated 1998), about 6 x 6 x 6 ft.
Photo courtesy of the Museum of Modern Art, New York,
ARS NY/ Smith Estate and Scala/Art Resource, New York.

1. Fried, "Art and Objecthood."

For Fried, *Die* was not so much a work of art as a provocation; its only purpose was to generate a gut reaction. Large, blank, and content-free, it existed to create feelings of physical threat and wincing self-consciousness. In this sense, *Die* certainly did *not* have a "life" of its own: it had no message, no independent merit, no *point*. It was like the proverbial tree in the forest that makes no "sound" without an audience. It was (though Fried was never this severe) a vacuous gimmick. It should be noted: the title *Die* refers primarily to the work's shape—as in one from a pair of dice—and not to some murderous intention. Smith was not, however, averse to wide-ranging interpretations of his enigmatic titles, which included the evocative *Smoke, Moondog* and *Source*.

In short, then, Tony Smith's *Die* functioned as a mere *object*, exemplifying what Fried called "objecthood"—one of the terms from his essay's title. It was a *tool* to be wielded by the devilish artist, and not a true focus for contemplation. Fried's essay was highly intuitive and at times terminologically imprecise (in fact, he was trying to coin a new terminology), so many of his labels are multifaceted in a way that Fried himself might not have recognized. For example, the word "object" recalls the powerful adjective "objectified" as it has been applied to women and minorities in the discussion of stereotypes. (In the decade after Fried's essay was published, this adjective would begin to gain currency in feminist academic discourse.) An objectified woman has lost her personhood and has become a *sex object*. She has become something to be manipulated and subordinated to a (usually male) viewer's will. For Fried—though his essay predated this common use of the word "objectified"—the same was true of Tony Smith's black cube. Though *Die* drew an involuntary response from its audience (in the same way a sexy poster might draw an involuntary response from an unwitting male viewer), it ultimately placed itself at the audience's service. That is, it made no claim on any regard *beyond* the physiological, or sensual. It did not awaken a sense of responsibility or second thoughts. It never suggested that it was more than what it appeared to be.

Contrary to this sense of "objectness" was Fried's quality of "presence." Fried's use of the word "presence" can seem paradoxical: wouldn't an object as physiologically provocative as Tony Smith's *Die* obviously have a strong sense of presence? For Fried, however, "presence" was something other than mere physical proximity or intimidation; it was rather a sense of internal dignity, a demand for regard, an insistence on *otherness* resistant to the viewer's psychological fantasies. The winking pin-up girl is not definitely *other*: she seems to exist solely *for* the one who ogles her. Similarly, Smith's *Die* is not definitely other—it exists only to produce a kind of thrilling or mysterious effect. For Fried, neither of these objects could rise to the level

of art, with its intrinsic nobility. What Fried seemed to posit, in fact, was that true art was somehow ensouled—or at least it appeared to be. He even used religious-sounding language. At the end of his essay, for example, Fried declared that "presence [in art] is grace."[2]

And there was one more important dimension to Fried's sense of "presence"—a dimension that likewise seemed almost spiritual in its profundity. For Fried argued that presence is also linked to "perpetuity," or *timelessness*.[3] A truly *present* work of art lifts one up into a timeless space in which past, present, future, movement, and change are lost in a single moment of what art critics have called "perceptual plenitude"—in other words, revelation.[4] Though Fried never went so far (rhetorically or philosophically), there was a sense here in which the artwork had to approximate the effect of the ensouled person as understood in traditional Christian theology. It had to simulate or point to an intrinsic dignity that was *incarnational* in its linking of the spiritually vast with the physically concrete. Fried's definition of art, forged in opposition to works that (for him) falsely claimed artistic status, can help us understand the shift from idols to art in the Early Christian period.

TWO MOTHERS

In the ancient Mediterranean, something like a transition from "objects" to "artworks" occurred as the once-dominant "classical," Greco-Roman worldview yielded to a new, early-Christian one. This was true particularly in sacred *milieux*, where the most precious fruits of human artistic craft were likely to be displayed. (Think idols, followed by icons and crucifixes.) To illustrate, I'll consider one particular, evocative contrast—a contrast of two "mothers," each an artistic monument, a focus of her children's faithful gazes, and a protectress and nurturer of her people.

The Salus Populi Romani

The Roman church of Santa Maria Maggiore was begun in AD 431, in the wake of the third Ecumenical Council at Ephesus, part of present-day Turkey. At that important council, the Virgin Mary (for whom Santa Maria

2. Fried, "Art and Objecthood," 23.

3. Fried, "Art and Objecthood," 21–22.

4. A definition and critique of this notion is discussed by the postmodernist critic Rosalind Krauss in her essay "In the Name of Picasso."

Maggiore was named) had been declared *Theotokos*, or "Mother of God." According to legend, the church was built on the site of a miraculous August snowfall foreseen in a dream. Today it is one of four papal basilicas (the most sacred in Roman Catholicism, considered extensions of the Vatican), and it remains perhaps the most revered Marian church in the world, welcoming thousands of pilgrims annually and hosting a "snowfall" of white rose petals on the anniversary of its founding.

From the beginning, Santa Maria Maggiore (in English, St. Mary Major) uniquely captured the legend and nature of its namesake. Its fifth-century mosaics are perhaps the earliest complete cycle of images depicting the life of Mary, in which she is shown in the majestic robes of a Byzantine empress. Its most opulent and important side-chapel, to the left of the apse, houses a very early Marian icon dubbed the *Salus Populi Romani* (the protector of the people of Rome). Underneath the church's main altar, the supposed remains of the infant Christ's crib are preserved in a silver casket. Above, an apse mosaic depicting Mary's coronation in heaven was added near the beginning of the Renaissance.[5] Finally, the stately procession of ancient columns lining the nave is among the grandest and most pristine in any Christian building, giving an impression of purity and serenity reflective (surely) of the traditional Marian persona. This is Mary-as-architecture, embracing and protecting the faithful who are her children.

5. The crowning of Mary as Queen of Heaven, or the "Coronation of the Virgin," was a popular artistic subject in the late Middle Ages and early Renaissance. A subject initially inspired by popular piety, it was theologically ratified by the Catholic Church in 1954.

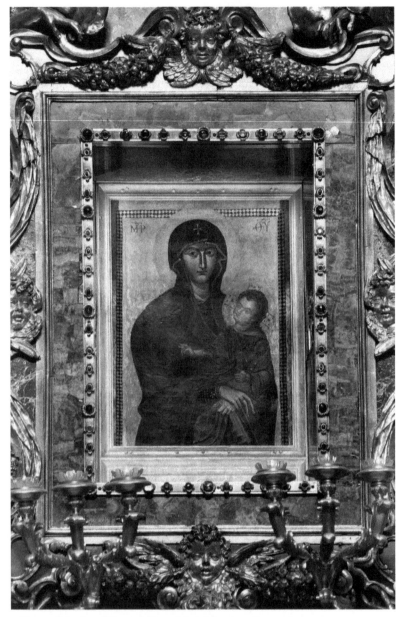

Fig. 2.2. *Salus Populi Romani*, Santa Maria Maggiore, Rome, about 590, 117 x 79 cm.
Photo courtesy of Scala/Art Resource, New York.

The *Salus Populi Romani*, an unusually large Byzantine icon that was
taken from Byzantium to Rome in around AD 590, is perhaps the most
important object in Santa Maria Maggiore. In fact the church today can

almost be understood as a treasure-box or reliquary for this image, highly venerated by the faithful for centuries. With dimensions of about 5 feet by 4 feet, the painting shows a regal Virgin Mary holding the infant Christ, who is seated peacefully on her lap. Touchingly, Mary crosses her hands over Christ's legs in a relaxed embrace; this unusual pose, in its idiosyncrasy and naturalness, suggests the early origins of the image, before the establishment of more rigid, imperious-looking formulas. Meanwhile, as in many other Byzantine icons, the background is covered in gold leaf and there is no trace of furniture or architecture. While the painting has been retouched extensively over the centuries, its composition and general *mien* are thought to be original. It is one of the best-preserved Early Christian icons in the Western world.

Artemis of the Ephesians

The *Salus Populi Romani* can be linked to another venerated feminine image, the cult statue of Artemis of the Ephesians—also a maternal symbol and a focus of pilgrimage. As we have seen, the city of Ephesus was the location for the third Ecumenical Council, where the Virgin Mary had been declared *Theotokos*. Its selection as host for the council had surely been strategic. By AD 431, Ephesus had been a major site of religious tourism for around 1500 years, thanks to its cult of Artemis—a pagan mother-goddess who was also, remarkably, a virgin. (Today Ephesus preserves its tradition of virgin-mother tourism by claiming to be the site of Mary's house.) The New Testament itself records the Apostle Paul's travails in Ephesus, where he ran afoul of an idol maker named Demetrius, who feared that Paul would ruin his livelihood. According to Acts 19, Demetrius's panic sparked a riot that nearly got Paul and his companions killed.

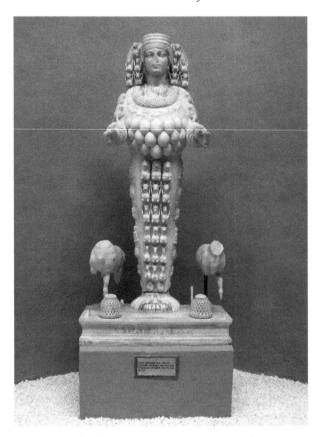

Fig. 2.3. Artemis of Ephesus, monumental cult statue, second century AD.
Photo courtesy of the Ephesus Archaeological Museum, QuartierLatin 1968,
and Creative Commons.

Artemis of the Ephesians was one of the most famous and respected
indigenous deities of antiquity. Deeply ancient in origin, she had, over
time, taken on a Greek name and Greek characteristics. According to
the biblical account, the Ephesians believed her statue had "[fallen] from
heaven"[6] as a special blessing to the city. The original statue was displayed
in the enormous Ephesian temple of Artemis, which was four times the
size of the Parthenon and one of the seven wonders of the ancient world.
The statue inside, meanwhile, was prolifically duplicated at smaller scales
by artisans like Demetrius, so that it is known today through over four
hundred surviving copies. Artemis's unusual raiment included a bodice

6. Acts 19:35.

of dangling lobes that have been interpreted variously as bulls' testicles, swollen breasts or bees' eggs.

The *Salus Populi* and the Ephesian Artemis were thus both miraculous images of virgin mothers. The Ephesian cult statue, of course, had apparently fallen from the sky. The Marian image, meanwhile, was attributed to the biblical St. Luke, and was thought to have been painted, under the advice of Mary herself, onto a tabletop made by the young carpenter Christ. Inspired by God, Luke was thought to have captured the appearance of Mary and her baby exactly, providing a reliable witness for future generations. Both images were therefore what Eastern Orthodox Christians would later call *acheiropoieta*—images made with divine intervention. But more importantly for our purposes these two miraculous works, when considered side-by-side, illustrate a shift from an "object"-paradigm (in the ancient world) to the "art" paradigm that Michael Fried would celebrate in the years *Anno Domini*. The *Salus Populi*, in fact, is a landmark early example of the thing we call "art."

THE INVENTION OF ART

So how exactly do these two sacred effigies differ? What can account for the paradigm shift? First, the move from "object" to "art" is most viscerally evident in the media used by the ancient artists: the Artemis was a sculpture, and the *Salus Populi* is a painting. Michael Fried, centuries later, would likewise contrast painting with sculpture (namely, Abstract Expressionist paintings like those of Jackson Pollock with Minimalist sculptures like Tony Smith's) in his "art" vs. "object" distinction. (Fried did believe sculpture could be artful under the proper conditions, as we will discuss later, but it had psychological biases to overcome along the way.) From a "self-sufficiency" vs. "dependency" point of view, as we have seen, the sculptural medium is at a distinct disadvantage as a platform for "art." Three-dimensional objects are especially liable to create in-the-moment physiological reactions that *act upon* the viewer, throwing the viewer back onto herself and generating both self-consciousness and awareness of her surroundings. This was precisely opposite to the goal of "art" (according to Fried), which was to *transport* the viewer to an eternal moment outside of time and space.

For the pre-Christian ancients, however, it was exactly sculpture's dependence on the viewer that made it the perfect medium for capturing the divine. Sculpture, with its place-bound potency, aesthetically affirmed that the gods and goddesses were appropriately *localized*, near to and protecting their human charges. Like Artemis of the Ephesians, who shared a special

relationship with her home city, pagan deities inspired devotion largely because they were fundamentally anchored to their temples or somehow *really fragmented* among their votive images. This made them confinable and manipulable, even as their images bore genuine, "living" magical power.

In his book *Making and Breaking the Gods*, the Danish art historian Troels Myrup Kristensen describes how beliefs about divine localization were manifest in pre-Christian outbursts of iconoclasm (that is, ideologically-motivated image destruction). As Kristensen shows, different patterns of image-destruction in the pagan and Christian worlds suggest fundamentally different beliefs about the *localization*, and therefore the independence and sovereignty, of pictured personalities. He observes, for example, that Christian iconoclasts were often satisfied to recontextualize offensive images, rather than destroy them; it was not the images' *substance* that was threatening, but rather their meaning. (A bearded head of Zeus could be repurposed in a church context as a head of Christ.) In the pagan world, however, mere recontextualization was not enough. The ancient practice of the *damnatio memoriae* (or "erasure from memory") is a case in point. This tradition, common to many different pre-Christian cultures, mandated that every single representation of a despised leader or deity be destroyed, no matter how much it had been previously altered, how small it was, or how hidden it was from the public eye.[7] Mere recontextualization would not do the trick. This is because the despised party somehow still *dwelt inside* its image.

With its postulation of a visible God who was also transcendent, Christianity made the old patterns of god-localization and *damnatio memoriae* obsolete. In fact, Christianity seemed to debase and elevate the sacred image simultaneously, both disempowering it and expanding its referential scope. It was through this process that Christianity created the thing we call "art." Though in the Christian world the sacred image no longer contained its own power, it could now *point toward* a power that was independent of any merely spatio-temporal manifestation. One can imagine how truly perplexing and awesome the earliest Christian images must have seemed to be. Deprived of their ancient magic (where magic is really just a collection of desperate human recipes for control), the new Christian pictures must have seemed truly terrifying in their evocation of a vast outside.

The Japanese Byzantinist Suzuki Michitaka approaches the shift from localization to transcendence in a different geo-cultural context. His work examines how Western Christian influence in the modern era is transforming indigenous Japanese understandings of Shinto-Buddhist sacred art. (As

7. Kristensen, *Making and Breaking the Gods*.

an example of this kind of work, picture a serene and fleshy sculpture of the seated Buddha.) In his essay "Invisible Hibutsu and Visible Icon," Suzuki considers the paradox of the "Invisible Buddha" genre in Japanese sculpture; these objects are carefully-wrought visual products that, for ceremonial reasons, have to be kept *in*visible—literally boxed-in—lest their wrath be unleashed.[8]

Invisible Buddhas were (and are) common in Japan, and the practices surrounding them stand in interesting contrast to Christian art practices. In their assumed wrathfulness, for example, Invisible Buddhas are believed to be really, truly alive, as much as a person is alive. (Suzuki notes that for some believers, "Buddhist priests and Buddhist statues . . . are ontologically the same."[9]) Consequently, there is no "one original prototype" of which the statues are thought to be copies; instead, each figure is independent and discrete, inextricably tied to its own time and place and the actions that are performed around it and for it. (Poignantly, this explains why seated Jizo Bodhisattvas are often clothed in the winter in Japan. Because their *being* is identical with their stone bodies, they are in danger of shivering in the cold.) Aesthetically and psychologically, meanwhile, the sealed-up shrines of Invisible Buddhas are rather like "black boxes" (Tony Smith's *Die* comes to mind here), that mark the landscape and provoke physiological reactions without communicating their own messages or emotions. For Suzuki, himself an Eastern Orthodox Christian, the Shinto-Buddhist compulsion to locate deity *within* representation is hard to overcome, though the Christian icon has provided a model for psychological reorientation.

Some Romantics Trace the Path

In the nineteenth century (which was, not coincidentally, also the century when academic art history and criticism were born), canonical Western philosophers like G. F. W. Hegel and Søren Kierkegaard similarly identified Christianity as "inventor" of a new form of representation that pointed toward, but did not encompass, the divine. (For Kierkegaard, this was simply *representation itself,* as we understand it: thus he stated outright that "the idea of representation was introduced into the world by Christianity."[10]) Drawing on intuitions later supported by visual theorists, Hegel and Kierkegaard

8. Suzuki, "Invisible Hibutsu (Hidden Buddha) and Visible Icon."

9. Suzuki, "Invisible Hibutsu (Hidden Buddha) and Visible Icon," 8.

10. Kirekegaard, *Either/Or,* Part I, "The Immediate Erotic Stages or the Musical-Erotic."

viewed Christianity as a paradigm shift not only in terms of theology and morals, but in terms of the lived experience of visual perception.

The idea that Christianity essentially invented pictorial representation may have first occurred in Hegel's *Lectures on Aesthetics*. Hegel wrote a generation before Kierkegaard, and he used art history as important evidence for his interpretation of human history as a dialectical (or trial-and-error) process of gradual awakening. For Hegel, the early Christians made great spiritual progress when they liberated the divine from its unworthy material vessels (cult statues, for example). A consequence of this breakthrough was the midwifing of "art"—that is, the sacred image that functioned as a mere reference rather than as an idolatrous center of power.

We can trace Hegel's argument—charting the path from localization to transcendence—through a few passages in Volume 1, Part 3, of his *Lectures on Aesthetics*. First, Hegel tried to describe the kind of truth captured in the idols of the classical world:

> In order to be a genuine content for art, such truth must in virtue of its own specific character be able to go forth into the sphere of sense and remain adequate to itself there. This is the case, for example, with the gods of Greece.[11]

Because Hegel's account of the unfolding of human history was a progressive one, premised on his belief that humankind becomes more and more enlightened as the ages pass, one might have expected the philosopher to quickly dismiss ancient idol worship as mere "superstition." Instead, however, Hegel did something more empathetic and profound. In the above passage, he suggested that the ancient sacred image emerged from a worldview in which the divine was conceived *in terms of* the physical ("the sphere of sense . . . [was] adequate"). This meant that the physical was considered wholly equipped to do the job of evoking, or summoning, the divine. There was nothing beyond the physical to get lost in translation.

In the years *Anno Domini*, however, the human mind (according to Hegel, animated by a churning, pantheistic World-Soul) had finally exhausted the capacity of physical things, great though it had been, to express the highest truths. Striving minds sought further limits. Therefore, according to Hegel:

> We have [now] got beyond venerating works of art as divine and worshipping them. The impression they make is of a more

11. Hegel, *Lectures on Aesthetics*, Volume I, Introduction, Part 3.

reflective kind, and what they arouse in us needs a higher touch-
stone and a different test.[12]

In other words, the artists of the Christian era stood on the shoulders of
metaphysical researchers (the ancient carvers of pagan gods) without whose
efforts the limitations of the physical could not have been known. Now, a
"higher touchstone" had been revealed. But the people of pre-Christian
times had done their best, and they were owed our gratitude and respect.

For Hegel, then, ancient "idol worship" was certainly not the result
of foolishly misattributing miraculous powers to a block of stone. It rather
came from the *de facto*, imaginative localization of *soul* and *deity* because,
of course, *everything* was localized, and how could it be otherwise? This was
a completely reasonable point of view, and for Hegel, only the unnatural,
seemingly irrational insights of Christianity could have destroyed such a
paradigm and injected an airy, diffuse and timeless notion of transcendence
in its place.

As a result of Christianity, sacred representation became slippery, the
gods could no longer be "held on to," and magic (that is, manipulation of the
divine) was no longer a viable pursuit. The classical idols, now considered
unable to contain the gods, were no longer deserving of "veneration," but
thanks to their eloquent and orderly forms, they began to demand a differ-
ent sort of gaze instead. (It is not difficult to see how disciplines like modern
physics and mathematics could emerge from such a paradigm shift.) Need-
less to say, the tenor of art continued to shift as the Christian revelation
permeated the cultural imagination. In the remainder of his *Lectures on Aes-
thetics*, Hegel traced an art-historical process whereby the localized divine
seemed to visibly stretch and strain until it escaped totally from its physical
vessels. In some ways, his account anticipated the thoroughly aniconic (that
is image-free) church spaces to which modern Protestants are accustomed.

Kierkegaard's later approach complemented Hegel's, but it went
further. In some ways, it even anticipated Michael Fried's "art vs. object"
dichotomy of 1967. For Kierkegaard, the pagan (pre-Christian) viewpoint,
with its exclusive concern for survival and pleasure, naturally interpreted the
world as a world of *objects*—that is, things to be "objectified" and brought
into service to the individual's needs and lusts.

As a so-called "existentialist," Kierkegaard's orientation was more
experiential and individualistic than his predecessor's. Kierkegaard's
view of art was informed by a notion of cultural evolution that was not,
a la Hegel, driven by growing, collective, intellectual comprehension, but
rather by improving moral sensitivity at the individual level. Before Christ's

12. Hegel, *Lectures on Aesthetics*, Volume I, Introduction, Part 3.

moral revelation, according to Kierkegaard, to pause and regard an "other" as a *person* with her own dignity and existential rights was inconceivable, counter-productive and even unnatural. Instead everyone and everything (including, one assumes, wives, fathers, children and gods) was "aestheticized"—turned into a mere object—and used for the satiation of need or desire. We can infer that this kind of ownership through "aestheticization" must have informed all visual production, as well.

Christianity, however, disrupted this tendency toward self-centeredness by positing a dignity, rooted in the transcendent, for everyone and perhaps every*thing*. It was through Christianity's evocation of a *separate* transcendence—a transcendence informing matter but not captured in matter—that representation became possible. Kierkegaard's framework resonates with the arguments of the great, early image-theologian Basil of Caesarea (AD 329–379), who famously said "the honor given to the images passes over to the prototype."[13] Basil's formula here is rich with meaning, suggesting myriad implications: first he affirms that image and prototype are separate; second he owns that a relationship nevertheless obtains between them; and third, he implies that the image is decidedly inferior to the original. Just like the human body, the image-body is lowly and finite, but it is anchored to something higher.

It was this new focus on the separate, divinely-guaranteed dignity of all things that would usher in more than a millennium of profound Christian "representation," or more simply, art. Indeed, the great combatants of Byzantine iconoclasm, John of Damascus and Theodore the Studite, had followed Basil's reasoning and helped make the new image-forms safe in the *Anno Domini* world. By Kierkegaard's reading this fresh Christian visuality, summed up in the form of the icon, could be understood as a potent, embodied metaphor for a revised understanding of human personhood-in-community—one based on the mystery and eternity of individuals (who are no longer mere "objects"); on requirements of openness and humility (so that a truth external to the self can be seen); and on the absolute necessity of mutual respect. If Kierkegaard was right, it is no wonder that the first Sunday of Lent in the Orthodox Church, during which the end of iconoclasm is celebrated, is also called the "Triumph of Orthodoxy." The triumph of the icon was also the victory of a gracious, new moral order that would transform the world. When there's more to an object than meets the eye, humble respect is always the best strategy.

Christianity posited a dignity beyond material creatures' mere "objectness;'" consequently, Christianity made all things "representations," in

13. Basil of Caesarea, *On the Holy Spirit*, chapter 18.

some way, of something deeper. The physical or sensory was only an outward manifestation. ("One face seems to be within the other," Kierkegaard wrote.[14]) Though Kierkegaard did not, like Hegel, consider the forms of Early Christian art specifically, his dynamic offers an explanation, complementary to Hegel's, for why the Christian sacred image departed from monumental sculpturality to became more frankly a mere *signal*. Thus huge statues like the Ephesian Artemis were replaced by rough paintings like the *Salus Populi*, which itself was a collection of marks on a tabletop, rather akin to writing.[15] Physical attempts to evoke the divine became humbler and more diffuse.

Unlike the pagan idol—often tremendous in size, crushingly heavy and made of durable stone—the Christian "representation" did not radiate completeness and all-at-once, smothering availability. Instead it was relatively open-ended and thin, made of sketchy, oily marks on a flat surface. It was straightforward about its inability to capture what it referred to. Paradoxically, however, this made such "representations," like Fried's preferred modern artworks, "inexhaustible." By seeming so poor and insufficient *as an object*, the new Christian picture indicated a greater life beyond itself, or "opened a window onto heaven," to use a distinctively Byzantine metaphor. It is not hard to imagine that early paintings in this vein might have actually seemed threatening compared to the earlier, localized deities of stone. Thank goodness the Christians reiterated always that "God is Love."

THE PICTURE

Certainly the portable picture, as we understand it, is largely the product of Christian culture. It is the Byzantine icon form—flat, light and rectangular—that has become the archetypal *picture* as it is now understood across the globe. In a certain way, all of us have icons on our walls, even though they now depict landscapes or family members rather than ancient saints. We have internalized the "window onto otherness" developed by the first Christian artists, and we approach such windows with an outward reach and a questing heart.

The exceptions prove the rule. In the first century AD, the Roman historian Pliny the Elder recounted the ancient Greek story of Zeuxis and his grapes—and this story seems to revolve around rectangular pictures.

14. Kierkegaard, *Either/Or*, Part I, "The Immediate Erotic Stages or the Musical-Erotic."

15. Indeed, in harmony with the notion that the icon cannot capture but only suggest, icon painting is traditionally called "icon writing."

According to legend, the great painter Zeuxis rendered an image of grapes on a piece of wood, and some nearby birds, so convinced by the realism of the grapes, flew down to peck at the painting. Nearby, Zeuxis's rival Parrhasius had mounted a panel covered by a curtain, and Zeuxis moved to pull the curtain back. He was dumbfounded to discover that the curtain itself was merely paint, and that he had been fooled just like the birds. Parrhasius thus won the day, and both artists went down in history as magicians of the brush.[16] Both of these paintings have been lost to time, but we can get a sense of their power when we contemplate something like the mural from the dining room of the Roman Empress Livia, now at the National Museum in Rome. Here, life-sized bushes, trees and a low fence have been rendered on a wall-sized plaster expanse, creating the illusion of dining in a garden. For Livia, this image, decorating a cool subterranean room, provided a welcome respite from the muggy Roman summers. It was a tool for sensory escape.

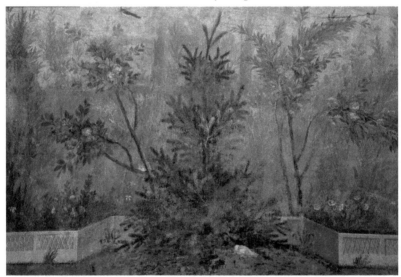

Fig. 2.4. Wall fresco segment from the triclinium (dining room) of the Villa of Livia, first century BC. This fragment was part of a continuous fresco that covered the walls of a room 40 x 20 feet in size. The fresco cycle is preserved in its (almost) entirety in a branch of the National Museum of Rome.
Photo courtesy of the Museo Nazionale Romano and Carole Raddato.

And that is precisely what distinguishes ancient painting from the painting invented by Christians: ancient painting was not representation, per se, but sensory manipulation. It partook of the objectification described by Kierkegaard. Zeuxis's grapes, for example, were not a window onto the

16. Pliny the Elder, *The Natural History*, chapter 36.

essence of "grapeness," inviting us to contemplate that noble fruit and its theological resonances. Rather, they were an illusion created to amuse the eye and perform a momentary function. The same was true of Parrhasius's curtain. In a Fried-ian sense, both Zeuxis's and Parrhasius's paintings existed for the viewer, creating a sensational effect that was exhausted once the conceit was grasped. They were not windows onto something separate, sovereign, and dignified.

The Early Christian icon is first and foremost a portrait, and two-dimensional portraiture also existed in the pagan world. It is notable, however, that this portraiture was usually a physical extension of the body of its subject and not a window onto some transcendent essence. The best pagan examples of two-dimensional portraiture might be the wonderful mummy portraits found in Egypt's Faiyum Basin: here, realistic faces overlay the quiet bodies of the deceased. The portrait's layering atop the body itself, however, is indicative of its function: it is not a free-standing reminder of some separate essence, but an illustration of the localized being to which it's attached. Even the intriguing marriage portrait of Terentius Neo and his wife at Pompeii fits into such a paradigm. Though not positioned atop mummies, this portrait decorated the physical wall of Terentius's house, in close proximity to the people it represented. It told viewers what they'd find inside. In all of these images, the sense of localization so fundamental to the pagan world was preserved.

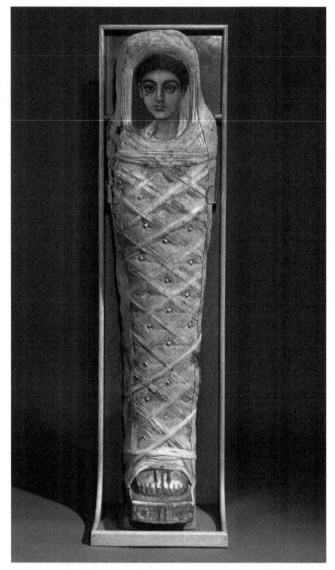

Fig. 2.5. Mummy of a young boy with portrait panel
from Hawara, Egypt, AD 100–120, height 133cm.
Photo courtesy of the Trustees of the British Museum, and Art Resource, New York.

Ancient Near-Eastern burials, and particularly the famous Egyptian burials at Giza and the Valley of the Kings, are well known for their proliferation of portrait sculptures; the practice of sculpturally capturing the royal deceased blended the tradition of sculptural idol worship with the tradition of portrait adornment as seen in the Faiyum mummies. The tomb of Gudea

in Lagash, Mesopotamia, for example, contained at least twenty-six statues of the deceased. But these images certainly were not meant as "windows" onto Gudea's soul or personality; in fact their makers probably assumed the statues would never be seen by human eyes. Rather these images (and their large quantity helps prove this) were meant to be back-up resting places for Gudea's essence. Operating with the conviction that everything must be physically localized, ancient cultures ensured the perpetuation of the royal (and therefore divine) spirit by providing numerous locales for its residence. If some were destroyed by time, surely others (sculpted from imperishable granite or diorite) would survive to the end of the age.

Early Christian audiences may have struggled to make the leap, in portraiture, from the image as localized dwelling place to the image as representational "window." Thus a phenomenon called the Iconoclastic Controversy roiled the Byzantine Empire for centuries, during which some Christians were accused of treating icons as localized deities. Famously, the first wave of iconoclasm was launched when Emperor Leo III removed a venerated image of Mary from above the palace gate in Constantinople. Perhaps swayed by Islamic advisors (according to some accounts), Leo was convinced that "Satan [had] misguided men, so that they worshipped the creature instead of the Creator."[17] Later in his reign, Leo deposed the "icon-loving" Patriarch of Constantinople, the effective "pope" of the Orthodox Church, and persecuted many other, similar offenders.

However, possible abuses notwithstanding, the rapid substitution of the flat picture for the monumental sculpture shows that Christian culture, from the very beginning, was changing the paradigm; the yeast was gradually working through the whole batch of dough. Indeed, the Holy Roman Empire of Charlemagne, which had emerged on the scene by AD 800, had already gotten past the "idol vs. representation" tension that roiled the East. Discourses by Western scholars exhibit bemusement and confusion about the high tempers of the iconoclasts. "Pictures. . .have a certain ability to remind one of things," Theodulf of Orléans had written in the *Libri Carolini*, but to argue more, as if they could embody the sacred, was "babbling."[18]

Picture-icons, therefore—like the *Salus Populi Romani*—slowly began to take over the world. Today, in fact, our visual experience is almost completely mediated by freestanding rectangles, whether canvases within frames, family photographs, smartphone surfaces, televisions or computer

17 This is a paraphrase of Romans 1:25. See *Epitome of the Definition of the Iconoclastic Conciliabulum*.

18. Excerpt from the *Libri Carolini* titled "The Caroline Books: A Frankish Attack on Iconodules," in Davis-Weyer, *Early Medieval Art 300–1150: Sources and Documents*, 103.

screens. None of these media are regarded as localized beings; all point in some way to something beyond themselves, whether in the Christian heaven or the information cloud. Cloud technology itself, in fact, can be seen as a living metaphor for a Christian heaven, sprinkling meaning and information onto God's creation.

THE CHRISTIAN PICTURE GOES GLOBAL

If the Early Christian icon introduced the notion of the detached and portable visual representation, it was early Protestantism that made the Christian picture a part of everyday life. Many centuries before, Christianity had made the codex—that is, the paginated book as we know it—the preferred means for the dissemination of writing. (In the Greco-Roman world, long-form writing had been preserved primarily on scrolls.) Along with the codex came the illustrated rectangular page—a more covert version of the rectangular picture that was evolving in the icon tradition. (Famous examples include the celestial vining decorations from the Book of Kells or the "author portraits" common in early Bibles.) During the Protestant revolution and the nearly simultaneous triumph of the printing press, rectangular codices and their illustrations were distributed throughout the middle classes of Europe, and with them a taste for the Christian picture. Soon, the Christian picture adorned the walls of merchants' homes, and the subjects deemed worthy of Christian representation (still with its undertones of iconic transcendence) expanded.

By the late sixteenth century, the sacred terrain considered worthy of "window treatment" extended to portraits of living Christians (not just bygone saints) and portraits of nature. But the latter—which we now know as landscape paintings and "still lifes"—were not the mere sensory triggers of Zeuxis and Livia. They were not "objects" in the Fried-ian sense. Instead, they were windows for contemplation onto a universe of creatures newly understood to have eternal import beyond their ability to serve or gratify. Zeuxis's grapes might not have been meant to provoke contemplation of "grapeness," but the grapes of the Flemish painter Frans Snyders certainly were. Snyder's luminous orbs swell toward the viewer with an inner life that conjures not only quotidian "grapeness," but all the assorted qualities of deep nourishment and vining life that Christianity has granted the grape in Scripture and ritual. And this new respect was not only for fruits: in the flowers of Jan Brueghel, and later the cows of Aelbert Cuyp, mysterious life and significance were newly found.

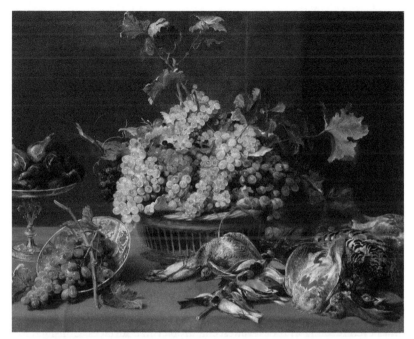

Fig. 2.6. Frans Snyders, *Still Life with Grapes and Game*, 1630, 90 x 112 cm.
Photo courtesy of the National Gallery of Art, Washington, DC.

Finally, simultaneous with the spread of a mercantile, world-embracing Protestantism was the spread of an international picture trade. Swift new ships distributed portable "icons"—that is, window-representations—to the entire known world, by the thousands. Artists trained in spontaneous, impressionistic techniques rose to meet the need, creating supply that met the voracious new demand. But these fresh and varied icons, unlike their ecclesiastical forebears, were not only novel in subject; they also embraced a new support: the canvas fabric used for ship sails. It was a medium that perfectly captured how the "Christian picture"—this new art form inspired by the Christian worldview—had colonized the modern imagination.

Notwithstanding the Christian picture's rapid spread, the leap from churchly icon to domestic still life (or portrait, or landscape) had been perilous. Just as the early Christians had struggled with the paradox of the Trinity, later artists working under the influence of the Christian worldview would struggle with the paradox of presence-in-absence. It was one thing to assert that God was transcendent, and that God's image (that is, representations of God), could only ever suggest God but not comprehend him. The next step, from God to the heaven-dwelling saints, was also, perhaps, not a difficult one to make. But what about things *still living*—things assuredly *located* in

the here and now? What about landscape, which was localization defined: immobility and *manipulability* (through agriculture, resource extraction, or structural development) to the utmost degree? In the Italian language, the term for "real estate" is *immobiliare*: that which cannot be moved. How could the Christian paradigm extend absence and transcendence even to the ground beneath one's feet?

Christian art's conquest of landscape, beginning in the fifteenth century, clarifies the extent to which earlier religious paradigms had been fundamentally chthonic, rooted in "blood and soil" and the claims of place. The localized pagan deity in her temple had been like the iceberg-tip of a magical subterranean network (or magnet, or *massiveness*—with its gravitational pull) that negotiated with the souls upon it. She was *meant* for her place, a *part* of it, as her people were meant for her.

However, when Christianity removed the god from the blood and soil, it inverted that vast pyramid. Suddenly meaning was located elsewhere, and its physical aspect was only a small bubble, or better, a water drop descending from a vast and ineffable celestial ocean—the heavens, from which true meaning came. The Christian picture simply traced those bubbles, sometimes even reveling in their evanescent, droplet-like surfaces. Consider, for example, the swelling, "fish-eye" landscapes of Pieter Brueghel and Benozzo Gozzoli. These landscapes almost seem to bulge out from the surface of a water-drop; they are fleeting apparitions of something deeper and more timeless rooted in the mystery of God's providence.

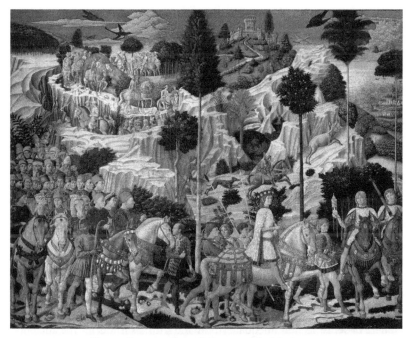

Fig. 2.7. Benozzo Gozzoli, *Journey of the Magi*, 1459.
This mural section covers an entire wall in the private chapel of the palace
it inhabits, and the scene even wraps around to decorate the adjoining walls.
Photo courtesy of the Medici-Riccardi Palace, Florence, Italy.

But wait: didn't that mean the "Christian" picture was actually Platonic—an echo form of an ur-form—and thus not distinctively *Christian* at all? (Was it, for example, like the shadows in Plato's cave: made of dark and faint traces of things that *truly* reside up higher in the light?[19]) Though popular image use in the Greco-Roman world did not anticipate the pervasiveness of the Christian picture, this was, it could be argued, because the sophisticated ideas of philosophers like Plato had not yet trickled down to the masses. The majority did not have the sensitivity of the intellectual few, and it demanded localized, touchable deities. Thus the Christians, it might be argued, didn't actually *invent*, the picture, they just popularized something the ancient philosophers had discovered long before.

It is important, however, to make a fundamental distinction between the Platonic form vis-à-vis its echoes and the Christian icon vis-à-vis its heavenly prototype. Platonic echoes could be understood as emanations, like ripples in a pond, that grew weaker and weaker the farther they strayed from their center. They were in substance not dissimilar to their center;

19. Plato's "Allegory of the Cave" can be found in his *Republic* 514a–520a.

they just happened to be poorer and more diffuse. In this, they continued to manifest what Hegel called "adequacy to their content." They were appropriate vessels for what they communicated, but they were poor vessels. This is because, in the spirit of ancient localization, they were simply *in the wrong place*, far from the source of life that was God, or the One.

The Christian paradigm, contrarily, never asserted a likeness in substance between the window-picture and the essence upon which it opened. It always insisted that the object of our wondering and gazing transcended the power of artificial, measurable forms to circumscribe it. The eternal and the creaturely were separate. Indeed, it was precisely this latter belief that made modern fine art, with its "timeless" aspirations, possible. The postmodernist art critic Rosalind Krauss noted that we expect genuine art to vibrate with "plenitude" (or vastness), so that it continually rewards contemplation.[20] This is artwork we live with and never tire of, because its content is actually *greater* than the physical substance that evokes it. The power of art as we know it, therefore, lies in adherence to these fundamentally Christian axioms: that things are more than mere objects, that a substance is more than its name, and that a person is greater than their label. For Christians, the "sphere of sense" is not "adequate" to divine truth as it was for the ancients. "Sense" can, however, *point* toward truth like a word points to its referent, or like the biblical "Word" (the visible Christ) revealed a transcendent God. If we lose this sense, then art also is lost.

And this in turn reveals a deeper principle: that true representation, the true picture, depends on the idea of *fulfillment in eternity*. It depends on the idea that there is a common but infinitely diverse goodness toward which every created thing can move, and in which it can ultimately dwell. (In a concrete sense, this fulfillment is perhaps represented by the "millennium" of Revelation.) Thus what is evoked through the "picture window" of the Christian icon is neither more nor less than the fabled "white stone with the new name" of Revelation.[21]

The white stone of Revelation is an "image" of white, imbued with meaning (a name), combining all lights together in a total, "fulfilled" whiteness. (White, after all, is the melding of all wavelengths of light.) The Bible says there is one stone-image for each of us, and each stone is alike in its completeness, but each is different in its inscription—its *message*. This prophetic metaphor is very different from the Platonic ur-form, with its demand for conformity to general archetypes (think Aphrodite as the ideal marriageable woman, or Apollo as the ideal young man). Rather, the

20. See Krauss, "In the Name of Picasso."

21. Rev 2:17.

Christian "form" to which we aspire in the years *Anno Domini* is a shared quality of fulfillment *each according to its own*. (This notion would find its echo in the Aristotelian synthesis of Thomas Aquinas.)

And so the Christian picture, in its early modern form embracing landscape, still life and the profane portrait, spoke of earthly things toward which respect was due. And this respect was anchored not in blood and soil, but in mysterious, God-hidden destiny—in the interplay of natural *telos* and supernatural providence. Jesus once said of the blunt and stubborn Peter, "on this rock I will build my church."[22] It was in this *destiny* (this assigned service) that Peter's meaning was found. The hero-prophet Samson's assigned service was to "deliver . . . Israel from the hands of the Philistines," and he would fulfill this role despite accident, confusion and disobedience.[23] In his painting *The Miraculous Draft of Fish* of 1446, the German artist Konrad Witz seemed to ask if the land itself could be honored through this same attention to destiny in the play of history. Here the shore of Lake Geneva, recognizable to anyone who had seen it, becomes the setting for a miracle of Christ. In this early Renaissance *tour-de-force*, Witz did not suggest that Christ actually walked on Lake Geneva (no true artist was ever so literal); instead he suggested that *real places*, in their humble specificity, could be lifted up—fulfilled—by their bashful participation in God's redemptive action. Moreover it is the sheer *fact* of participation, not its perceived fame or magnitude, that secures the honor of the "white stone." For God, the perfect builder, will make an edifice in which every stone is needed and none is superfluous; the complexity of God's imagination is matched only by the elegance of his economy.

22. Matthew 16:18.
23. 1 Samuel 28:19.

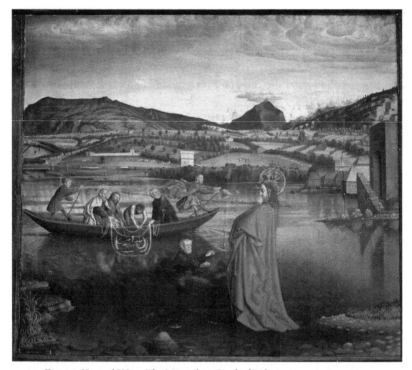

Fig. 2.8. Konrad Witz, *The Miraculous Draft of Fishes*, 1444, 132 x 154 cm.
Here, the water and shore where Christ walks was purposely made recognizable as 15th-
century Lake Geneva. Photo courtesy of the Musee d'Art et d'Histoire, Geneva,
and Bridgeman-Giraudon/Art Resource, New York.

To summarize, then, the Christian picture asserted something wholly
new in the history of human communication. It metaphorically captured a
meaning for earthly objects that had henceforth been hidden or misunder-
stood. It said *first* that earthly things were windows onto transcendent mean-
ing. (It said this through an anti-sculptural insubstantiality, and also through
the window-like, rectangular frame). *Second*, it said the divine was the source
of all meaning, showing itself in diverse aspects through multitudes of dis-
tinct window-views (portraits, landscapes, still-lifes and more, all imbued
with higher meaning). And *third*, it said that earthly things are nevertheless
distinct and self-contained, despite their participation in the whole. (The
frame-boundary, again, says this, as does the centripetal visual force—pulling
everything inward—of the self-contained Christian picture).[24] In other words,

24. Our intuitions to the contrary, it is actually rather unusual in the history of art
for images to be "pulled inward," anchored toward their center. In ancient Mesopota-
mia, for example, images unfurled like scrolls or friezes, seemingly open-ended on the
sides, as if they could march on forever. And in traditional Chinese and Japanese art,

the Christian picture somehow suggested *both* that every individual thing is singularly meaningful *and* that every individual thing is fulfilled by joining the larger whole. The Christian picture in all its aspects was a new and potent symbol of *proliferation, diversity* and *community.*

And how could this distinction-in-wholeness be? It could *be* precisely because of *history* and *action*, unfurled through the invention of time, in which finite, separate, miniscule things, operating on a plane of lawful, harmonious separations (separations of forces, of things, of types), can share in a process toward unity and fulfillment. At the end of everything, *we will be what we have manifested in space-time*—no more, no less. Yet what we have manifested will unfurl as a song in a greater story—an epic story of divine glory, virtuosity and profundity before which the angels will swooningly bow. As actors in the drama of history, it is through service—*completed, ontologically fitting service*—that our individual meaning will be sealed. And as viewers of the drama of history, it is through *witness of others' service*, solemn recognition, that each of us will channel the meaning-giving gaze of God. To understand an artwork, especially in its early-Christian icon form, is to affirm a destiny discovered and gathered up into finality. It is also to recognize the centrality of destiny and the claim it has on our own, unfurling lives. When art seems to look back, it tells us that we, too, have an inborn burden to discharge. We, too, must rise to be etched, like Hercules or Cassiopeia, into the stars. But above the stars.

There is a reason why saints are not canonized until well after they've died, and why portraits of the living often seem unfinished or hollow. The service must be complete for the picture to shine true. There is also a reason why images of Christ have proliferated with such diversity through the millennia *Anno Domini*. With each generation, we discover more about Christ's particular service, predicated on the potentialities of his being, as its effects ripple through our time-fabric. Thus it is true (what a marvelous paradox!) *both* that Christ's destiny is finished ("it is finished," he declared on the cross) *and* that we contemplate it anew forever.[25] Indeed, if Christ's earthly destiny were *not* finished, we *could not* keep contemplating it forever, for it could not yet be gathered up and truly known. When Christ's time-journey was complete, its significance, planned from the beginning, was finally unveiled. Such a dynamic is mimicked in art—art with its retrospective insight, its air of final epiphany, its all-at-once plenitude and completeness captured in a time outside of time.

images likewise seem to fly apart, extending beyond their boundaries on all sides, as if the painting is only a slice from a larger field.

25. John 19:28–30, NKJV. The Greek verb *tetelestai* ("finished") can also mean "perfected."

FLESH AS WINDOW

The Renaissance artist Raphael Sanzio perhaps deserves the most credit for synthesizing the realms of natural observation and sacred icon-writing, as invented by the early Christians. A giant of his time, he briefly surpassed even Leonardo da Vinci and Michelangelo Buonarotti in fame and esteem, but he is poorly understood today. (The extreme sweetness and curviness of his figures can be off-putting to jaded modern viewers, and he undoubtedly spawned lesser imitators who tarnished his name.) Nevertheless, Raphael was a prodigy who quickly grasped the unforeseen implications of his rivals' work. Who knows what he might have accomplished had he not died prematurely at the age of 37?

One look at Raphael's captivating *Madonna della Granduca* in the Pitti Palace, Florence, can persuade one of the ease with which the physical and sensual could be adapted to the iconic form. Put another way, Raphael showed how human destiny (embodied and particular) encompasses not just the sort of generic goodness discerned from the earliest icons, but also more quotidian things like gentleness, affection, humility, work, strength, labor and sacrifice. If the Protestant revolution said that all tasks could be a calling (making the baker as sacred as the bishop), Raphael paved the way for such expansiveness. His *Madonna della Granduca* has all the pulsing life of Leonardo's *Mona Lisa*, and it ennobles the latter thereby. It suggests that all women (all people), in the specificity of their embodiment, perform subtle but integral services in the evolution of the kingdom of heaven. "The creation waits in eager expectation," the apostle Paul wrote, "for the children of God to be revealed."[26]

26. Rom 8:19.

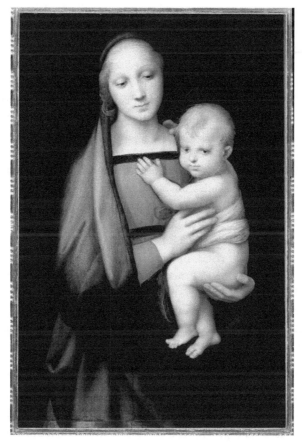

Fig. 2.9. Raphael (Raffaello Sanzio), *Madonna della Granduca*, 1504–5, 84 x 55 cm.
Photo courtesy of the Palazzo Pitti, Florence and Album/Art Resource, New York.

The Early Christian icon-picture, by definition, depicted saints who had already passed into heaven, and their arrangement within the picture's space reflected this. Not only were they surrounded by flat expanses of gold, but they had been captured from ambiguous points of view, often with a rich and burnished coloration that resisted interpretation as mere skin. In her book *Space, Time and Presence in the Icon*, Clemena Antonova describes the phenomenon of "reverse perspective" as it is experienced in the icon— a shaping of space that deliberately lifted the icon subject outside of the bounds of time and specific location. (The rigid, linear, one-point perspective familiar from high school art classes conjured the opposite effect—a sense of anchored, confined location in time and space.)[27]

27. Antonova, *Space, Time and Presence in the Icon*.

In the *Madonna della Granduca*, however, Raphael used the subject of the Madonna and Child to experiment with the iconic potential of time-bound flesh itself. It was as if he wondered: "Can the saintly body seem exalted and yet touchable?" Or more precisely: "Can transcendent meaning be visually linked to historic instantiation, so that flesh itself becomes the Word of God?" Raphael's *Madonna della Granduca* pushes the logic of John of Damascus (the great champion of the Christian icon) to its conclusion: "through [physical things] and in them it pleased God to bring about our salvation," John wrote.[28] It was that *throughness* that Raphael aimed to capture in his Madonnas—a "throughness" that implied all the dimensions of physical birth, maternal affection and daily work.

Thus Raphael's *Madonna della Granduca* is not in a golden, heavenly space, but in a dark space that could exist anywhere on earth; it is a space that neither alienates nor limits possibility. Raphael's Mary is solid, specific and tangible, as is her child. In her massiveness, she exerts a gravitational pull (the "centripetal force" I mentioned above) that bespeaks her person-hood and boundedness—she is an object that draws other objects, activating the space around her, because she possesses a power and dignity of her own. And in this visual containment, this balance and self-sufficiency, she is beautiful.

Moreover, as she swells toward the picture plane, Mary is almost palpable, like a still-living friend, wife or daughter; her form bulges and curves and seems touchable—even inviting. Yet her precise, pendular suspension within the rectangular "picture-window" of icon-tradition makes her sacredness inescapable, providing a context of holiness and reverence. Mediated by this window, Raphael's Madonna is indeed transcendent and distant, but in her fleshiness and detail, she is also worldly and human.

Finally and most intriguingly, Raphael has avoided the fixed, one-point perspective that had become *de rigueur* for many of his High Renaissance peers. In fact, in their spatial ambiguity, his Madonna and Child are impossible to translate into "real life." This wasn't "reverse perspective," exactly, but it preserved the sovereignty of the transcendent, the *finished*. And it anticipated Cubism in its implication of multiple angles at once. (The breadth of Mary's face, for example, seamlessly combines side and front, in an effect that is beautiful in its "picture window" but would be monstrous if somehow transferred to the outer world.) Christ and his mother vibrate across planes of time-space, touching every human life in one eternal moment. At the same time, their pinkish-gold rotundity shows that they were a part of history, enfleshed into historical roles.

28. John of Damascus, *Apologia against Those Who Decry Holy Images*, part III.

It was paintings like this—at once specific and transcendent—that would license the spread of "profane" picture-icons in the mercantile world of early Protestantism. For in the Protestant world, unfettered by tradition and eager to assimilate new cultural insights, there was a "priesthood of all believers" that made everyone sacred. Furthermore, the Protestant drive to unhinge Christianity from the respective imaginative fulcrums of Papal Rome and the Holy Land (always so alien and distant to the majority of Christians) made every *place* potentially sacred, as well. Thus Conrad Witz's Lake Geneva would be succeeded in England by the farmsteads of Constable and in America by the majestic valleys of Thomas Cole. All of nature could sing the glories of God. (Yet Protestants would remain ambivalent about the power of art and would limit its role in worship. This will be discussed in later chapters.)

MODERNITY AT THE TIPPING POINT

Modern artists were implicitly aware of this legacy they had inherited, even when they no longer consciously adhered to the theology that undergirded it. The Austrian modernist Gustav Klimt, for example, paid obvious homage to the Byzantine icon in his many lush pictures of beautiful women. For Klimt, a sensualist and libertine, the transcendent "female" was tantamount to divinity, and so his portraits of women, like those of Adele Bloch-Bauer and Eugenia Primavesi, have an almost Marian majesty coupled with a ravishing sensual beauty. Swathed in heavenly gold leaf and ornamented with mosaic-like jewel and flower patterns, they are secular saints. But in the Kierkegaardian tradition of representation, these portraits are not idols to be worshiped; rather, they are bejeweled windows (like stained glass windows) yielding onto separate feminine essences that the viewer can only hope to fleetingly grasp. Like Klimt's secular goddesses, Early Christian icons also, frequently, had visually "broken" surfaces that made clear their status as mere representation, and as in Klimt's work, their "brokenness" came from the many-vectored sparkling of gold leaf and brushwork that was deliberately vague and sketchy in its application. Klimt combined these techniques with the fragmentary *mien* of mosaic to conjure an effect that was even more illusory and frankly *representational* than its inspiration—even more "spiritualized." How appropriate that the movement with which he is associated, Symbolism, openly strove to capture spiritual symbols rather than physical appearances.

In Russia, building on a long tradition of icon veneration, the pioneering abstract artist Kasimir Malevich likewise considered the rectangular picture a

symbol of the transcendent. Nowhere is this more evident than in his *Black Square*, which he displayed like a Byzantine icon in an early exhibition, angled and elevated in precisely the way a domestic icon would be. Commentators have made much of the fact that Malevich purged his modern "icon" of any religious symbolism, but Malevich's foundations were still stubbornly anchored in Christian theology—particularly in the Christian notion of the image as a "window" onto something higher. Indeed, what is Malevich's *Black Square* if not a window within a window, so saturated as to contain every object of contemplation within itself? In an essay discussing the hostile public reaction to his *Black Square*, Malevich insisted: "'(the interior quote is inverted here) practical things'. . .become ridiculous. . .It cannot be stressed too often that absolute, true values arise only from artistic, subconscious, or superconscious creation."[29] For Malevich, pure geometries yielded a view onto "absolute, true values" that transcended momentary, real-world appearances. He preserved the icon-sense in a newer, simpler form.

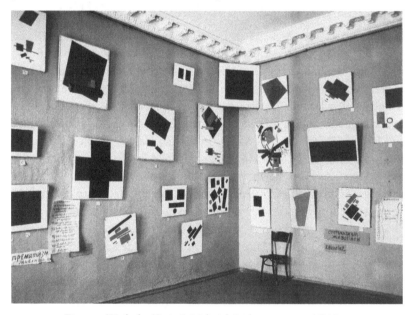

Fig. 2.10. Works by Kasimir Malevich in the 1915–16 exhibition
"0,10: The Last Futurist Exhibition of Pictures," 1915.
Photo courtesy of Wikimedia Commons.
Notice the disposition of the *Black Square*, angled in an upper corner of the room as a domestic icon would be.

29. From Malevich, *The Non-Objective World*, 100.

It was this very icon-sense that Michael Fried found lacking in the work of Minimalists like Tony Smith and Donald Judd. And it was precisely this icon-sense that Fried celebrated in the work of earlier Abstract Expressionists like Robert Motherwell and Mark Rothko. Like the Early Christian icon, the real *picture*, the product of genius that we all celebrate, "evoke[ed] . . . a continuous and perpetual *present*"[30]—according to Fried. It figured a meaningful essence taken up beyond time, immortal and inviolable, held in the palm of God yet still grounded in the realm of human action, of destiny. What are the drip paintings of Jackson Pollock, after all, if not life-story? Made while he danced around his floor-bound canvases, Pollock's drip paintings show the effects of irrevocable action, coming from a specific source, writ directly on the picture surface and preserved for all time. This was just a different kind of icon—a different way of reckoning the saint. We seem to have forgotten that this very aura of specificity and gathered full-ness, preserved in a rectangular window-space, was the legacy of the first Christian artists—the first artists to develop their craft within a securely Christian *milieu* and infused with Christian thoughtways.

Eventually, of course, even sculptures became "picture windows." Before this could happen, the sculpture had to be filtered through the "picture-window" paradigm by means of its literal hollowing-out, its incorporation into the Christian altar and its reconstitution as an avatar of its former self. This trajectory is most evident in Northern Europe, where flat, painted altarpieces (the paintings behind the altar that served as the devotional focus of the mass) evolved into expanses of shallow, painted relief sculpture. Later, the individual, saintly figures from these relief sculptures could be spun free of their flat, scenic setting and into niches that they occupied independently, separate from the altar. These sculptures were typically hollow in the back, because they were never meant to be viewed from behind; they were bound to remain within their "window" forever.

30. Fried, "Art and Objecthood," 21–22.

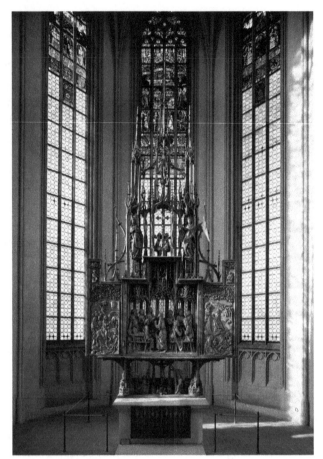

Fig. 2.11. Tilman Riemenschneider, *The Altar of the Holy Blood,* from St. Jacob's Church,
Rothenburg-on-the-Tauber, Germany, 1500–1504, 13 ft. x 10 ft.
Photo courtesy of Erich Lessing/Art Resource, New York.
The scenes in this altarpiece are examples of the kind of shallow relief carving popular
before the re-emergence of freestanding sculpture during the Renaissance.

In the Renaissance, especially in Italy where the quarrying of hard
marble was common, niche sculptures in the round (that is, fully carved and
not hollow) became more popular—but their positioning within an arched
frame still produced the "window" effect of the classic Christian picture.
Thus by the early sixteenth century, when Michelangelo's *David* was dis-
played under the sky outside Florence's city hall, the notion of sculpture-as-
window had become so deeply ingrained that there was no question of
understanding the work as an idol with a localized personality. It was simply
an icon in different, new, gargantuan form. When Gian Lorenzo Bernini

arguably perfected the art of Christian-era sculpture a century later, crafting pieces that rewarded viewing from all sides, there was still understood to be one main view that yielded onto the transcendent essence "behind" the image. (Bernini's *Apollo and Daphne* was even displayed against a wall so that its "main" view was unmistakable.) In the twentieth century, sculptures by abstract artists like Anthony Caro and David Smith continued to assert one major vantage against the continuous sphere of possibilities. Not surprisingly, their sculptures were considered "art" by Michael Fried while Smith's and Judd's sculptures were not.

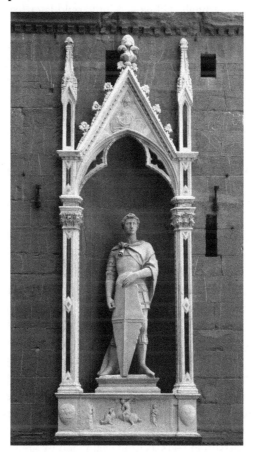

Fig. 2.12. Donatello, *St. George*, from the Tabernacle of the Guild of Cuirassiers (copy), Orsanmichele exterior, Florence, Italy, 1415–17, 214 cm high.
The original version of Donatello's St. George has been removed to the Bargello Museum for safekeeping. This copy, occupying the same space as the original statue, shows how Christendom's first freestanding sculptures were still placed within "window frames" that seemed to open onto a separate, transcendent existence.

By the late nineteenth century, the integrity of the Christian picture was already being dissolved in some circles. I mentioned before that Gustav Klimt was a Symbolist, and indeed the Symbolist movement as a whole veered back toward Platonism in its quest for objects of "sense" that were adequate to divine Truth. Hence the proliferation of esoteric, runic canvases around the turn of the twentieth century, often produced under the influence of a Theosophist faith that promised direct apprehension of divine secrets. This artwork moved from a focus on destiny, virtue and choice, retrospectively and reverently discovered, to a focus on occult seizure—a new kind of magic. Accordingly, Hilma af Klimt could later regard her nested circles as keys to the universe, and Wassily Kandinsky could regard his swirls as capturing a perfect heavenly bliss. This was nothing more than a return to the localized deification-tradition of the Ephesian Artemis, which held that copies actually bore a slice of divinity and could be manipulated in magical ways, like ancient totems. This was a step back toward the soul-pedestals of Gudea, and, in the reverse, to the existential threat of the despised, embodied memory that had not been sufficiently "damned" through ritual destruction.

We see echoes of this return to pre-Christian thoughtways even in twenty-first-century political and critical discourse. For increasingly—especially within the postmodern humanities academy—words are imbued with the power to existentially harm (consider trigger warnings and "de-platforming" toward the suppression of speech). We are experiencing, in these latter days, a slippage toward the reintegration of source and symbol, of vista and window, so that representations (even words) are now no longer representations. Rather than signals of an absent power, or stories of awaited fulfillment, they have *become* "divine" power (through some process of arcane seizure), able to cause genuine ontological harm. In his Sermon on the Mount, Jesus had warned that anger toward one's fellow was just as bad as murder. But for Jesus, the greatest danger was to the perpetrator rather than the victim. Anger was corrosive to the one who felt it—a departure from the acceptance of otherness and therefore betrayal of a facet of God. Today, the harm of words is increasingly understood as not just internal and spiritual but real and physical, like the effects of a magical hex. A chthonic sort of pagan superstition rears its head again, and we are unwise to give it power over us.

One benefit of our current, apparently "post-Christian" moment is that it affords a viewpoint from which to look, retrospectively, onto the expanse of Christian culture as a totality. From this viewpoint, we can begin to see outlines emerge of a worldview that spans countries and traditions and has been generative, the world over, of separately evolving but mutually

complementary philosophical dispositions. One such disposition is the universal Christian tendency, anchored on the notion of the Incarnate and History-Dwelling Word, to see the social identity and the essence as separate—to acknowledge an anchoring, full and dignified life beneath what the mere psyche impatiently maps—even as the psyche's *limited* mapping ability is affirmed. This disposition was productive of modern science and modern art, and it is too precious to be lost.

In our postmodern period, are we witnessing the extinction of transcendence and the return of dark magic and manipulation? Are we returning to the thoughtways of the ancient pagan world? In some ways installation art—maybe the most distinctive and representative form of postmodern fine art—is a return to the grapes of Zeuxis and the dining room of Livia. It provides a fleeting sensory experience without aiming toward a transcendent or meaningful "beyond." In 2006, the German artist Carsten Höller was invited to create an art installation for the Tate Modern's Turbine Hall. (This is a blockbuster space that is devoted to a new, gigantic installation each year, hosting superstars as diverse as Louise Bourgeois, Ai Weiwei, and Anish Kapoor.) Höller chose to install a series of enormous, shimmering twisty slides. His goal, he said (adopting the words of the writer Roger Caillois) was to force "voluptuous panic upon an otherwise lucid mind."[31] He aimed, in short, to provide an ephemeral and physiological effect. He hoped to root viewers in the *local*, providing a *localized* experience that could be manipulated as the visitor wished, and that did not point to anything beyond itself. Ai Weiwei's thousands (millons?) of porcelain sunflower seeds spread out across the floor of the Turbine Hall in 2010 had a similar effect. While the sunflower seed has obscure symbolic resonance, the major impact of the work was localized and physiological, creating awe from qualities like size and multiplicity. Deep cultural habituation to the Christian "window" still helps many visitors find transcendent meaning behind installations like Höller's and Weiwei's, but the trend toward sensory button-pushing is significant. In some ways, the Turbine Hall is a return to the Temple of Artemis—localized power, miraculously contained.

OTHERNESS DIAGRAMMED

In the previous chapter, we saw how the human creature, from the beginning of time, has struggled to accept *otherness* as a state of equal dignity before God. The Christian artwork, through its air of implied fulfillment

31. See Höller's interview with Vincent Honoré, Assistant Curator of the Tate Modern.

and its presence-but-absence, conjures this authentic otherness by proxy, in order that we may rehearse our duties toward it. This was evident in the early centuries of icon veneration, and it remains evident in formulas like Fried's, where the true artwork symbolizes independent, sovereign identity worthy of respect.

Both the Christian icon and the modern painting, unlike the pagan idol or the minimalist sculpture, summon "otherness" without allowing manipulation of that "otherness." They make the viewer feel helpless before a separateness that must be regarded with circumspection and awe. The true "artwork," in this sense, does not demand ritual acts for the achievement of a result; rather its "absence"—its evasion of immediate usefulness—makes it unresponsive. But this unresponsiveness is paradoxically confrontational. It points to the work's arrogated right to exist independently, apart from its uses for *us*. I believe the Renaissance genius Giotto understood this when he made figures who loomed with their backs turned in some of his biblical paintings. These are figures who deny all attempts to *use* or *read* or *judge*. These figures have hidden roles, like the hidden destiny of each of us living now, toiling toward fulfillment. Meanwhile sainted figures, like Jesus and Mary, are painted in fear and trembling, with an air of ontological completion, still only partially known by us, but sealed in the heart of God.

Such experiences of "confrontational absence," whether through mystery or overwhelming, blinding completeness, are often impossible in our daily encounters with the living world, toward which we bear social responsibility or upon which we might physically depend. We view other persons through lenses of usefulness made necessary by the state of toil in which we live—the "post-Edenic wasteland" discussed in the chapter before this one. But thanks to the Christian picture, truly a window onto a heavenly economy, humans in the years *Anno Domini* can still imaginatively experience living othernesses that echo out everywhere (albeit wanly and nostalgically, as the next chapter will show)—from books and walls and pedestals, and even, if we have eyes to see, from glowing screens.

3

Private Worlds

From the very beginning of our lives, we start to map the terrain of our conscious experience. If we're lucky, an early environment of safety and love will encourage us to reach far and map fearlessly, accepting the different and unexpected. If we're unlucky, we may develop in privation and fear, afraid to venture beyond the "home base" of the self. Both Hans Urs von Balthasar and Jacques Lacan, in their different ways, showed how this process began. With the infant gaze into the mother's eyes, the first "other" (and by extension all otherness) is initially recognized. This begins the adventure of coming to terms with God's diverse creation. As we grow, we are bound to keep looking, seeking, and recognizing, whether out of optimism (per von Balthasar) or out of desperation (per Lacan). Because human life is an echo of the Trinitarian adventure in Otherness, we are bound to spend all our days mapping, naming, place-marking, and seeking truth and acceptance. God willing, we will also learn to give truth and acceptance in return. With each cry of desire, and each want met or denied, we stretch, learn and adjust according to the paths laid out for us by nature, nurture and providence. We balance on the edge of a knife between the Nothing and the All.

In his treatise *Fear and Trembling*, Søren Kierkegaard outlined three stages of moral development that illustrate the dialectical pull of the Nothing versus the All. First there was the aesthetic, then the ethical, and then their synthesis: the religious. In the "aesthetic" stage, as we have noted, the individual lives and works merely to please himself. The external world is nothing but occasion for the indulgence of hoped-for pleasures, and there is no effort to "look outside," as it were, and think about justice, "the right" and

"the good," or others' claims. Later, in the ethical stage, the claims of others are acknowledged and the concept of the "common good" enters the picture, so that individual actions become governed by norms, demands, and expectations imposed from the social "outside." The ethical stage is rigorous, uncomfortable and guilt-inducing, but necessary—it inspires habits of self-sacrifice, discipline and duty. Finally, in the religious stage, the individual discovers exquisite pleasure (a sort of return to the aesthetic) in something that transcends both himself and human society: the life-giving beckonings of God, independent of their social "usefulness." These beckonings, these inspirations, completely evade all attempts at logical derivation; their appeal is self-evident, like the appeal of the beautiful. The only possible response to this splendid self-evidence is what Kierkegaard calls "faith."[1] It is my position that Art, too, elicits a faith-like response, in imitation of the call God issues from himself, and the call he also issues through his creatures, with their intrinsic, beckoning dignity.

In my previous chapter, "New Wine," I drew on Kierkegaard's terminology to help explain what was going on with image-making in the pre-Christian West. I linked Kierkegaard's "aesthetic stage" (described above) to the "object"-paradigm discovered (and criticized) in the 1960s by the art critic Michael Fried. Both of these thinkers, from their different perspectives, had identified a psychological disposition that humans can adopt toward other bodies (whether human, natural, or artificial) that denies the other's *otherness* in favor of the solipsistic projection of what I have called a self-centered, "monolithic" space.

I further suggested, in my previous chapter, that Christianity introduced a new paradigm into the world. Now sharp, "monolithic" boundaries were punctured; a higher, ineffable purpose seemed to inform everything (Hegel's "higher touchstone"); and the sacred image, which had once seemed to be a dense engine of power, instead became a fleeting suggestion of something definitively *else*. Thus the "Christian picture" was born, with its window-like frame, its slender lightness, and the delicacy and sometimes haziness of its painted marks.

Finally, I suggested that the separate, transcendent, *otherness* of art (which symbolizes the sovereign otherness granted to all God-created bodies) is being denied in some quarters today, and that we sometimes verge, again, into collapsing into a new kind of "localization." I mentioned Carsten Höller's high-art twisty slides, for example, which are meant to give the visitor an inward experience of reference-less, "voluptuous panic" rather than an outward experience of encounter. Works like Höller's can reinforce the

1. Kirekegaard, *Fear and Trembling*.

sense of the modern subject (that is, the modern knower) as a self-contained monolith.

In this chapter, I want to consider the late-modern-into-post-modern "de-Christianization" of art more closely. Specifically, I want to consider how contexts of artistic display that evolved in the late modern period have both revealed and facilitated our perpetual human tendency to localize, consolidate, and manipulate. I contend that we are moving ever closer to a worldview that lacks conceptual-symbolic handholds for recognizing the God-given dignity of all creatures. Modern techniques of mass production and taxonomization have hastened this shift.

Thus in this chapter, I am concerned primarily with the survival and reassertion of Kierkegaard's first stage, the "aesthetic stage." The "aesthetic" disposition stems, at least in part, from human difficulty accommodating "allness." Rooted in distrust, our modern bent toward the "aesthetic" arises from a complex woundedness inflicted by our alienation from the divine gaze. In today's world, that woundedness can have many causes. It can be imprinted on us as children, insofar as our earthly caretakers deny us the loving echo-gazes our souls need for development. It can be "drilled in" through the tenets of dogmatic worldviews, so ingrained as to be naively held, but so distorting as to create painful dissonance when placed against reality. And it can be self-perpetuated, insofar as we deny (whether out of fear, or shame, or ignorance) our own woundedness in a way that prevents us from seeking healing. In each case the response can be a flight from the "gaze" (the appraising eyes of the genuinely other, whether divine or human) and a retreat into a private world of mere objectifications.

OBJECTIFICATION AS DESTRUCTION

In his "Seducer's Diary," a part of *Either/Or*, Kierkegaard modeled the ramifications of a deadened, "aesthetic" view of reality—a view for which Christianity had provided an alternative, but a view that remained common nonetheless.[2] Here, an unnamed young man heartlessly describes manipulating a poor young woman's affections. Throughout, the young woman (Cordelia) isn't so much a person as a tool for entertainment, to be discarded when the amusement has worn thin. (Earlier, the author had described looking at young women as "traders might look at horses." Everything—woman and beast—existed to be *used*.[3]) The Seducer, meanwhile,

2. Kirekegaard, *Either/Or*.
3. Kierkegaard, *Either/Or*.

is blithe and careless, never troubled by guilt, always ready to make a new conquest or court a new experience.

We have seen how Kierkegaard's "aesthetic" drive was manifest in traffic with the gods in the pre-Christian period. Pre-Christian deities (such as the Ephesian Artemis) were localized, containable, and often strictly identified with their locales. Their "confinement," in this regard, could have the effect of giving worshippers a sort of powerful, cosmic ownership that forestalled grappling with the truly "other" or with true existential challenges. (The chthonic god was psychologically protective as well as physically so.) Localized deities were, after all, loyal to their worshippers and even a part of them. They were "spirits of place" that made one complacent toward the universal order. Exerting magnetic pull toward home-space, and seemingly forbidding contemplation of truths beyond community walls, the localized god seemed to say: "there are no horizons beyond your immediate desire; the life you know is the best and only life. Do not consider the claims of others, but proceed from this core." No wonder Demetrius, the Ephesian idol-maker in the book of Acts, regarded Paul as such a threat.[4]

Christian-era artists have often been fascinated with this disposition, even as they were afraid of it. I think of Albrecht Dürer's allegorical *Melancolia*, wherein a brooding female figure hunches heavily with an inward gaze, oblivious to the fascinations outside of her. Or I think of William Blake's strange portrait of Isaac Newton, which shows the famous mathematician doubled over blindly, measuring circles on the ground. And I think especially of Eugène Delacroix's languid anti-hero in the fantasmagoric painting *The Death of Sardanapalus*. Here the legendary Ninevite king Sardanapalus is shown gazing dispassionately upon a scene of slaughter and despair. The naked bodies of women, dead and dying, are strewn everywhere. Brutal soldiers are stabbing panicked horses and concubines. Yet despite the drama, Sardanapalus is self-absorbed and unmoved. Next to the king, a turbaned servant brings a ewer of wine. Piles of golden treasure lay haphazardly on the floor. In this scene, Sardanapalus has ordered that all his possessions be destroyed, lest they be seized by his sworn enemy; afterward, the king himself will commit suicide.

4. Demetrius's story is recounted in Acts 19, and also in my previous chapter, "New Wine."

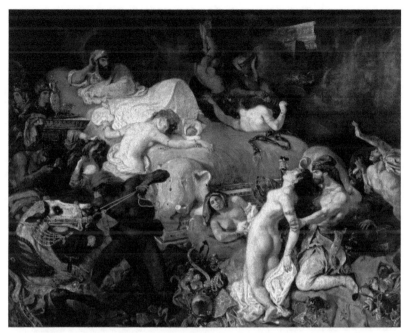

Fig. 3.1. Eugène Delacroix, *The Death of Sardanapalus*, 1827, 13 ft x 16 ft.
Photo courtesy of the Musée du Louvre, Paris.

Delacroix's *Death of Sardanapalus* is an apt visual symbol of Kierke-gaard's aesthetic stage pursued to its conclusion. Mired in solipsism, Sar-danapalus considers the Ninevite court a mere extension of himself, to the extreme that both must be (in their interdependence) extinguished simul-taneously. If Sardanapalus refuses to continue the drama of life, so must all around him, as parts of his consciousness. Thus "aestheticism," in its final and darkest form, is a force of total obliteration; smallness begets smallness until nothingness is reached. This was the logical fruit of Victor Cousin's "Second Copernican Revolution," and this was the tragedy of Goethe's *Faust,* the story of a demon-dealing alchemist that fascinated both Kierke-gaard and Delacroix. Goethe's Faust character, in fact, hoped to become a new Sardanapalus, whose motto (appropriately) had been, "though know-ing full well that thou art mortal, indulge thy desire."[5] In the end, Faust's world is likewise reduced to the prison of his own self-singularity, his child murdered and his lover driven mad thanks to his own selfish manipulations. It is no accident that Kierkegaard, Delacroix, and Goethe all stood at the threshold of late modernity, when transcendence seemed to take flight and everything else seemed to collapse inward in lightless density.

5. Athenaeus, *Deipnosophistae* 8.335f–336b.

ZONES OF SUBJECTIVITY

In the realm of postmodern visual theory, the historian James Clifford has introduced new vocabulary to the discourse around the degrading "aestheticization" of the world outside the individual. I believe Clifford's work traces, along one distinctive vector, the re-emergence of what I am dubbing a kind of primitive "magic" (though now of wider and subtler reach), together with the decline of the Christian philosophical paradigm embodied visually in the work of art.[6]

In his 1988 book *The Predicament of Culture: Twentieth-Century Ethnography, Literature, and Art*, Clifford outlined the surprising social consequences of a modern interiority similar to the "aestheticization" of Kierkegaard. Most usefully, he coined the term "zones of subjectivity" to describe certain boxed-in spaces (both metaphorical and actual) that emerged in late modernity. It is important to note that Clifford's "subjectivity," here, should be understood as a total inwardness that does not make space for a disruptive "outside." Thus Clifford's "subjectivity" bears no relationship to the experience of Kierkegaard's "religious stage" which, in its celebration of personal inspiration, could also seem to be highly "subjective." In fact, Kierkegaard's religious "subjectivity" and Clifford's "zone of subjectivity" are very different. Kierkegaard champions a personal posture of humility and attentiveness that ignores social norms in favor of that "still, small voice";[7] meanwhile, Clifford diagnoses a state of total self-protectiveness that controls and cocoons. When I discuss the phenomenon of "subjectivity" below, I will be defaulting to Clifford's definition.

Clifford's main focus of examination in *The Predicament of Culture* is cultural display as it is configured in "authoritative" venues like museums, universities, and libraries. He is particularly concerned with the distinctively Western agglomerations we call "collections," as they have formed the basis for so many of our prestigious institutions. (It is worth noting that the public museum, as we know it, was effectively invented in Europe in the eighteenth century.) In Clifford's hands, the museum becomes a spatial-architectural metaphor for a forbidding new social order.

John Fowles's 1963 novel *The Collector*, together with its Oscar-winning film adaptation, comes powerfully to mind in this regard; its horror-movie narrative helps us understand the museum's destructive power. In *The Collector*, a solitary young man seems to be merely a collector of butterflies—but something isn't quite right. His obsession with finding the

6. Clifford, *The Predicament of Culture*.

7. The "still, small voice" is heard by the prophet Elijah in 1 Kings 19:12.

rarest specimens and arranging them perfectly becomes downright creepy. (In the film version, the camera lingers ominously over shadow-boxes full of impaled butterflies covering the anti-hero's basement walls.) Something that looks like curiosity turns out to be a twisted need for control. The implication, in both Fowles's novel and William Wyler's film of 1965, is that a mindset capable of such relentless acquisition is a diseased one; collecting is a symptom of something suffocatingly dark. In the end, the anti-hero "collects" a beautiful young girl whom he traps and murders just like his ill-fated butterflies. The same suggestion that collection is linked to atrocity subtly informs Clifford's influential study.

Thus, in a disturbing turn, Clifford suggests that our celebrated cultural institutions (art museums, museums of natural history, ethnographic museums) are rather like Clegg's butterfly collection: they gather and violently pinion once-vital "specimens" for the pleasure, comfort, and flattery of a monolithic viewing audience (Euro-American, Western, elite). This audience, flushed with triumph at its colonial and commercial successes across the globe, longs to view the whole world as its cognitive possession and an extension of its desires. In a modern museum context, symbols of disturbing "otherness" are mounted like trophies and contained within boxes, aestheticized so as to offer interest and remove threat. They are like tamed bears or paraded prisoners of war. Once we adapt to Clifford's lens, no visit to a typical, Western-style museum is ever again the same. What Boston museum promoter Benjamin Ives Gilman once called a "temple" of enlightenment and cultivation becomes something almost macabre—something from which to avert one's eyes.[8]

Thus the modern art museum, and to a lesser extent the art gallery, functions as a spatial symbol of a new kind of collectivist monolith (a more popular analogue might be the cube-vessel of the alien Borg in the *Star Trek* TV series). Clifford's ideas (and many similar ones rising to prominence in the late 1980s and early 1990s) have had an enormous influence on the art intelligentsia, even if most curators have yet to figure out how to remove the museum's air of piracy. As early as 1934, the philosopher and educator John Dewey, in his book *Art as Experience*, had recommended that organic, "native" contexts be evoked within the art museum in order to honor the works' intrinsic meanings.[9] Dewey's recommendation sparked a robust literature probing a wide array of curatorial strategies, but it didn't amount to an answer. Instead, efforts toward greater "native context" have been criticized as demeaning (framing artifacts as "scientific" specimens rather than products

8. Gilman, *Museum Ideals*, 81.
9. Dewey, *Art as Experience*.

of human creativity) and reductive (in their efforts to manifest stereotypes that were previously only implied).[10] As a result, some activists have even recommended the complete obliteration of the museum as an institution.[11]

Not surprisingly, it is artists who have critiqued the monolithic museum framework, and by extension the imperial zone of subjectivity, most powerfully. With their sensitivity to the mis-contextualization of artworks (including, at times, their own pieces), some have reconfigured museums in satirical ways, exposing those institutions' power to distort. This sort of curation-as-subversion is being invited more and more by museum administrations, who are attentive to the postmodern critique of the museum paradigm, and who wish to find solutions for a new era.

In her 1995 installation *Peep,* for example, the British artist Sonia Boyce, who is of Afro-Caribbean descent, played a trick on visitors to the Brighton Museum's collection of non-western art and artifacts. She positioned cloudy scrims, strategically punctured, within the glass cases of the Brighton collection. The scrims seemed to fog the glass so that the objects on display were hard to see—except in the places where small circles had been cut out. Viewers were forced to lean, crouch or squint in order to gain partial view of the pieces—reenacting with their bodies the conceptual limitations already imposed by the original museum context. Boyce hoped to reveal at least two truths through this forced engagement. First, she suggested that the imposition of external organizing structures onto rich cultures is extremely limiting. Second, she implied that these very structures have shaped the Western mind so that it must always crouch and peer—indeed, it feels safe crouching and peering. Habituated to museums' "zones of subjectivity," the Western mind has come to expect only visual "soundbites"—tiny, uniform reductions of whole lives, and whole peoples, to single gestures.

The African-American artist Fred Wilson mounted a similar critique of the monolithic museum space in 1992. In his famous exhibition *Mining the Museum* staged at the Maryland Historical Society, Wilson examined the hidden parts of the MHS's holdings to uncover the collecting strategies of the past. He then populated the MHS gallery with some of his embarrassing

10. See, for example, Ramirez, "Brokering Identities: Art curators and the politics of cultural representation," in Greenberg, Ferguson and Nairne, *Thinking About Exhibitions.*

11. In his anarchist newspaper *Black Mask,* for example, artist and activist Ben Morea proclaimed: "Destroy the museums, then let the struggle begin." (Quoted in Armstrong, "We're Testing the Limits!") Various artists since the 1960s have echoed Morea's sentiments, including the Japanese collective Hi-Red Center, whose *Great Panorama Exhibition* of 1964 was nothing more than an art gallery with a locked door. Recently, curator Mathieu Copeland chronicled these efforts in his edited volume *The Anti-Museum.*

Benjamin's great insight lay in his clear grasp of how human-made objects (such as artworks) must have appeared before the advent of mass printing, film and photography (the modes of "mechanical reproduction" referenced in his title). In that earlier world, most things were unique and hand-crafted, and viewers never saw mass-produced copies (like photographs) of similar objects. To understand Benjamin's point, a thought experiment might be beneficial: imagine encountering the heirloom lamp in figure 3.3 sitting on your grandmother's bedside table. Imagine being captivated by its smoothness, detail and unusual shape. Now imagine, alternatively, that your first encounter with antique lamps came via the photographic collage in figure 3.4. Suddenly that first exemplar loses its mystique. It becomes one of a type rather than a special product of its own.[17]

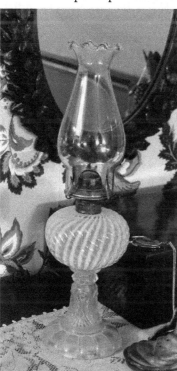

Fig. 3.2. "Sheldon Swirl" pressed-glass oil lamp, c. 1900.
Photo courtesy of T. Mullis.

17. The lamp pictured here is actually a mass-produced object, but the point still holds. As an antique today, it is comparatively rare, and as a family heirloom, it has a particular life history. Photographic taxonomies in collectors' books, however, have the effect of diminishing the object's specialness in favor of its suitableness to type, or its approximation of the "mint condition" highly valued by collector-investors.

findings, including a whipping post.[12] But Wilson went a step further than merely unveiling the hidden. Instead, he disrupted the museum's taxonomic organization in order to create a seemingly lived-in home space that allowed certain objects to again perform their original purposes. In *Cabinet Making, 1820–1960*, for example, ornate Victorian chairs were positioned before the aforementioned whipping post, as if to create a theater of torture. "Cabinet Making" is a historical term for early American furniture design; thus Wilson's title misleadingly hinted toward a standard, museum-style chronological presentation. In his own version of *Cabinet Making*, however, Wilson subverted expectations, revealing the lived consequences of rigid social pigeonholing (such as the practice of racism itself). Far from achieving a correct and enlightened understanding of humanity, Wilson asserted, the "civilized" benefactors of museums like the MHS had been openly barbaric behind closed doors.

THE STATE AS TOTAL SUBJECTIVE ZONE

In 1943, C. S. Lewis published his famous essay "The Poison of Subjectivism" in the periodical *Religion in Life*.[13] This was followed by a more complete outworking of the theme in his popular book *The Abolition of Man*.[14] According to Lewis, the pernicious idea that moral truths were not objective, and that moral systems were culturally conditioned, had obviously led to the twin disasters of Fascism and Communism, whose abuses were just coming to full, repulsive light in Hitler's Germany and Stalin's Soviet Union. In this, so far, Lewis might sound like a Bible-thumping moralist imploring return to rigid, traditional mores. But Lewis was not in favor of limitation and rule enforcement—he was in favor of *expansion*. He encouraged readers to absorb the whole spectrum of historical wisdom in their search for truth.

In fact for Lewis, the "subjectivism" exemplified by the Nazis and Soviets artificially *limited* the vast field of truth, for it plucked singular "traditional" (we might say, "hardwired") maxims and elevated them above all the others. The results were disastrous. The opposite of the totalitarians' reductive "subjectivism," according to Lewis, was "traditional morality," defined as the rich sum of all the good wisdom passed down through human history. In the *Abolition of Man*, Lewis dubbed this good wisdom "the Tao," deliberately choosing a term with universal resonance. The Nazis ignored this "Tao" when they

12. For the Maryland Historical Society's own account of this event, see "Return of the Whipping Post."

13. Lewis, "The Poison of Subjectivism."

14. Lewis, *The Abolition of Man*.

seemed to focus on "purity" above all else; the Soviets did the same when they focused maniacally on "equality." For both groups, all nuance and contradiction was relegated to the historical dustbin. (Needless to say, severe Christian moralism—no dancing, no card-playing, no drinking—would also be reductive by this measure.) Remarkably the avowed Marxist Walter Benjamin, who is a major theorist of modern visual culture, came to a conclusion similar to Lewis's in his 1933 essay "Experience and Poverty," when he lamented that "We have given up one portion of the human heritage after another . . . in exchange for the small change of 'the contemporary'"[15] Writing in 1933, however, Benjamin did not have the benefit of Lewis's hindsight when it came to the worst abuses of the Communist powers.

Lewis's "tradition," then, was nothing less than a deep common sense drawn both from historical trial and error and from the mysterious well of collective human conscience. (Fittingly the Chinese term "Tao"—literally, "the way"—describes a life-strategy based on rich understanding of how the universe works.) This meant that for Lewis, traditional morality was more heuristic—that is, practical and earned through experience—than rigidly doctrinal. The Christian Bible recorded inspired peoples' navigation of (and sometimes departure from) the so-called "Tao," offering comparative wisdom for the reader's own life. The fundamentally selfish and simplistic tendency of modern political philosophies, however, ignored the Tao—to humankind's great peril.

Historians of visual culture will recognize that the error of these philosophies, as identified by Lewis, was both prophesied by (and retroactively diagnosed by) developments in the art world. The modern museum, after all, was born "upstream" of the frightening early-twentieth-century movements Lewis criticized, and the museum's creation of a monolithic concept-space was a portent of what would come later on a vastly wider scale. This is why Lewis's critique is so resonant with Sonia Boyce's in her installation *Peep*. Both Lewis and Boyce called out against the reduction of broad expanses to tiny points, distorting human movement in the process. And both hinted at the abuses, born of pride and ignorance, that would surely follow. Lewis, as we have seen, described this tendency in the politics of his own day; Boyce, meanwhile, revealed how such a drive had already been present, and had been worked out quietly through the centuries, in modern museum spaces. The modern museum, in short, had primed the twentieth-century imagination to deny otherness-as-such and yield to centralized, totalitarian control.

Aficionados of twenty-first-century mass media will instantly recognize the predicament described by Clifford and the subjectivism decried

15. Benjamin, Walter, "Experience and Poverty."

by Lewis in contemporary discussions of our "ideological echo chambers." With growing distress, cultural commentators are noting the tendency of human communities to fragment, cluster and create virtual institutions (rather like disembodied museums) that selectively contextualize all facts according to a single, preferred viewpoint. As a result, there is no longer any shared "truth"—no longer any "Tao" acknowledged by everyone—and the civic world becomes dangerously extremist and polarized. If Clifford's museum was an "echo chamber" that united the West in a shared truth that diminished other cultures, now the West itself has divided into many more, shifting, virtual communities that diminish each other.

THE PROMISE OF ART

An art object, however, is not a message but a substance. (As I have noted, it is a stand-in for the ensouled person in that way.) That is why visual artists have always been in the vanguard against reductive "subjectivisms," why museums often feel inadequate to the treasures they hold, and why artworks have been difficult to coopt into propaganda campaigns. (As an example of the latter, I offer Grant Wood's famous *American Gothic*, which came during a government-subsidized wave of nationalistic American art, but which still feels subtly critical. Or anything by Caravaggio, whose profoundly gritty and realistic biblical scenes could anger a white-washing Catholic hierarchy.) Thus a picture is said to be "worth a thousand words," while political slogans are literally "worth" only three or four. Artworks, with their maddening multivalence that comes through embodiment, remind us that there are no easy answers. In fact, when an artwork's meaning is too easily grasped, too quickly exhausted, it can be said to fail as "art"—at least, this has always been the position of the most sensitive critics. Interpretive richness distinguishes real art from propaganda in fancy dress.

As I have noted, the cultural critic Walter Benjamin was a major architect of the visual theory that informs art discourse today. In 1935 Benjamin, a Jewish intellectual who later became a victim of Nazi persecution, wrote a much-referenced essay called "The Work of Art in the Age of Mechanical Reproduction."[16] Here, he grappled with a reductivist mindset that squashed artifacts—*substances*—into "boxes," not literally, but psychologically. His essay can help us link the consolidating, monolithic museum space with the similarly monolithic mass-communication space that followed it (what we might call "the mass media"), both of which portended the crushing social spaces that developed in certain early-twentieth-century dictatorships.

16. Benjamin, "The Work of Art in the Age of Mechanical Reproduction."

Fig. 3.3. Example of diverse sizes and types of antique lamps juxtaposed. The "Sheldon Swirl" lamp above is in the bottom center of this page. Note that the lamps represented are of many different sizes, but they have been reproduced at identical sizes to provide a uniform taxonomic grid. The image here is from *Treasury of American Design* by Clarence P. Hornung, Harry N. Abrams, New York, 1950. Photo courtesy of T. Mullis.

What made objects like the heirloom lamp so valuable, to their earliest audiences, was something Benjamin labeled "cult value." And here we must avoid a tendency to recoil at the word "cult" (summoning, as it might, images of David Koresh or Jim Jones). What Benjamin meant by "cult" was something more like "applied," "lived," or "cultural." The "cult value" of an object consisted in its unique preciousness for the people who made it and used it in its proper time and place. (In this way it was rather like the human phenomena of friendship and loving relationship.) Cult value was acquired through blood and sweat, through practice and skill, through reverent use in ceremony, through traditions of family ownership, connections to deep memory, and the artwork's presence at momentous times. Cult value utterly transcended types of mere "appearance," such as the symbolic or the aesthetic, and instead participated in the vibrancy of life.

When we consider Benjamin in tandem with Clifford, we might find ourselves asking: in earlier times highly aware of cult value, how would

something like the modern museum have even been possible? (The closest things were royal families' private collections—like battle spoils—showing the fruits of conquest. But even here, cult value would have been pungent and blood-won.) In most cases, it would have been unthinkable to put the precious accessories of life in vitrines fixed with labels. Indeed, similar reactions arise today when Native American communities encounter important tribal objects in museum contexts. There is a rich history of tribal activism demanding the return of artifacts still pulsing with embodied community significance.[18]

EMBODIMENT, NOT MESSAGE

Thinkers across the ideological spectrum, like Lewis, Clifford, and Benjamin, help us understand the dangers of imposed, limiting conceptual taxonomies. They help us see that visual practices—of sculpting, of painting, of building, and of curatorial display—can contribute to the erection of imaginative (and later enacted) social monoliths. If not deployed carefully, these modes of visual expression can begin to shape a social imaginary that denies "otherness" and seeks crushing homogeneity, or at least, an imprisoning texture of control.

However, if we remember our discussion of "Art vs. Objecthood" in the previous chapter, a confusing tension comes into play. Art is supposed to stand above networks of social usefulness, proclaiming a sovereign independence and dignity redolent of the human individual. However for Benjamin, it was *past social usefulness* that set the "cult object" above the mass-produced cipher and made it both worthy of contemplation and also transcendent of limiting conceptual categories. Is Benjamin's "cult value" actually similar to Michael Fried's "objecthood"—thus challenging our evolving definition of "art" in the Christian era? Indeed is Benjamin's "cult object," with its sacred, ritual implications, actually a return to image-making before the Christian revolution? Did Benjamin view the "cult object" as a fully-fledged localization, *a la* the idols of the ancient world?

When we examine Benjamin's essay more closely, we see that the answer is "no." In fact, we see in Benjamin's "cult value" something more akin to the notion of "fulfillment" signaled, as discussed in my previous chapter, in the icons of the Early Christian saints. In fact, the distinction

18. In response to these controversies, the U.S. Government enacted the Native American Graves Protection and Repatriation Act in 1990. Activists' efforts to repatriate Native American cultural properties have been ongoing since at least the 1970s, when Dakota activist Maria Pearson staged a sit-in in the Iowa Governor's office.

between Fried's "object" and Benjamin's "cult object" helps us understand how the total, lived, time-bound *embodiment* of artworks (with patterns of wear, decay, accretion and modification) is central to their transcendent function. Benjamin, after all, did not anchor the "cult object's" importance in the physiological response it produced by virtue of its formal qualities (such as size, brightness or luster); meanwhile Fried's "objects" had relied on just such formal qualities for their effect (think of Tony Smith's big, black *Die*). In fact, Benjamin did not talk about formal qualities at all. Rather, his notion of "cult value" relied heavily on the artwork's capacity to *witness*, and even be shaped by, important life events (prayer, ceremony, celebration, tragedy) as if it was a participant. This was a return to the early Christian "window" paradigm, but from the other side of the pane.

"Cult object"—and artwork—as witness? Though Benjamin was a secular Jew, his influential formula depended on deeply-embedded thoughtways stemming from the Christian revolution in the early centuries *Anno Domini*. For the cult object, as a "seeing eye," seemed to measure and judge, conferring value and eliciting honesty. As a manifestation of digni-fied otherness, it prompted mindfulness of the good and right. Though his essay has an implicit moral thrust, Benjamin did not write explicitly about the "dignity" of the cult object or its capacity to spur responsibility. He did, however, flesh out his ideas (literally and figuratively) by identifying cult objects with stage actors.

The cult object, like an actor on a stage, is a palpably near and vulner-able presence offering its whole self to an audience. In their proximity to this audience, both actor and cult-work seem to react and vibrate, as if they were *made* for this personal contact. The power of both comes from the *frisson* of presence, from the give-and-take of a real and high-stakes en-counter. Both produce a charge of reciprocity that arouses duty and respect, yet both also exist independently of the encounter and possess their own, mysterious dignity. Accordingly, Benjamin's concept of "cult value" is not mere "objectness" at all, but is instead an uncovering of another facet of "art" as developed in the Christian paradigm. Now, added both to art's window-sense and to its sketchy insufficiency, is a newly-recognized vulnerability to life-processes that, like the human life-process, respond to the lashings of time and the accruals of sentiment.

Furthermore, as a quality shared by the human actor, "cult value" is certainly more than a mere cognitive trigger that presents ideas only "in theory" without provoking embodied *response*. This is why Benjamin takes time to define a second concept, that of "exhibition value," which is cult value's dialectical opposite. For Benjamin, "exhibition value" was the free-floating signal-content of a work. Or put another way, it was the abstracted

message the work *conveyed*, outside of its physical incarnation. "Exhibition value" made the physical vehicle secondary. It suggested that the object's paint or stone was not integral to its purpose, but was rather meaningless matter for shaping into something higher. In cultures where exhibition value is everything (as ours is becoming), substance is indeed a crude inconvenience. This is because all real importance lies with the concept itself, untethered from physical compromise. Appearance is infinitely more important than the reality underneath. In his discovery of the rise of exhibition value, Benjamin sadly prophesied the decline of both true art and a richly sacramental view of the universe. If Thomas Aquinas had insisted that *Nihil in intellectu nisi prius in sensu* (nothing is in the intellect which is not first in the senses), "exhibition value" tried to challenge that notion.[19] Or rather, it tried to reduce the sensory to such a minimal trace (small, flat, textureless, light) as to call into question its epistemological usefulness altogether.

Photography

Walter Benjamin was particularly obsessed with photographic technology, hence the inclusion of "Mechanical Reproduction" in his title. With photography, the "message" of something—its basic outlines—could be captured and exported again and again, while substance could be forgotten. Because photographs could be disseminated far and wide, they could eclipse the fame of the object they represented, effectively replacing that object in the imagination of the public. Specifically, they replaced a textured, three-dimensional thing with a flat, smooth, and usually quite small simulacrum. Thus something like the Eiffel Tower (for example) was no longer, in the public imagination, a thing so industrially gargantuan that it defied comprehension and transformed its environment; instead it was a quaint, filigreed triangle that symbolized Paris on postcards. A similar kind of reduction can occur in photographs of human beings—and it does, with increasing power and frequency, every day.

Furthermore, building on the distortions of still photography, film photography distorted human behavior. In the longest and most challenging passage of his essay, Benjamin described how film robbed narrative drama of its scintillating presence—of the physical immediacy of a real actor's gestures and the embodied responses they prompted. Viewing drama was no longer a reciprocal, communal experience, but a contemplation of symbols only incidentally transmitted through human vessels. There was no longer a charge of real encounter and mutuality. In fact, Benjamin noted

19. Aquinas, *De veritate*, q. 2 a. 3 arg. 19.

how the lens of a camera could virtually dismember a performing body and then reassemble it through cuts and collages to produce meanings the actor never intended. This, indeed, reduced actual humans to mere building blocks of communication. The human becomes a mere label, or "magic word," whose utterance by another encompasses its whole existence. (Now, with "deepfakes," the stakes of the deception grow even more.)[20]

Benjamin's discussion of film and photography, then, allows us to complete our definition of the "cult value" to which modern (and postmodern) society has grown desensitized. If "exhibition value" was ultimately misleading, lulling viewers into accepting the flat and obvious, that meant *true meaning* must depend on its physical support and that support's performance and endurance in the world. As far as art is concerned, that means the deep intentions that once underlay each brushstroke and chisel mark should not be lost; they were always an integral part of the message. And as far as humans are concerned, that means life history and destiny are far more important than label or "identity." Thus Jesus said of those who self-labeled as his followers: "Why do you call me 'Lord, Lord,' but do not do what I say?"[21] Authenticity requires blood, time, sweat, and sacrifice—it can never be conferred by mere declaration. Shortcuts, meanwhile, produce nothing but phantoms and counterfeits.

THE MODERN MONOLITH CONVERGES

It is no coincidence that the modern art museum exploded in popularity at about the same time as the popularization of photography. By 1870, most middle-class households possessed at least some form of photograph (maybe a tintype). Meanwhile Boston's Museum of Fine Arts, New York's Met, Berlin's Alte Nationalgalerie, the Tokyo National Museum, the Chicago Art Institute, the Philadelphia Museum of Art, and the Stedelijk Museum in Amsterdam were all formed in the 1870s. The museum, like the photograph, promised to "frame" perplexing or exotic objects in a clear way according to the dictates of modern "science." Both were tools that promised a kind of intellectual ownership—through the creation of an "authoritative" zone of subjectivity. New monoliths were emerging everywhere, denying "otherness" its power to beckon and challenge.

20. "Deepfake" is a neologism for an utterly false digital video that appears to be real. There is fear that "deepfakes" will be used to manipulate voter perception in upcoming political elections. For an introduction to deepfakes, see Danielle Citron's online journalism at Stanford's Center for Internet and Society.

21. Luke 6:46.

And sure enough, twelve years after Walter Benjamin's "Work of Art in the Age of Mechanical Reproduction," the French art theorist André Malraux published his essay "The Museum without Walls" as part of his multi-volume work *The Psychology of Art*. In this important text, which has been reprinted numerous times and translated into several languages, Malraux made explicit the connection between the museum "mindset" and the photographic "mindset" of the modern age. For Malraux, modern sciences of culture (of which art history was one) depended on the scholar's ability to imaginatively remove artifacts from their time and place and compare them with other artifacts that had been similarly decontextualized. This comparative exercise was really only possible on a wide scale *because of photography*. The photograph, like the museum (or butterfly collector), "pinned" the artifact to a neutral surface and placed it in a standardized box to be compared with other, similar objects. But better than the physical museum, the photographic collection made all of these artifacts portable and juxtaposable, so that endless similarities and contrasts could be observed. (Indeed, there is a famous photograph of Malraux standing above just such a two-dimensional "museum without walls"; at his feet lie dozens of photographed specimens from across the globe, all monochromatic, all "boxed" by white margins, and all identically sized). It was comparative photographic studies like these that made the museum as a teaching space possible; such exercises provided a conceptual framework for how museums could "box" specimens in reality.[22]

Malraux himself observed that that the "museum without walls" had significant epistemological drawbacks. When, say, an 8" by 10" flat reproduction of an artifact becomes the conceptual standard, important characteristics are lost, including texture, depth, and (perhaps most dangerously) scale. To cite a particularly well-known art-historical example: the prehistoric Venus of Willendorf, a female fertility sculpture from around 25,000 BC, is only about four inches tall. But many viewers who have seen it only in theatrically-lit photos assume it is monumental. Such photos, though attractive, dramatically distort assumptions about the sculpture's original importance and use.

Malraux also noted how the comparative-photographic approach to understanding artifacts favored objects that could be shown off to advantage in small, flat, thin, and textureless contexts. This meant that objects that were difficult to photograph "well" (such as certain sculptures or buildings, or even particularly "chunky" paintings) could disappear from the discourse altogether. As a result, hierarchies of value were formed based first on a skewed data-set (things that were photogenic), and second on a visual

22. Malraux, "The Museum without Walls."

context that flattered some qualities above others. "Good" artwork became that which looked good in a photo. The scholarly understanding of cultures was filtered through which of their artifacts photographed the "best." And stories of triumph and innovation began to revolve around artists who unconsciously anticipated the aesthetics of photography. In 1987, the art historian Hans Belting hinted that all recent art history and criticism, no matter what period it treated, had been conceptually shaped by a modern, implicitly photographic framework.[23]

It is not difficult to understand how the distortions noted by Benjamin and Malraux have only been amplified in contemporary digital culture—and this with respect to actual human bodies, of which human artifacts had been the precursors. It is commonplace today, after all, for cultural "influencers" to craft parallel "lives" entirely through photographs, even placing their "real" lives entirely in service to their virtual ones. Nothing they do is authentic, it is asserted; everything is staged for Instagram. Kim Kardashian has become an archetypal example of this boundary-blurring. Australian Instagram star Essena O'Neill famously confessed to staging her online life in 2015 and then quit the platform. And the Argentinian artist Amalia Ulman garnered 100,000 Instagram followers in 2014 by manufacturing an entire identity from whole cloth; she revealed her ruse as a stunt at Miami's top art fair later that year. Ulman's project, titled *Excellences and Perfections*, traced its digitally-enhanced heroine's photogenic life, from "carefully arranged flowers and expensive lingerie" to "highly groomed interiors and perfectly plated brunches."[24] It showed that desire can be more powerful than truth.

If today's canny self-marketers have unwittingly (or wittingly) exposed such a vast gulf between that which looks good "on camera" and that which really happens, then how trustworthy are the older, largely unquestioned photographic archives we study? And by extension, how trustworthy are our narrative histories, which engage in their own kind of reduction? (That is a matter, of course, for literary theory.) And then, of course, how trustworthy are our social spaces (like museums, statehouses, churches, even neighborhoods), which shape space according to implicit hierarchies of value? In actual fact, every "authoritative" or "factual" presentation of human culture—or really, of anything—is a "zone of subjectivity" created

23. Belting, "The End of the History of Art," 14. Belting does not reference photography directly in his discussion of the modern era's reassessment of past artworks, but I think our habituation to photography plays a large role in the revisionism he discusses.

24. See Ulman's online exhibition hosted by the New Museum, New York: https://www.newmuseum.org/exhibitions/view/amalia-ulman-excellences-perfections.

by and for a people anxious to hold the world in its hand. This is the core insight of so-called "postmodern" theory.

FROM MONOLITH TO MONOLITH, AND THE TREMBLING SPACE IN BETWEEN

Much of the "postmodern" theoretical tradition, the *bete noire* of so many religious conservatives, contains rich wisdom. In fact in many ways, both "fine art" and "postmodernity" are simply natural reactions to a *modern* way of pretending that everything can be perfectly captured for a new, collective monolith. For both artists and some "postmodernists," goodness and truth can be authentically experienced—just not, perhaps, in a way that is infinitely and easily reproducible. (That is, in a way that has not been properly "earned.") When too much flattening and boxing occurs, crucial information is lost, resulting in pernicious stereotypes, misbegotten policies, and even horrors like genocide.

In some ways, both artists (with their typical insistence on the uniqueness of their products) and "postmoderns" (with their distrust of authority) attempt to divert the flow of history toward something *premodern*. This is well, if a return to the localized and chthonic, as desired by so many ethnonationalist groups, can be avoided. But unfortunately, humankind's fallen state seems to consist, in part, in a susceptibility to easy answers—in a kind of discursive entropy toward the flattening and the simple. The reductive appeal of the totalitarian, on the one hand, and the narrowly tribal, on the other, seems almost impossible to resist. The middle state—a social order informed by a truly humane, respectful and humble regard for the dignified individual, can seem almost a miracle in the history of the world.

Indeed, despite intuitions to the contrary, there is evidence that even the deeply hierarchical societies of pre-modern times protected the notion of individual sovereignty in some ways better than our society does today. Considering the biographies of medieval saints, the Christian apologist, author, and poet G. K. Chesterton famously marveled at a pattern of dramatic, unexpected gestures that could completely alter the medieval life course: an example was St. Francis's sudden renunciation of his fortune.[25] In his influential book *The King's Two Bodies: A Study in Medieval Political Theology*, the cultural historian Ernst Kantorowicz showed how even kings, the most "stereotyped" and oft-represented figures in the middle ages, were regarded as two-fold: there was the ineffable man at the core, and then on the outside, there was the kingly avatar he wore as a costume. (In other words,

25. Chesterton, *St. Francis of Assisi.*

not even the king was "just" a king.) The American artist and writer John La Farge made a complementary observation when he visited late feudal Japan in the 1860s: here, in a place where social roles were rigidly locked in from birth, there was a clear separation between *role* and *self*. When not performing their social duties, individuals could be far more spontaneous, mercurial, and well-rounded than their American counterparts.[26] Thus, understood properly, a return to the experiential field of tradition need not be regressive, but additive and expansive, re-incorporating past solutions and synthesizing them with the best insights of modernity.

Looked at another way, maybe the flattening social stereotyping of late modernity is just a historical "blip." We've all been sucked bodily into a collective Zone of Subjectivity—down to our very marrow, and we kick against the goads. A wide range of social "roles" (most of them unofficial) are broadcast and repeated on the internet, on television, and in film, both in public and private; the breathing room between "role" and "soul" disappears. Even our most trivial actions drip with self-consciousness and calculation. Our shoes, our gestures, our breakfasts, our shopping bags, are calibrated to communicate—to implicate us in the collective roleplay. We feel there is no escape from the all-seeing eye—the Great Paranoid God— that finds meaning in the smallest, unconscious tic. But it wasn't meant to be that way. Do we labor under a fleeting, dark cloud that will be dispelled (at last) by the grinding stubbornness of human nature? Will we recognize (soon) that social "role" and "soul" are different, and that social avatars bear little relation to the real, uncategorizable *persons* underneath?

Art is a way out of this mental prison. Its core purpose, in fact, is to embody a paradox of *otherness* that—thanks to its mystery—elicits focused social responsibility. The artwork, like the properly approached human being, proclaims its uniqueness and intrinsic value in time and space. At the same time, it is vulnerable and "on display," calling out to the viewer for response and contemplation. And maybe the artwork, set apart as it is from the world of utility and consequence, "calls out" more effectively than individual humans bodies can do—at least as far as our momentary perceptions are concerned. The social rituals we've developed around art demand that we pause to contemplate rather than quickly categorize. Unfortunately, no such rituals exist around our day-to-day encounters with other human beings. The difference is telling: in fact, parallel worlds like the "art world" are really worlds of learning and discipline, where we can slowly cultivate behaviors that are too difficult to achieve automatically. Art, in other words,

26. La Farge, *An Artist's Letters from Japan*.

is meant to give us a space, and a place, to develop an openness that can seep into our *human* interactions as well.

ART DEPENDS ON PARADOX

Our practices around fine art can have surprising outcomes. For example, prolonged contemplation can make the artwork seem unstable, almost like itself and a negative of itself at once, flashing back and forth in dual existences: It is like Chesterton's St. Francis, at once poor and rich, sacred and profane, sophisticated and savage. Are the lines we see outsides or insides? (Think of the famous "vase-or-two-faces" optical illusion.) Are darkened backgrounds, meanwhile, empty or full? Welcomed intentionally, the practice of yielding to these visual paradoxes can foster a healthy humility in our approach to the world.

Meticulous craftsmanship in art can also have this "flashing," paradoxical effect; often, dense detail actually highlights shortcomings, suggesting the failure of even the most ambitious human efforts to understand and represent reality. And, of course, the circumscribed window-context of art (discussed in my previous chapter) can seem to proclaim limitation in a way that is charmingly, humbly self-defeating. Artists have long used the existence of the frame to wittily undermine their own ambitions to wholly "capture" anything; the result is a celebration of the ineffable otherness of the Great Outside.

Positive/Negative

A good example of "dual" or self-contradictory art that actively undermines a collective "zone of subjectivity" is Tom Wesselmann's *Great American Nude* series from the 1960s—a set of paintings that could almost be viewed as pornographic until the "artistic" intention is recognized. In this series, flat, smooth, and eyeless nude women are splayed across vast canvases. Wesselmann's rigidly careful paint application deliberately evokes the slickness of advertising—a field in which the reductive "zone of subjectivity" attains its greatest power. Often Wesselmann's nudes are positioned on top of leopard prints or next to vases of flowers (both accessories with erotic connotations). Frequently they are holding a smoldering cigarette. In each painting, meanwhile, their erogenous zones are starkly emphasized—lips, pubic areas, breasts—whether through the painting of harsh tan lines or, in the case of the faces, bright lipstick. These images are extraordinarily off-putting at first (at least to the female viewer); they seem like violent, degrading

reductions. But because the art-context developed in the Christian West demands that we contemplate these images *as windows*, we look for something behind the superficial reductionism—and we begin to see more. Is the artist drawing attention, through paradoxical subtraction, to a rich feminine substance that modern advertising had reduced to superficial characteristics? Should these figures be viewed as mysterious and pitiable rather than as eminently available objects of lust? We begin to pivot (as Wesselmann himself encouraged) toward viewing the figures' sexiness as only one facet of a fuller existence, hinted at through blinding planes of color. Wesselman's nudes are meant to be like goddesses, brandishing divine powers that momentarily dazzle. Yet beneath their glamor, they are vast. I believe Andy Warhol, with his simplified, iconic grids of Hollywood stars like Elizabeth Taylor and Marilyn Monroe, was trying to say the same thing. In addition to wryly celebrating the celebrities' sex-symbol glamor, he wanted to arouse curiosity about the mysterious personalities "underneath."

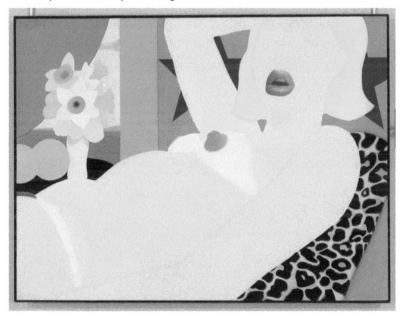

Fig. 3.4. Tom Wesselmann, *Great American Nude #57*, 1964, 123 x 166 cm.
Photo courtesy of the Whitney Museum of American Art,
ARS NY/Wesselmann Estate and Scala/Art Resource, New York.

Craftsmanship and Futility

The *oeuvre* of the Latvian-American artist Vija Celmins undermines the "zone of subjectivity" in a different way. Instead of highlighting facets of things while exhorting us to keep their complex substrate in mind, Celmins deliberately (perhaps maniacally) *copies the substrate*, frustrating and awe-ing us with its uncapturable richness. In her assemblage titled *To Fix the Image in Memory*, completed in 1982 and now in the collection of the Museum of Modern Art in New York, Celmins offers a prosaic collection of small stones. The work seems at first like "found art" in its humblest mani-festation, perhaps recalling prehistoric (and today, childlike) impulses to collect attractive objects from one's surroundings. This is because at first glance, Celmins's textured, nuanced, and irregular stones appear incontro-vertibly *real*, and thus underwhelming and confusing. Accordingly, they provoke obvious questions: "Why are they in an art museum?," we are prompted to ask. And also: "why choose these stones and not others more beautiful or rare?" Upon inspection, however, we realize that only half of the stones have come from nature. The other half are actually meticulous copies that Celmins herself crafted from paint and bronze.

Fig. 3.5. Vija Celmins, *To Fix the Image in Memory*, 1977–82.
Artwork copyright Vija Celmins, courtesy Matthew Marks Gallery.
Photo courtesy of the Museum of Modern Art, New York,
and Scala/Art Resource, New York.

The stones are arranged in pairs, and within each pair is one natu-ral product and one product of human analysis; a challenge is thus raised. Is it possible to tell which stone is which? Is the human hand capable of

reproducing something even as prosaic as a rock? Do even the most inert, most mute natural objects have a complexity that belies our ability to comprehend them? Celmins's assemblage is poignant both for her impressive success copying the stones and for the undeniable sense that even an expert hand could not capture the simplest natural object in its totality. We are motivated to look at the stones themselves afresh, as tiny, complex galaxies. And we are moved to doubt every other product of human mimicry as a result.

Addition = Subtraction

Meanwhile, contemporary Japanese artist Hiroshi Sugimoto has produced ingenious commentary on the limitations of conceptual "boxing" and the futile possessiveness of the modern subjective "frame." Sugimoto is primarily a photographer—an artist in the very medium Walter Benjamin criticized as flattening and reductive. But Sugimoto frankly owns the limitations of his medium, and he has used those limitations to comment on the pigeonholing tendencies of modernism. His first cycle of photographs, *Dioramas*, are coy framings-of-frames: they are snapshots of antiquated museum dioramas. As reductions of reductions, these photographs wittily highlight the conceptual violence of the modern museum's "authoritative" presentations of historical fact. Through Sugimoto's lens, the dioramas are preternaturally eerie and flagrantly artificial—more products of human fantasy that real records of life.

In a later series, *Theaters*, Sugimoto also presents frames of frames: this time photographs of vacant movie theaters. In each photo, a film is being screened. But the photographs have been exposed continuously over the run-time of the film, meaning each frame of the film has overlapped with the previous one. As a result, the screen in each photo appears to be vacant and white. Sugimoto's *Theaters* series has many implications, but perhaps the most important one involves the perils of over-confident conceptual possession. The zone of subjectivity, after all, is subtractive. When it is combined with other such reductive zones, the total effect can be one of complete erasure, like overlapping movie frames that wash each other out, leaving nothing behind.

Fig. 3.6. Hiroshi Sugimoto, *Carpenter Center, Richmond*, 1993, 119 x 150 cm.
Photo courtesy of the artist and Marian Goodman Gallery.

Open and Closed

Among traditional Christian artworks, the sculpted altarpieces of Northern
Europe, produced in an area where limewood carving was the dominant
expressive medium, most closely anticipate Sugimoto's commentary on the
limitations of "boxing." These altarpieces approximate museum dioramas in
that they are frozen, pedagogical scenes that spatially and factually captured
historical (sacred) events. Perhaps this undercurrent of confinement and di-
dacticism explains why the carver Tilman Riemenschneider developed the
habit of "puncturing" his frames and making them smoke or spill, as if the
subjects literally could not be contained. In his remarkable Altar of the Holy
Blood still *in situ* in Rothenberg, Germany, the vining architecture of the
depicted scenes (and primarily the central scene of the Last Supper) extends
at a larger order of magnitude into a gigantic, almost surreal finial extend-
ing above the altar-frame proper, almost doubling the entire work's height
(see fig. 2.11). Riemenschneider's climbing filigree appears organic and pro-
pulsive, like a secret life bursting out. And with its delicacy and openness,

it seems to dissolve toward an immaterial unknown. We have noted that Christian painting could suggest its incompleteness through broken color, light and brushstroke; Riemenschneider showed that sculpture could do the same through extension in space. Having established the necessity of the frame-as-window, Christian artists like Riemenschneider could "play" with that frame and undermine it, continually resisting the human tendency to localize, contain and define.

Works like Riemenschneider's remind us of the Pop artist Louise Nevelson's *Sky Cathedral* of 1958—a modern, secular work that evokes the frame-bursting success of Riemenschneider's wooden altarpieces. Like the *Altar of the Holy Blood*, Nevelson's *Sky Cathedral* is made of wood and is aggressively monochromatic. And like so many medieval and renaissance carved altarpieces, *Sky Cathedral* is also modular, stacking frames upon frames and frames beside frames, reminding one of tree-bark patterns, rock formations or honeycombs. Also like the typical carved altarpiece, some versions of Nevelson's *Sky Cathedral* press toward the ceiling with a central, stepped peak. The Jewish Nevelson, like Kasimir Malevich, was of Russian origin, and she was thus no doubt steeped (voluntarily or not) in the visual culture of Orthodox Christendom. Therefore her *Sky Cathedral* investigates, like so many of the artworks we have discussed, the perils of framing and the nature of the "Christian picture"—the icon, in its earliest form. For Nevelson, however, it is not saints but discarded objects (refuse, trash) that are positioned elegantly within shallow frames. Her final product resembles an Iconostasis (or Orthodox icon-wall) of mysteriously silhouetted shapes, humble yet elevated into something higher. The sense of personhood radiated by the framed implements (including a washboard and a chair leg) illustrates just how effectively the window-icon form points to life beyond its boundaries. With its extension of personhood to objects (seasoned objects, that have fulfilled a *destiny*), Nevelson's *Sky Cathedral* might evoke a kind of animism, but it is an animism indebted to an implicitly Incarnational, Christian regard for matter as window to God.

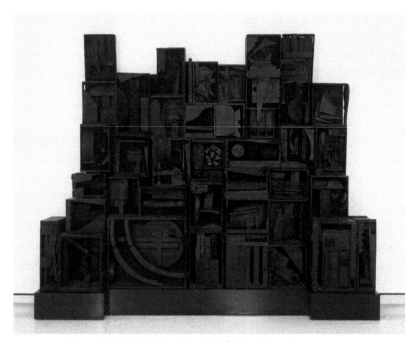

Fig. 3.7. Louise Nevelson, *Sky Cathedral*, 1958, 292 x 343 x 51 cm.
Photo courtesy of the Albright-Knox Art Gallery, ARS NY/ Nevelson Estate and Art
Resource, New York.

ART MAKES PLAIN

The Zone of Subjectivity, with the "exhibition value" it lionizes, is more dangerous than a visual culture merely enthralled by what Fried called "objecthood." An "exhibitionist" visual culture, after all, ultimately envelops both substance *and* meaning. ("Objecthood," meanwhile, concerned itself with substance alone, and its sensory effects.) The zone of subjectivity, in fact, negates substance by dismissing it as a mere vehicle of communication. With the stubbornness of matter having been dodged, whoever controls the zone is then free to define everything as they wish. The result is at first comforting and congratulatory. It layers moral complacency on top of sensory stimulation, and its pinioned prisoners, the labeled constituents of its collections, thank you for your meager attentions, as if your approval was all they desired. But the zone of subjectivity is also, therefore, the great enemy of individual dignity.

The African-American artist Carrie Mae Weems acknowledged such imperious zones of subjectivity in her photographic series of 1996 titled *From Here I Saw What Happened and I Cried*. The series consists

of twenty-eight separate photographic prints of real African-American slaves. Each photograph is overlaid with both a lurid red filter and a brief, strident phrase. Early in the series, a photograph of a nude female slave turned to the side reads "YOU BECAME A SCIENTIFIC PROFILE" in all capital letters. Another image, depicting a male slave seated frontally, reads "AN ANTHROPOLOGICAL DEBATE." A third image, depicting an older man with sagging flesh and visible ribs, reads "A NEGROID TYPE." A fourth, depicting a nude female face-on, reads "A PHOTOGRAPHIC SUBJECT." The series continues through several more cringe-inducing images, each with a reductive label emblazoned across its surface.

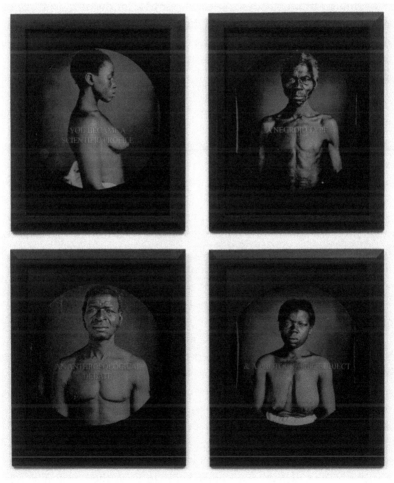

Fig. 3.8. Carrie Mae Weems, panels from *From Here I Saw What Happened And I Cried*, 1995–96, copyright Carrie Mae Weems. Each panel is 68 x 58 cm.
Photo courtesy of the artist and Jack Shainman Gallery, New York.

Here the pronoun "YOU," which begins the text when read from left to right in the manner of a page, summons a sense of personhood—we imagine a conversation partner, a fellow and equal. But the *things* this "YOU" become are all reductive and subhuman: "a scientific profile" is a specimen, rather like a taxidermied animal in a museum vitrine. "A negroid type" evokes all of the racialist stereotyping that justified the institution of slavery. Finally, "a photographic subject" implicates photography—at least, insofar as photography is regarded as "objectively truthful"—in the confinement of living things within the reductive frame of a collectively-held stereotype. Together, both modern technology (through photography) and modern science (through anthropology) are held responsible for the dehumanizing of an entire population of individuals. The promise of conceptual possession lying at the origins of both photography and modern science is declared to be dangerous to the point of atrocity. Similar attempts to "box" unruly individuals into purportedly all-knowing "zones of subjectivity" resulted in twentieth-century tragedies like mass sterilization and the Holocaust.

Carrie Mae Weems did not mean to indict only backward antebellum slaveholders through her critique. Significantly, the photographs she used in *From Here I Saw What Happened* came from an anthropological archive at Harvard University maintained by the famous professor Louis Agassiz, who denied the common origin of the human races. The photographs were specifically taken at Agassiz's request in a manner that would frame the subjects as "specimens" and would highlight crucial ethnological differences that would disprove notions of a universally shared humanity. In this context, the photograph-as-scientific-box had become the perfect tool for creating a highly convenient and destructive Zone of Subjectivity: one that insulated white Americans from predictable torments of conscience, and that justified the continued exploitation of Africans and African-Americans both legally and economically.

Weems is just one of many modern and contemporary artists who expose, consciously or not, the dangers of Kierkegaard's "aesthetic" posture. She and others probe minds that refuse to accept the full *otherness* of others, seeking instead to instrumentalize everything outside of the self. Far from welcoming a complementary "body of Christ" evocative of the communitarian Trinity, humans in this "aesthetic phase," addicted to their "zones of subjectivity," compete together in cruel Darwinian struggle, forging alliances of mere convenience in the quest of each to assimilate or annihilate. In such a regime, each man or woman works to create their own Monolith, whether imaginatively or in a dystopian reality. In his grappling for mastery, Josef Stalin is said to have uttered "Death is the solution to all problems. No man, no problem." Person and problem were identical. The individual was

assimilated into the system of thought—completely. This will lead inevitably to my next chapter, "The Theater of the Self."

OUTSIDE THE BOX

To feel safe, to maintain control, human beings tend toward "boxing"—both intellectually and physically. In this light, it is worth returning to the Hebrew Tabernacle once again. The Tabernacle was an ur-artwork that resisted assimilation into the controlling human consciousness. Like James Hampton's *Throne of the Third Heaven*, which I mentioned in the introduction to this book, the Tabernacle was a construction that forced acknowledgement of threatening and unpredictable *otherness*. And remarkably, the biblical Tabernacle was both a thing—an object of contemplation—and a *place*. It was at once identical with and dependent upon its architectural envelope. It could never, therefore, become like a specimen in a museum. By God's design it was self-sufficient, self-contained, un-compassable and free. When we reflect on the Tabernacle as something irreducible and un-cageable, we gain new appreciation for the nomadic character of the people who bore it. The Children of God, as embodied by the ancient Israelites, resisted confinement and predictability, confounding each new civilization they encountered. Their Tabernacle, in this sense, was a symbol of who they were as God's chosen people. In the Christian worldview, this same quality of unpredictability echoes down into each individual life, for each individual life bears the spark of God.

Furthermore the Ark of the Covenant, around which the Tabernacle was built, was never meant to be "collected." In fact, the Bible recounts that those who touched it without God's specific permission would die. Thus both literally and figuratively, the Tabernacle resisted possession and taxonomizing. In the famous Stephen Spielberg movie, efforts to collect the Ark memorably resulted in the collectors' destruction. Both the Ark and the Tabernacle, like God and every other sovereign creature he made, remain stubbornly outside merely human systems of knowing. To manipulate (to even *try* to manipulate) is to die, whether physically or spiritually; the sense of power that comes from control is only an illusion. In their unassailability and sovereignty, the Ark and the Tabernacle were the absolute models to which Christian artwork in later days would aspire.

When James Hampton built his *Throne of the Third Heaven*—or rather, *while* he built it, for the process claimed years or even decades of his life—he did not imagine that he captured the meaning of God. In fact, he did not intend for his masterpiece to *communicate* at all in the sense that it would

send a "message" about divine truth. On the contrary, there is evidence that Hampton never expected for his work to be seen—he never expected it to "speak." The *Throne of the Third Heaven* did not create a circumscribed "zone of subjectivity" that defined social meaning so much as it functioned as a liminal space, a *contact* space, where the Great Other could be contemplated in all of its perplexing otherness, to the benefit of Hampton's own profoundly devout and sensitive soul. Hampton achieved this goal by means of a wide variety of complementary techniques. There was the multiplicity of parts, defying easy comprehension. There were the reflective surfaces, suggesting dimensions beyond the brute boundaries of the artwork itself. There was the scale and the elusive detail, confounding all attempts at "reading" and conjuring instead a stubborn monumentality. In its size and richness it seems "uncollectable" (despite its having been collected), and even today it seems to burst from its niche at the Smithsonian. For it was meant to be its own space, to inhabit any space and no space. Because it was native to a cramped garage, there was no question of proper vantage or use. It grew like an embryo within an eggshell, swelling to meet the contours of its incubating cloak. It did not *show*; it rather *dwelt*. It was its very existence that mattered. In its refusal to communicate, it left itself open to a meaning-vector that might descend and give it life, assign it *service*. Such, in the eyes of God, is the body of every woman and man.

4

The Theater of the Self

In the beginning there was contact. *Sight*. Father gazed upon Son, and energy resulted—a swirling, propulsive, ascending, expanding energy called the Holy Spirit. The Holy Spirit also *saw* and rejoiced. Harmonies were added to the divine melody, and force was added to the divine energy so that it spiraled further and further, leaving ten thousand and more beauties in its wake: the universe and its galaxies; the ocean with its creatures; the earth with its minerals, seeds and sprouts; animals and humankind. All of this came from contact. From intrinsic, recognized and beloved diversity. "To the one who has, more will be given," Jesus said. The one who has the most is God, and He gains more and more forever.

In the previous chapter, we saw how zones of subjectivity diminish and ultimately erase otherness. The zone of subjectivity culminates in the monolith, which subsumes everything to a single, mastering will. The monolith is the precise opposite of the multi-personal, endlessly creative God. Each of us, as knowers of the universe, can either be darkly inward, pulling the outside into a private zone of subjectivity, or we can reach outward and joyfully reflect the All. Like mirrors hanging from delicate filaments, spinning in an empty space with eastern sun and western dark, we are at every moment a breath between hanging fallow in uniform blackness or reflecting, with all its geometries, the mirror-domain of the Light of Lights.

My previous chapter treated the human individual as a subject—a knower. As one who looks out from within and either reconciles or rejects. This chapter will expand from there to treat the human as *object*—as an object of revelatory knowledge uniquely and grandly endowed. For as copies

of God, resonant with his incarnation-form, humans have tremendous visual power in the fabric of their bodies. They can lasso, grasp, or radiate glories of a vast, sometimes untamable scale.

We have seen already that individuals can become "objectified," playing degraded roles in someone else's fantasy. There is, however, another, more deceptively grand dimension to the human experience of objectification. As I suggested in the very first chapter to this book, the great quest of human life (for which art is a useful tool) is the maintenance of *relationship across axis,* so that we can look clearly at God and God can look invigoratingly back. But of course the axis-space can be traversed, to our peril. And so there is a second kind of "objectification": the kind that comes when we pivot into a spot that blocks and usurps God's illuminating gaze. In a way, this is the principle of the Anti-Christ, whose apparent glory makes him seem to take Christ's place as an object of worship. But on a smaller scale, and more concretely, this is simply what happens in all ordinary human hero-worship, when too much regard is given to too little, when we become a bit too starry-eyed, when we lose a sense of proportion in the universe.

For even if our eyes—our soul-mirrors—be hanging toward blackness, looking away from the Source and back toward an inner monolith, our *selves* can yet be "backlit" by distant Light, making us take on glory in others' eyes. In this way, the human person herself can become a sort of localized idol for certain viewers at certain times, spreading a different kind of monolith-impulse that is unstable and explosive in its power. For apart from everyday, ordinary hero-worship, this impulse can also breed a dangerous form of cultishness (separate from Benjamin's "cult value"): imagine cults of "stardom," personality cults that revolve around gurus or visionaries, or cults around royalty. Such conditions may sometimes foster social cohesion, but they frequently end in the frothing rage of deep disappointment, so that tragedies like witch-hunting, mobbing, lynching, and scapegoating follow.

In his epic examination of human weakness known as *War and Peace,* Leo Tolstoy memorably conjured one such episode of scapegoating—when worship, rage, and mass mentality conspire to take an innocent life. Just as Moscow is about to be seized by an invading French army, the reigning city administrator, Count Rostopchin, scrambles to channel the panic of the mobbing citizens. He does this by concocting a lie about his prisoner Vereshchagin, a shabby young ne'er-do-well who happens to be waiting at his door. As the crowd surges around Rostopchin's palace, the Count sends out the poor captive, painting him as a glamorous, wily traitor capable of delivering the city to Napoleon. He then offers Vereshchagin to the mob as a sacrifice, and they accept ("Cut him down! I command it!" Rostopchin cries). The boy is torn to pieces as the Count rides away grandly in his coach,

seeking shelter at his country estate.[1] This, as Tolstoy suggests, is the way of all things: first, there is our earnest longing to exalt; second, our drive to blame; and third, our lust to luxuriously destroy.

THE TOTAL MONOLITH

The Zone of Subjectivity is one way of understanding the imposition of "monoliths." It is most easily grasped as a physical space (like the museum or collection) in which roles are mapped and meanings are set, creating suffocating fixity. In the preceding chapter, we discussed how photographic "collections" (whether in books, or portfolios, or today, on the internet) can also create zones of subjectivity—portable and personalizable—that, like the museum, can work to prepare the mind for more expansive prisons. But even as they shaped the imagination, these earlier phenomena (museums, collections, photographic books) were also the *product* of imagination—that is, they were possible because a certain mindset was being achieved among the Western elite, perhaps unconsciously. Therefore it is no surprise that other thinkers, outside of the realm of visual criticism, began to prophesy the advent of social "monoliths" as well. They pointed, sometimes unwittingly, toward the totalitarian abuses of the early twentieth century, and they also foresaw a host of lesser oppressions still present in our world today.

In Germany, Martin Heidegger discovered "monolithic" tendencies in what we have come to know as the mass media, with its attendant stifling of ideological diversity. He lamented, for example, what he called "The Chatter" (*das Gerede*) of the dense modern city, which captivated citizens through its loud repetitions and unrelenting social pressures. He felt that a new sort of urban echo-chamber was sweeping individuals into storms of collective opinion, drowning out the witness of "authentic" selves.[2] For Heidegger, it was important to pry oneself free of this "chatter" and reconnect with nature. Unfortunately, his advice was not heeded; the following decade would produce the mass insanity of Nazism. (Even Heidegger himself was complicit in the Nazis' rise.)

Later, in France, the philosopher Louis Althusser saw monolithic dangers emerging from entrenched governing hierarchies of all kinds. Writing

1. Tolstoy, *War and Peace*, book 11 (1812), chapters 24 and 25.

2. The concept of personal "authenticity" is strongly associated with Heidegger thanks to early translations of the philosopher's *Being and Time* of 1927. What in the English-speaking world came to be understood as "authenticity" was perhaps better understood as full awareness of, and commitment to, one's orientations, so that one's role in the world is fully "owned" (*eigen*).

in the counter-cultural 1960s, Althusser warned against the "Ideological State Apparatus"—an unholy union of church, state, and industry—whose primary role was to shove citizens into social boxes from the moment they were born. According to Althusser, a cultural process called "interpellation" (or "hailing") brainwashed citizens from their earliest days, making them feel that their lot was inevitable. If one is "hailed" as trash from birth, she will believe it and become it. But one "hailed" as princely will grow in confidence to rule the world.[3]

Perhaps the most useful harbinger of Clifford's "Zone of Subjectivity," as far as visual culture was concerned, was Guy Debord's "Spectacle." In his prophetic manifesto of 1967 titled "The Society of the Spectacle," Debord, a French philosopher and artist, made the following cryptic observation:

> An earlier stage in the economy's domination of social life entailed an obvious downgrading of *being* into *having* that left its stamp on all human endeavor. The present stage, in which social life is completely taken over by the accumulated products of the economy, entails a generalized shift from *having* to *appearing*.[4]

What Debord recounted, here, was degeneration from a pre-industrial worldview that ascribed independence, sovereignty, and dignity to *individuals* into a post-industrial worldview that cared only how individuals *signified*—how they looked, or what obvious social role they played. Personal desirability became everything. The intermediate step, "having," had emerged from high capitalism and stemmed from the belief that worth is "purchasable"—that an agglomeration of *things* could give one status, at least for a while. Debord's final step to "appearing" (after "having") acknowledged that even money was less important than the ability to psychologically manipulate—to radiate power, charisma, or glamor according to the preferences of the time.

For Debord, the power of the Spectacle rested on at least two things: first, it depended on humans' unthinking thralldom to sex, glamor, and strength—and their capacity to be manipulated as a result. But second and more importantly, it depended on our need to lurch toward promises that stand above our ordinary lives. We are born to be seekers, never satisfied, as von Balthasar and Lacan knew, so we are ever attracted toward fresh and glamorous enticements. In fact, Debord, knowingly or not, profoundly

3. Althusser, "Ideology and Ideological State Apparatuses."
4. Debord, "The Society of the Spectacle."

understood "the lust of the flesh, the lust of the eyes and the pride [*alazo-neia,* or pretentiousness] of life" as identified by the author in 1 John.[5]

The Spectacle surrounds us, massages us, and seduces us with its flickering promises. But more than that, it rewards us for being a promise to others—for embodying what others desire, if only for a moment. This is how one becomes a good citizen in the Spectacle-world: one plays along, frankly using others but also being used in return. Richard Hamilton's seminal pop art collage, *Just what is it that makes today's homes so different, so appealing?*, was made eleven years before Debord wrote, and it captured the danger exactly. Here, a middle class husband and wife have reshaped themselves to mimic the desirable bodies in movies and advertisements; they stand in seductive, exhibitionist poses, ready to be consumed. Meanwhile their home is like a department store showroom with brand names triumphantly displayed.

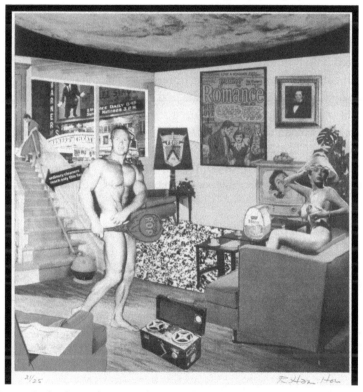

Fig. 4.1. Richard Hamilton, *Just what was it that made yesterday's homes so different, so appealing?* 1992, 26 x 25 cm. This image is a laser print, issued by the artist, that faithfully reproduces his collage of 1956.
Photo courtesy of ARS NY/Hamilton Estate, the Metropolitan Museum of Art, and Art Resource, New York.

5. 1 John 2:16.

The figures in Hamilton's picture are inhabiting mass-media roles (the husband is a competitive bodybuilder, the wife is an exotic dancer). Consequently, they hint at the subject of this chapter: performance art. Hamilton's husband and wife (an Atomic-Age Adam and Eve) willingly perform social roles that conform to the Spectacle—to the monolithic Zone of Subjectivity that begins to control all modern culture, whether we know it or not. Perhaps Hamilton's middle-class dupes do not rise to the level of "artists" in this sense—they are not self-aware in their performance; they betray no winking irony. But on their bodies, they suggest the new medium in which artists would work beginning in the 1960s: the medium of the flesh itself. And it was not long before artists would show that the Spectacle demanded not only objects of sexual desire and glamor, but objects of deeper needs—needs to trust, venerate, worship, genuflect, and sometimes destroy.

With the "new wine" of the Christian artwork in the early years *Anno Domini*, true personhood was shown to elude control—to transcend implication into either social zones of subjectivity or chthonic, pagan systems of localized power. But the lesson of the Christian artwork has been difficult to hold onto. Just as with the Trinity (three-and-one) and Christ (fully man and fully God), the artwork's paradoxical nature has been challenging to keep in mind, requiring great cultural resources, dogged education, and networks of accountability. In the modern West, as the delicate machinery of traditional Christian culture begins to crumble, its hard-won lessons can be forgotten. As a result, the meaning of "personhood" itself runs the risk of becoming lost again in unstable social structures of expectation and control.

SPECTACLE AND VIOLENCE

Seven years after Guy Debord published his *Society of the Spectacle*, the Serbian artist Marina Abramović performed her infamous *Rhythm 0*, which still generates controversy. The performance was part of the artist's larger *Rhythm* series, in which Abramović repeatedly courted physical harm, whether via knives or fire. In her first "Rhythm" pieces, Abramović directly orchestrated the dangerous circumstances she endured. (For example, in *Rhythm 5* she had inscribed a star shape in gasoline on the floor of a cultural center and then set it on fire.) However in *Rhythm 0* (which, despite its number, was the last of the series), the artist placed herself at the mercy of an anonymous audience. This was social distortion brought to life: the violence of the Spectacle—of collective delusion—enacted directly onto someone's skin.

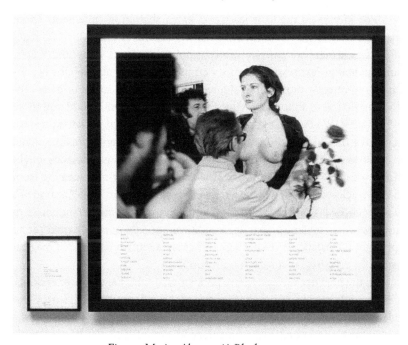

Fig. 4.2. Marina Abramović, *Rhythm 0, 1975.*
The commemorative photographic plaque pictured here was issued in 1994.
Photo courtesy of the Solomon R. Guggenheim Museum Foundation, New York,
ARS NY, the artist and Art Resource, New York.

A declared feminist, Abramović wanted (at least in part) to *physically manifest* the helplessness and objectification women feel in rigidly patriarchal societies. Thus she invited audience members to assail her—for six hours—with seventy-two common objects (including flowers, oil, a razor and a loaded gun). The artist, meanwhile, would remain passive throughout, not even flinching when the pistol was raised to her head. A frenzy built near the end of Abramović's performance—at around two o'clock in the morning. The artist was stripped naked, groped, dealt bloody cuts and bruises, and marked with the words "END" and "HOMO" across her head and chest. How can we understand the psycho-spiritual engine of this frenzy? Maybe this was rage at a counterfeit "mother" who raised herself up but refused to give an answering gaze. (Such rage would be soothed in Abramović's much later performance, *The Artist is Present*, as my next chapter will discuss.) At any rate, in the context of artists' awakening to the disfiguring Spectacle, *Rhythm 0* equated social "boxing" (that is, the social imposition of identity) with the creation of real, physical wounds.

For *Rhythm 0* made at least two, earth-shattering statements about Spectacle society. First, thanks to the gallery setting, it contextualized hateful acts as artistic statements, showing how violence is also—and maybe fundamentally—expressive. (As its victims often sense all too clearly, violence is frequently more about signaling allegiance, rejection or even self-loathing than it is about achieving a practical end.) And second and more disturbingly, *Rhythm 0* suggested how, by extension, *all* social expression may have the literal power to transform. By collapsing expressive signal with physical effect, Abramović hypothesized that social violence might define who we *are*—that the individual is not meaningfully separate from the Spectacle-web in which she lives and breathes. In this way, Abramović's performance was indeed a harbinger of twenty-first-century tendencies to view speech as violence, or to view political opposition as a "denial" of an opponent's "existence." (All of these things are a return to a kind of magical regard for certain loaded gestures or words.)[6]

In the next decade even more performers—whether brave, or reckless, or both—followed in Abramović's footsteps. The gay multi-media artist David Wojnarowicz, for example, stitched his mouth shut prior to his appearance in the landmark AIDS documentary *Silence = Death*. For Wojnarowicz, who had been diagnosed with HIV and would die three years later, the social silencing of gay Americans had resulted in literally thousands of deaths due to AIDS—an understudied and then notionally "gay" disease. The artist's mouth-stitching was, according to critics, "self-inflicted damage announcing larger harm"[7]—a sensational form of awareness-raising that brought home gay Americans' plight. And it also showed, just like *Rhythm 0*, that the Spectacle's judgment (in this case, a judgment requiring silence and invisibility) was coterminous with the artist's own body. Polite circumspection had become identical to existential snuffing-out. Wojnarowicz's mournful self-mutilation, captured so powerfully in Andreas Sterzing's photograph of 1989 (below), can be understood as the precursor to today's "Day of Silence" movements, when activists wear duct tape on their mouths to signify how they've been "silenced" by an unsympathetic majority. Twenty-first-century refugees have also been known to stitch their mouths shut in protest of how they've been denied basic human rights.

6. For a sense of the debate today surrounding the power of words and "speech as violence," see, for example, Feldman, "When is Speech Violence?" and its rebuttal by Haidt and Lukianoff, "Why It's a Bad Idea to Tell Students Words are Violence."

7. See Laing, "A Stitch in Time."

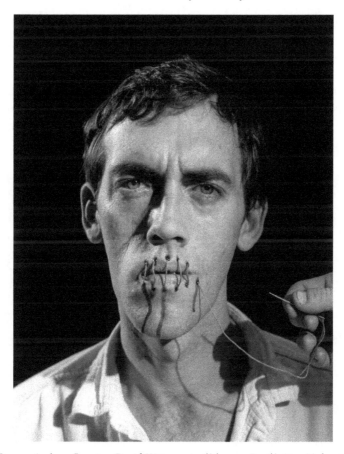

Fig. 4.3. Andreas Sterzing, *David Wojnarowicz (Silence = Death), New York 1989*.
Photo courtesy of the artist and P·P·O·W Gallery, New York.

Sometimes these performances are documented in ways that lead to a kind of second-order, iconic monumentality. Traditional pictures are made that enshrine the painful, prophetic act. In 1993, the artist Catherine Opie (who is lesbian, and whose primary medium is photography), produced a photo of her unclothed back titled *Self-portrait/Cutting*. Literally etched into her skin, the bloody lines still showing, is a childlike drawing of two girls holding hands in front of a house, with the sun, a cloud and birds overhead. The title, of this work, of course, is *Self-portrait*, and the portrait aspect is double: Opie's own body is clearly shown in the work, but so is her stereotypical "identity" as a lesbian, in the form of a girl who would hold hands with another girl. Opie's lesbian identity, here, is cast as natural and innocent through the naiveté of the childlike drawing, but it has also been re-framed as a weapon meant to harm. After all, the image is *literally carved*

into Opie's back, a kind of "scarlet letter" that moves beyond stigma into actual violence. It has become a uniform Opie wears that marks her for persecution—and it is an unremovable uniform, embedded in her flesh. As a classic self-portrait with a lavish background and dignified symmetry, Opie's image is certainly *iconic* in its sense of authority and traditionalism, but it is also *spectacular* in its elevation of social symbol to ontological definition. Opie's sexual identity seems (with great injustice) to comprise the full and exclusive meaning of her life.

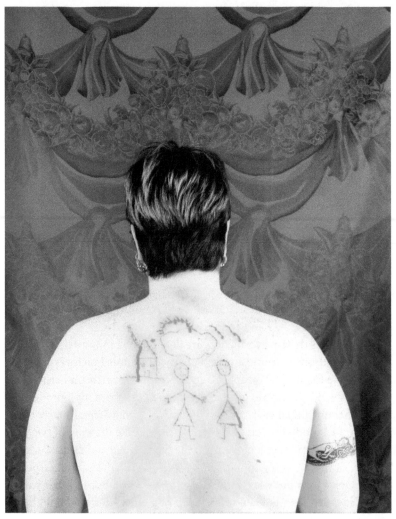

Fig. 4.4. Catherine Opie, *Self-portrait/Cutting*, 1993, 102 x 76 cm.
Photo courtesy of, Museum Associates/LACMA, and Art Resource, New York.

SOCIAL ROLE = SOUL

In a 2016 essay titled "How Identity Politics Conquered the Art World," the New York art critics Jerry Saltz and Rachel Corbett described how something they titled "The Theater of the Self" was born. The phrase "theater of the self" did not originate with Saltz's and Corbett's essay—it had been the title of a Yasumasa Morimura exhibition three years before. (Morimura, who we will discuss later, is a Japanese artist who has made a career of ironically performing a range of Western-cultural archetypes.) In their 2016 essay, Saltz and Corbett borrowed the term "Theater of the Self" to characterize the entire contemporary art world—or at least the art world's central, most important dynamic. As Saltz wrote near the beginning of the piece, "the core materials" of the twenty-first-century art world are "biography, history, the plight of the marginalized, institutional politics, context, sociologies, anthropologies and privilege."[8] In other words the artist's tools, once understood to be things like paint, pencil, or canvas, had become something much more intimate. They had become the very self—body and history. Role is no longer a theatrical costume, but something embedded in one's organs and skin.

Saltz and Corbett began their analysis with the 1993 Whitney Biennial, a controversial exhibition that brought the notion of "politicized art" to an entirely new level. (Foreshadowing the heated climate of online racial discourse in the new millennium, visitors to the exhibition were given a button reading "I CAN'T IMAGINE EVER WANTING TO BE WHITE.") The authors' discussion of the Biennial, prefaced by events reaching into the early 1980s and the beginning of the AIDS crisis, forcefully supports the "trickle down" theory of culture that places the art world and academia at the vanguard of mass-culture change. In so many ways, the rhetoric prepared in 1980s avant-garde culture and embraced at the 1993 Whitney Biennial is reminiscent of mass political discourse today.

But the shifts chronicled by Saltz and Corbett have import beyond their prediction of the hyper-polarized political climate of the twenty-first century. They also illustrate something more fundamental: a new fearlessness in self-disclosure—a willingness to broadcast personal pain through a megaphone—that makes embodied suffering almost magically symbolic. "Artists now work at the scale of medieval cathedral façades," Saltz wrote, "meant to tell universal stories in highly accessible ways. But they do so

8. Salz and Corbett, "How Identity Politics Conquered the Art World."

with their own personalities, histories, biographies always front and center—speaking, imploring, knocking us down with the idea of a self."[9]

What Saltz and Corbett describe as the "Theater of the Self" is an ingenious and profound response to the "Society of the Spectacle," marshalling the weapons of the Spectacle to remake it from within. But the implications are frightening, for these new techniques show that the Spectacle has become entrenched so completely, and taken over our imaginations so thoroughly, that nothing can exist outside of the Spectacle's purview. Resistance to the Spectacle becomes another part of the Spectacle. And as the "self" becomes more and more "theatricalized," playing out its torments on the Spectacle-stage for mass-consumption, the inner life gradually disappears. Many such rebellions against the Spectacle, despite their good intentions, have actually strengthened it, for they threaten to remove any lingering sense of the individual as *independent*—as ennobled by a timeless meaning that evades social categorization. The sociologist Richard Sennett prophesied something like this in his 1977 book, *The Fall of Public Man*.[10] For Sennet, public costume (most archetypally the powdered wigs and satin breeches of the eighteenth century) had always been necessary to separate the social self from the *real* self. Today, we have no such barrier between self and Spectacle, so we become vulnerable to deformation. In response, we incorporate symbol into the fleshly body, fighting fire with fire.

SURFING THE SPECTACLE

The Spectacle promises to fix everyone in amber (or pixels), binding them forever in legible roles that are quickly understood. It professes to say *what things are*, on an ontological level, so that no one will wonder any longer. It is the comprehensive textbook of our time, explaining everything to everyone. Its power helps reveal why someone like the French artist ORLAN (formerly Mireille Suzanne Francette Porte) would go to such enormous lengths to manipulate "spectacle" thinking. ORLAN is famously quoted as stating that "my work is a struggle against the innate, the inexorable, the programmed, Nature, DNA (which is our direct rival as far as artists of representation are concerned), and God!"[11] In other words, ORLAN seeks absolute freedom from any shaping power beyond that of *her own will*. She wants to bend the Spectacle to her desires.

9. Salz and Corbett, "How Identity Politics Conquered the Art World."
10. Sennett, *The Fall of Public Man*.
11. Weintraub, *Art on the Edge and Over*, 81.

ORLAN became famous in the 1990s for undergoing nine plastic surgeries toward the end of transforming herself into "Saint ORLAN," a composite of notable features from classic paintings (the chin of Botticelli's Venus, the forehead of the Mona Lisa, the lips of Boucher's Europa, etc.). Then, in the early 2000s, the artist shifted her tactics, foregoing further surgeries and plugging directly into the "spectacle" itself. In her more recent works, therefore, ORLAN remakes her image under different guises with the aid of computer graphics; these new "faces" can then be disseminated digitally (and infinitely). Her physical body takes a backseat to a digital self that can truly go anywhere and be anything.

This brings us, at last, to the aforementioned Yasumasa Morimura, who arguably coined the term "theater of the self." Like ORLAN, Morimura also seems to celebrate the infinite malleability of the self in an age where imaging technologies can shape and mediate all of our social interactions. In dozens of photographic self-portraits, he has cheekily cast himself as Western icons ranging from Marilyn Monroe to Albert Einstein, leering with glee from behind personas he wears like Halloween costumes. Together with his often irreverent facial expressions, Morimura's distinctive racial characteristics make the effect particularly jarring. He really *does* look like Marilyn, for example, but he also looks like a Japanese man. How can this overlap be possible? What does it tell us about the simultaneous power and thinness of the visual packaging that controls our lives?

There is something accusatory about Morimura's work, but also empowering. Having been given a stereotypical visual language by the "chatter" around him (most of it emitted by the U.S. and Europe), Morimura uses that language to control his own experience and self-apprehension. In his "Theater of the Self" exhibition from 2013 staged at the Warhol Foundation in New York City, Morimura used imaging technologies to become a body-hopping tourist, vicariously experiencing many socially-constructed realities, many of which were female, many of which were highly sexualized, and all of which required virtual travel through time and space. Morimura never completely obscured himself within these alternate identities—in fact, oftentimes he flaunted his male physiognomy while assuming "female" forms. He cast himself, therefore, as someone who is sampling before moving on—as a "tourist" in the world of social experience. If we have to be immersed in the Spectacle, Morimura seems to argue, why not learn to ride the waves? Why not accept roleplay as a game—as something that can be aestheticized for our enjoyment? It is not surprising that Morimura's art arose coterminously with a boom in Japanese pornography. Both phenomena embrace the loss of self in an ocean of vicarious stimuli.

But there is something else behind performances like ORLAN's and Morimura's. Both artists are astonishingly prolific in their generation and dissemination of self-portraits, and both lavish tremendous detail on every carefully-rendered image. Moreover, both have essentially erased or withdrawn any notion of self that is apart from the Spectacle they manipulate. They seem rather like entities *within* the Spectacle, skittering from image to image in ceaseless flight. *Flight.* The word evokes the action of birds, but it also conjures escape from danger. In many interviews, Yasumasa Morimura has discussed his obsession with "oblivion"—that which has been hidden, forgotten, crushed out. At the same time, he has also owned his "fascination with being seen."[12] For both Morimura and ORLAN, complete surrender to the Spectacle has resulted in something like dependence. What once sapped life now becomes a life-sustaining addiction.

Indeed, the sense one takes away is that these artists are like modern-day Gudeas, fashioning legions of soul-sanctuaries to escape the ravages of time and entropy, or like the Shinarites of Babel, building their gargantuan tower. Creeping into Morimura's work, and ORLAN's too, is a feeling that there is no home for the soul, and so one must build it homes: lavish tombs defying the desert sand. Put another way, when there is no eternal God granting meaning through his gaze, then visibility (which equals existence) must be seized in another way. The glare of the Spectacle takes the place of the eyes of the life-giving Trinity.

THEATER AND HISTORY

"All the world's a stage," William Shakespeare wrote, "and all the men and women merely players."[13] Shakespeare's verse goes on to chart the many parts that people act, from "the infant, mewling and puking," to the "lover, sighing like a furnace," to the "justice, in fair round belly with good capon lined," all the way to "second childishness and mere oblivion." Perhaps Shakespeare's character "Melancholy Jaques," in the play *As You Like It*, is suggesting in these verses that beneath our social roles there is nothing—that time and nature make us infinitely malleable, infinitely shaped to collective will. We play the roles we are expected to play, reinforced by the assumptions of our fellows. Since Shakespeare wrote, additional roles have been highlighted in the theater of human experience: most notably, the roles of class, race, and gender, which confine us even more. These roles overlap in a Venn diagram of identity so that we can seem to be "intersectionally"

12. Morimura, *Daughter of Art History*, 226.
13. Shakespeare, *As You Like It*, Act II, Scene VII.

condemned from the time we are born.[14] And paradoxically, despite our helplessness to define ourselves, we *still do* exert formative power over our human brothers and sisters, pressing them, too, into the roles they were bound to play. We are at once tormenting and being tormented forever.

This sounds like a ring of Dante's hell, but it is not the result of sin; and it is not, of course, *hell* at all—only life. Perhaps the fact that we possess the self-awareness to mourn this condition is a hopeful one: how can we mourn the loss of something illusory—of something we've never tasted or known? Why lament that we are merely "players" of various "roles," if such conditions are inevitable and natural? Doesn't our melancholy (like Jaques's) suggest that we know better: that we know, deep down, that we possess stable selves that are loved and lovable—that can be seen properly with the eyes of love? In 1 Corinthians 13:12, after all, the apostle Paul stated that "now we see as through a glass darkly, but then we shall see face to face." And what is this face-to-faceness if not proper recognition on both sides—recognition of *selves* that transcend utilitarian categories? "Then I shall know fully," Paul went on, "even as I am fully known." Of course Paul's "then" is maddeningly eschatological, after and outside the current order, "when the times reach their fulfillment." But it is something to hope for, as we cling to the dearest secrets of our innermost selves. For now, however, we see "only in part," always underestimating and suffering insult. If only our humility were commensurate with our ignorance.[15]

Shakespeare wrote before anyone knew of the Spectacle—and before an age of genuine mass media. (Though arguably the age of mass media was born with the print culture of the Protestant Reformation.)[16] Visual artists just after Shakespeare's time showed a similar prescience, resistance, and melancholy. And they often did this, remarkably, through the metaphorical use of theater.

Consider, for example, the sad Pierrot—inspired by the Italian *commedia dell'arte*. Pierrot is painfully self-aware of his indignity and mourns it, even as he "struts and frets" in ruffled collars and checkered suits. Jean-Antoine Watteau's oil painting *Pierrot* of 1719 is especially poignant. Here a

14. The term "intersectionality," which attempts to capture the tapestry of social consequences that arise from the overlap of an individual's demographic "identities" (e.g., race, gender, sexuality) was coined by legal scholar Kimberlé Crenshaw in 1989 at a meeting of the University of Chicago Legal Forum and is now commonly used across many academic and popular discourses. Crenshaw herself was interested in the circumstances of African-American women, whose circumstances as "black" overlapped with their circumstances as "female" in ways that had not been anticipated by policy-makers.

15. Ephesians 1:10.

16. See, for example, Pettegree, *Brand Luther*.

mournful youth with heavily lidded and almost puffy eyes stands isolated on a tussock of grass as if on a stage or pedestal. Beneath him, leering, is an audience (incidentally also *commedia dell'arte* characters), at once amused by and indifferent to his pain. According to *commedia dell'arte* convention, Pierrot will always be sad, as his character is by definition a melancholy one (like Shakespeare's Jaques). There is no escape. Bound to perform sadness, he is destined to become sadder still, trapped in the role that defines him forever.

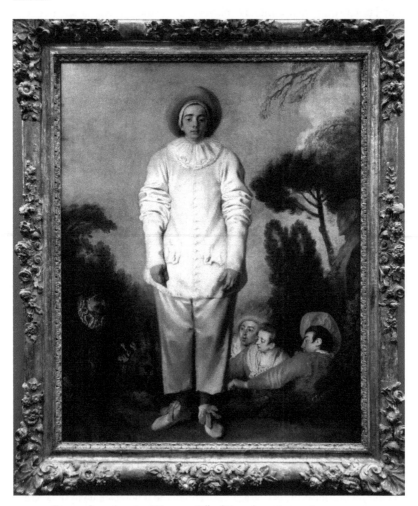

Fig. 4.5. Jean-Antoine Watteau, *Gilles (Pierrot)*, 1718–19, 185 x 150 cm.
Photo courtesy of Sailko and the Musée du Louvre, Paris.

The *commedia dell'arte* theater form, consisting of seven main, archetypal characters whose immutable attributes, and the consequences thereof, were explored in thousands of theatrical scenarios across centuries in Europe, probably had distant roots in the mask culture of Venice, Italy. The Venetian *Carnevale* was, legendarily, a time when anyone could don a mask and escape into a role other than their own—at least for one night. What is lesser known is a mask tradition that extended before and beyond *Carnevale*, in which nobility were required to wear masks when conversing with foreigners.[17] Under this regime, the mask erased individual identity (guarding privacy) while preserving class identity, making fusion with one's "stereotypical" role complete. Thus while the mask in the *Carnevale* context could seem to bring freedom, it did so at a cost. It affirmed that the individual is always lost in a role, whether a role assigned by birth or a role assumed in opposition (in the deliberate topsy-turvydom of Carnival time).

Jean-Antonie Watteau, a sickly man of precarious finances and low origins, was obsessed with the ironic clowns of the *commedia dell'arte*. In his signature, elegiac style, he captured these sad characters again and again; sometimes they are oblivious to their indignity, and sometimes they are heartbreakingly sorrowful. They seem at once degraded by, and accepting of, their "roles." Watteau implicitly understood the connection between the theatrical role and the social role, thus his society paintings and his *commedia dell'arte* works are connected. In *L'Indifferent*, for example, a youthful nobleman frankly offers himself up as a theatrical figure, posed and self-conscious like an actor. He even spreads his arms as if to show off his opulent "costume." In works like *The Pilgrimage to Cythera* and *The Scale of Love*, lovers pantomime affection in a language of theatrical, utterly studied erotic performance, affecting "sincerity" but never capturing it. Watteau understood that the aristocratic performance of beauty, effortlessness, and bliss was just that—a performance—meant to cement the status of a precarious ruling class that was destined to fall. The tight, shimmering clothes and powdered wigs of the elite, which look so fussy and artificial today, were desperate attempts to signal a divine right and worthiness that had become harder and harder to believe. (Later, the incongruity between the portraitist Goya's dull royals and their opulent trappings would heighten this tension.)

17. This tradition is recounted by Ada Palmer, professor of History at the University of Chicago, on her blog *Ex Urbe* at https://www.exurbe.com/venice-ii-mask-culture.

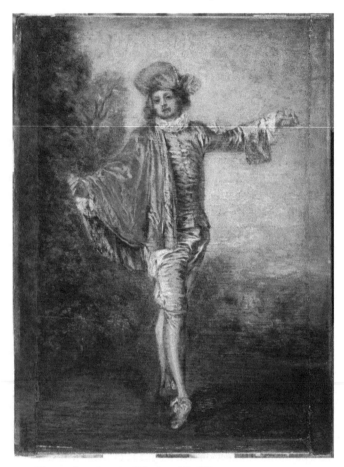

Fig. 4.6. Jean-Antoine Watteau, *L'Indifférent*, 1717, 26 x 19 cm.
Photo courtesy of the Musée du Louvre, Paris
and RMN-Grand Palais/Art Resource, New York.

In his Rose period, Pablo Picasso made further use of this theatrical tradition. His *commedia dell'arte* figures are uniformly mournful and stoic, always self-aware and painfully accepting—even the children. In his *Family of Saltimbanques* from 1905, for example, a mother, father and four children, all angelically beautiful, gaze out mournfully from their comedic costumes, their true identities lost within the roles they must forever play. ("Saltimbanques" were traveling performers, something like today's "carneys" or "circus freaks.") By giving these humble figures such dignity, Picasso encourages us to identify with them. We feel that the saltimbanques are all of us, so that no demographic is safe from the degrading necessity of "performance." The children are the most tragic, as we see them forced into

a role from the very beginning, dutifully acting out parts with which they feel no sympathy and prohibited from discovering who they really are. They are beautiful, blasted-out shells from the very first. This core insight would be brought to an almost macabre head in later works by Picasso like *The Three Musicians*, in which personhood is lost altogether and the symbols of "role" overtake everything. In *The Three Musicians*, a monk, Pierrot, and Harlequin flatten and dissolve into interlocking geometric shapes, becoming soulless and phantom-like. They look outward with empty eyes, playing the same predictable, theatrical music forever.

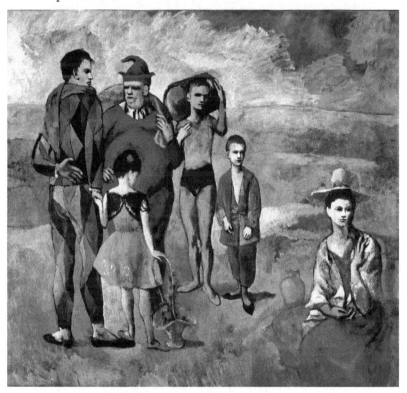

Fig. 4.7. Pablo Picasso, *Family of Saltimbanques*, 1905, 213 x 130 cm.
Photo courtesy the National Gallery of Art, Washington, DC,
ARS NY/ Picasso Estate and Album/Art Resource, New York.

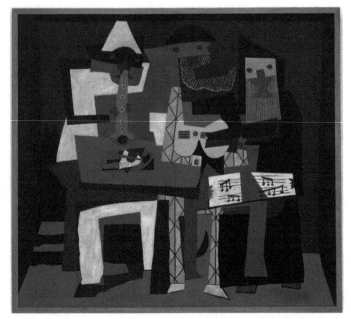

Fig. 4.8. Pablo Picasso, *Three Musicians*, 1921, 200 x 223 cm.
Photo courtesy of the Museum of Modern Art, New York,
ARS NY/ Picasso Estate and Scala/Art Resource, New York.

In his development of Synthetic Cubism (shown off in works like *The Three Musicians*), Picasso applied the notion of identity-as-theater to everything. Everything had become a collage of theatrical signals, with all sense of true substance and personhood having been lost. His *Portrait of a Young Girl* from 1914, for example, is a faceless, pear-shaped agglomeration of pastels, calico prints, and floral motifs; for Picasso, not even the most innocent were exempt from the crushing necessity of role-play. Later that same year the American synthetic cubist Marsden Hartley, inspired by Picasso, painted his haunting *Portrait of a German Officer*. Here, a young soldier (a real-life casualty of war, Karl von Freyburg) is completely lost beneath an encrustation of regalia and patriotic symbols. His unique personhood has been obscured by, and ultimately sacrificed to, a nationalist cause.

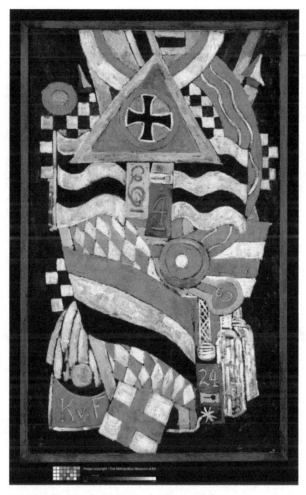

Fig. 4.9. Marsden Hartley, *Portrait of a German Officer*, 1914, 173 x 105 cm.
Photo courtesy of the Metropolitan Museum of Art, New York,
and Art Resource, New York.

While Picasso developed Synthetic Cubism in France, the Expressionists in Germany used similar methods to represent the suffocating expectations of modern life, and to similar ends. They portrayed the people of urban, twentieth-century Europe as thralls to dehumanizing social roles. The leader of the *Der Brücke* collective, Ernst Ludwig Kirchner, painted city scenes wherein well-dressed passers-by seem to wear ashen or sickly carnival masks—or maybe their faces have become mask-like in a rictus of social decay. Kirschner's friend Erich Heckel did the same, often focusing on the mask-like expressions of young girls who had been eroticized and exploited.

Both artists seemed to suggest that everyone is always playing a role, no matter how banal their activities and no matter how personally insignificant they might be. Everyone is a degraded cog in the social machine.

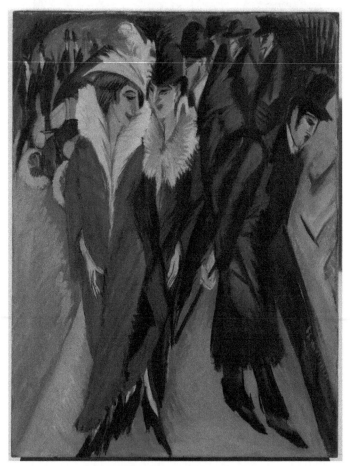

Fig. 4.10. Ernst Ludwig Kirchner, *Street, Berlin*, 1913, 121 x 91 cm.
Photo courtesy of the Museum of Modern Art, New York,
and Scala/Art Resource, New York.

ABSORPTION AND THEATRICALITY

In 1981, the art critic Michael Fried (who, as we saw in the second chapter of this book, distinguished "Art" from "Objecthood") wrote a tome called *Absorption and Theatricality: Painting and Beholder in the Age of Diderot*. This was a remarkable shift; suddenly, Fried was tackling content from almost three centuries before the modernist, Minimalist art upon which he had

cut his teeth. But Fried had noticed something intriguing—he had realized that the self-conscious theatricality of Watteau's clowns and frivolous nobles pointed toward the Minimalist objects he disdained, insofar as they radiated servitude to the viewer. Like Tony Smith's black cube, which had no mysterious inner content rewarding of contemplation, the "theatrical art" of the very early modern period (the eighteenth century) obscured inner content beneath shallow, "button pushing" melodrama.

Watteau, whose works were poignant and deeply conflicted, was not the villain in Fried's story. He was only exposing what others blindly took for granted. His figures were playing roles, yes, but they were self-aware and mournful, seeming to guard wounded inner lives. No, the real villains were painters like Jean-Baptiste Greuze, whose soap-operatic pictures were the epitome of unearned emotional manipulation. In paintings like *The Father's Curse of the Ungrateful Son*, every single character gesticulates hysterically. Hands are clasped, eyes bulge, lips sneer. Every detail is brought in service to the tragic, dramatic effect so that the figures read like the hollow theater masks of the classical stage. They are frozen icons of emotion (like revolutionary-era emojis) rather than true humans experiencing pain. In other words, in Greuze's work, there was no *there* there. Nothing to contemplate behind the sensory signals. Greuze's work was not really "art."

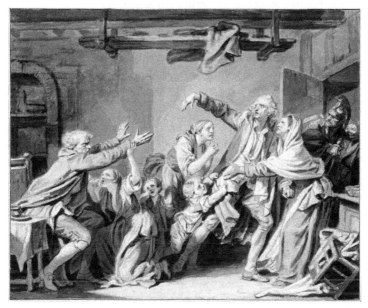

Fig. 4.11. Jean-Baptiste Greuze, *The Father's Curse of the Ungrateful Son*, 1777 (preparatory sketch of the large painting now in the Louvre).
Photo courtesy of the Albertina Museum, Vienna, and Google Cultural Institute.

The word Fried chose to describe fleeting emotional provocations like Greuze's was "theatricality," by which he meant a kind of degraded, insincere performativity. And it is notable that Fried metaphorically invoked a different art form—an embodied, *personal* art form (theater)—to capture this phenomenon in painting. He could not avoid the sense (as I have been arguing) that visual artworks are proxy *persons* governed by rather human ethical laws. Our interactions with visual artworks are healthy insofar as they mimic healthy *human* reactions, fostering a gaze that is respectful and contemplative, but they are unhealthy when they radiate degradation or disrespect. Fried instinctively knew that the artwork must capture otherness like a human radiates otherness—in sovereign, mysterious separateness and dignity.

Fried did not mean, I think, to lambast all *theater*, per se, as bad and melodramatic. Rather, he was thinking about ordinary human interactions and the casts they can take. For individuals to behave "theatrically" in real life, for example, is not desirable. It can seem manipulative, false, undignified, and insincere. Think of the fawning salesperson, the over-promising politician, or the con artist with his sob story. (Even stage acting itself is best when it is most deeply felt and most derived from authentic life experience.) We recoil from false, "theatrical" presentations and we cannot help but think that the "actors" are degrading themselves.

Far better, Fried thought, was the opposite quality of "absorption," where an individual seems humbly obedient to an inner conscience (we might think of Kierkegaard's "religious stage" here). In "absorbed" artworks, the figures do not gesture wildly, as if pleading for a reaction. Instead they maintain a quiet integrity in every situation. For Fried, Watteau's pictures of solitary children (blowing bubbles, playing with cards, sitting in the grass) best captured the quality of "absorption." Perhaps for Watteau, childhood with its innocent explorations was the only time one could be largely free of stifling social roles. And the tension around "role" would only increase as modernity progressed (as we have seen). Watteau lived at the conception-moment of our current mass culture, wherein "role" threatens to penetrate every second and every inch of our lives.

COSTUME AND SKIN

In my last chapter, I suggested that premodern lifeways (rigorously hierarchical, free of mass media) in some ways preserved the individual's inner life better than does our own, flattened and connected world. A comparison of Watteau's *Pierrot* with ORLAN's practice of body sculpture makes this clear.

Wherever he could, Jean-Antoine Watteau took pains to disconnect his mournful actor from the socially mandated costume he wore. The shoulders of Pierrot's blouse are too broad, for example, and the bunched-up sleeves are too long. The gaping pants are both too wide and too short. Finally, the actor's slack face is deliberately non-theatrical and inward-looking, as if he refuses to fully inhabit his part. He holds onto something secret of himself, despite his audience's expectations. (Only his ass, that servile beast, looks outward to gauge audience reaction.)

ORLAN, however, has striven to erase any distinction between social "uniform" and inner self—in fact, she seems to revel in their inseparability. What results is a declaration that the "inner self," or the intrinsic self, no longer matters. As we have seen, ORLAN declared her struggle to be against "the innate, the inexorable, the programmed, Nature, DNA. . .and God!" One the one hand, ORLAN's crusade against natural and biological necessity might seem like a quest for deep freedom. But the reality is more sinister. By remaking herself according to the ideals of artists like Boucher, Botticelli and da Vinci, she has suggested that her very self is best expressed in someone else's terms. In the name of freedom, she has become a slave to an ancient Spectacle of vast proportions and timeless reach.

Other contemporary artists—and particularly contemporary artists of color—have been less eager to escape into the Spectacle's transformative power. They are the heirs of Watteau, demonstrating to a new age how the social "costume" dishonors the real person underneath. For these artists, there is no question of adaption to social desire; that seemed impossible all along. Instead, there can be only protest.

In 1994, for example, the African-American artist Renee Cox defiantly donned a strange new sort of costume. In a portrait made in collaboration with the photographer Lyle Ashton Harris, she satirized (and reclaimed) popular stereotypes about black women's sexuality by posing as "the Hottentot Venus." Over 100 years earlier, the South African woman Saartje Baartman (the so-called "Hottentot Venus" of the work's title) had been kidnapped by European showmen who, fascinated by her sensual physiognomy, paraded her naked around Europe as a specimen of African eroticism. In her performance-cum-tribute to Baartman, Cox strapped huge, gleaming golden breasts and buttocks to her own form, evoking Baartman's supposedly outlandish physiognomy. Meanwhile Cox herself faced outward, defiantly wearing a modern hairstyle and cosmetics. Like Opie and Wojnarowicz, Cox and Harris showed how stereotypes are forced onto literal bodies. But at the same time, they highlighted the absurdity and anachronism of such stereotypes, rooted as they often are in sensationalism, money-grubbing or the justification of conquest. Through the contrast of

shining prosthetics with soft skin, the artists also highlighted how Cox herself was separate from the stereotype literally imposed upon her. They made the absurdity of the Spectacle clear to see.

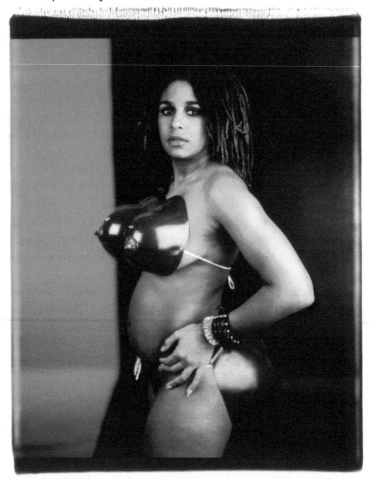

Fig. 4.12. Lyle Ashton Harris, *Venus Hottentot 2000*, 1994.
Photo courtesy of the artist and Salon 94, New York.

In 1980, the African-American artist Kerry James Marshall, a consummate painter, offered up a different kind of self-portrait. In a small, haunting canvas called *A Portrait of the Artist as a Shadow of His Former Self*, Marshall depicted a coal-black face, flat, featureless and dimensionless, gazing out from a dark gray background. The only features clearly visible are the glaring whites of his eyes and his smiling, gapped teeth. Marshall's picture-self is dressed in an inky black hat and coat that heighten the shadowy *mien*. This is a human

being reduced to *nothing but* his color—which has made him, quite literally, a shadow: a flat silhouette, a wan echo, of the real human being he once was. Marshall's use of blackness here, both as a color and a concept, is clever and incisive. Perhaps African-Americans living in a white world have been doomed to second-class status due to the unfortunate connotations ("shadowiness" being one of them) that are associated with the archetypal black/white dyad in the Western world (one thinks of day and night, "black hats and white hats," or frightening dark forests and bright, open meadows).[18] Needless to say, Marshall's "self-portrait" bears no resemblance to his actual, physical self. What is important in our age of chatter, he sadly affirms, is not so much granular accuracy but the ability to categorize quickly.

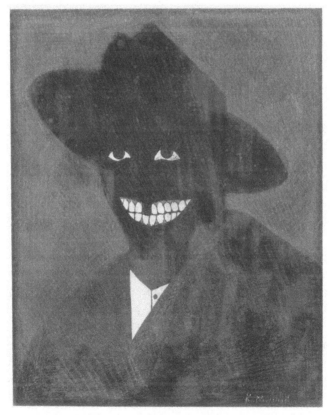

Fig. 4.13. Kerry James Marshall, *A Portrait of the Artist as a Shadow of His Former Self,* 1980, 20 x 17 cm, copyright Kerry James Marshall. Photo courtesy of the artist and Jack Shainman Gallery, New York.

18. For an examination of how color associations may impact our reception of both figural imaging and real-life bodies see, for example, Boime, *The Art of Exclusion.*

The feminist artist Andrea Fraser has also (controversially) walked the line between role as costume and role as identity. She has done this by graphically enacting the kinds of real-life transactions that, for all practical purposes, ontologically reduce an individual to a role. Her subject, in a notorious, untitled video of 2003, was artmaking itself. Here, Fraser showed that in a *milieu* where artists' tools have become *themselves*, the artist has become a commodity to be traded—her private pain and love and weakness transmuting into consumables to buy and sell. Thus Fraser's video is a "high art" version of a lurid sex tape, where Fraser is seen *in coitus* with a paying "collector." The implications are clear: art itself has become a form of prostitution, wherein a supposed "inner self," a legible intimacy, is packaged and offered up to the highest bidder. The very condition of "being an artist" is its own kind of social role, one that demands the ever-more-aggressive presentation of borderless vulnerability—of self transformed into product, right down to the core.

PROPHETS

Before Catherine Opie cut her back, and before Andrea Fraser used prostitution as a rhetorical weapon, there was the biblical prophet Ezekiel. Over a course of years, Ezekiel staged public "performances" in Babylon; his actions symbolically accused both the craven Judahite royalty and their Babylonian conquerors. In one "performance," he lay on his side for an entire year. In another, he cut and burned his own hair. Ezekiel was not the only Old Testament prophet to use theater to symbolically communicate. The prophet Jeremiah wore a wooden yoke meant for oxen (this was to portend Israel's eventual captivity), and the prophet Isaiah apparently went around naked for three years, foreshadowing Egypt's eventual degradation and punishment. A twentieth-century analog to these performances might be the work of Tehching Hsieh. Hsieh is known for endurance art that raises awareness of social ills: in one performance, for example, he lived as a homeless man for an entire year. In another performance, he spent a year locked in a cage. Of course Hsieh never claimed to be directed by God, and his actions were never meant to predict the future. But like Ezekiel, Jeremiah, and Isaiah, he strove to expose the inevitable effects of evil, and he did not speak for himself personally, but rather on behalf of whole communities

However, the Bible's prophetic "performances" were not always of the official, oracular kind. A closer scriptural analogy for today's "Theater of the Self," I submit, is the intervention of Tamar in the book of Genesis, chapter 38. In this tawdry episode so shocking to modern minds, Tamar poses as

a prostitute and seduces her father-in-law Judah. Later, when she becomes pregnant, she is condemned to death for adultery by Judah himself; only after she proves that Judah is her child's father is she freed. In the biblical account, Tamar's action is justified because Judah had been obligated to marry Tamar to his son, yet he refused, leaving her dispossessed and destitute. Her targeted prostitution was thus a prophetic reminder of Judah's treachery and a concrete attempt to make things right. In "artistic" terms, Tamar's action against Judah here could also be considered *performance*: when she masqueraded as a prostitute, she acted out a carefully chosen role, and when she later brandished Judah's staff to prove that he fathered her child (one imagines to startled gasps), she prophetically announced God's judgment. Meanwhile, *in her body*, Tamar dramatically showed the consequences of social corruption. Judah's reply says it all: "she is more righteous than I."[19] Thus Andrea Fraser could (if she wished) point to biblical precedent for her action of prostitution-as-revelatory-performance.

These prophetic performances, however, are not exactly like the kind of *Anno Domini* "art" I've been trying to define and trace. They have no real "window sense"—they do not purport to issue onto the transcendent. They are a category of thing that is more pedagogical, more metaphorical, and also more ancient than the "Christian" artwork in its post-Incarnation fullness. They could coexist with the localized idol-deity and perform a function separate from it. Despite their unfurling through the medium of a human body, these prophetic acts were warnings, proofs, and demonstrations rather than *presences*.

PRIESTS

The category of "priest," however, was always more classically "artistic," and *Anno Domini* artmaking seems almost like an extension of the mystery of the priesthood, in some ways. Priesthood, after all, is intrinsically creative and transformative on an ontological level. Albrecht Dürer knew this when he represented himself as Christ in his famous self-portrait. The priest does not effect justice or expose injustice (like the prophet), so much she proclaims *what things are* with the vicarious authority of a god. It is the priestly ministrations of contemporary performance artists that most reveal the character of our time and the spiritual-conceptual paradigms to which we are returning. This rebirth of the magical, all-transforming priest was, I believe, inevitable with the coming of the Spectacle.

19. Genesis 38:26.

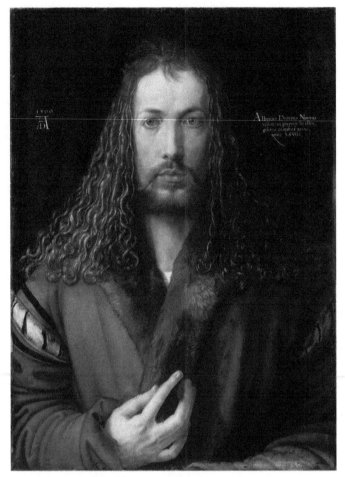

Fig. 4.14. Albrecht Dürer, *Self-portrait*, 1500, 67 x 49 cm.
Photo courtesy of the Alte Pinakothek, Munich and Wikimedia Commons.

In many world traditions, the priest is empowered to summon and embody the gods with their creative powers, enacting the true naming, the true *declaring*, that the Shinarites sought through the tower of Babel (see my chapter "Biblical Otherness"). In the ceremonial cultures of indigenous America and Africa, for example, celebrants don masks and perform dances and rituals; when they are in this state, they are considered to be identical with the gods themselves, able to effect ontological fixing. Meanwhile in India there have emerged gurus called "godmen," who have supposedly cultivated such personal holiness that they can perform transformative miracles at will. Roman Catholic priests enjoy a more moderate role; they bear the title "father," and are meant to demonstrate god's "fatherhood" to

the Christian flock through a sort of ontological resonance, but they are also understood to be flawed and human. Nevertheless, when properly vested in liturgical garments, they can wield godlike, transformative powers, especially in their performance of the Eucharistic consecration, when grain is turned into the literal flesh of Christ. Due to the complexity of his role, the priest has traditionally been two things at once: he has been an object of contemplation (like the artwork), but he has also (and maybe primarily) been a finger of God, able to exalt and transform. In the priest, something like the boundary-blurring of ORLAN (where social self equals actual self) takes place, but only in certain moments of vicarious grace. At special times, the god descends to envelop both role and soul into a single vector of power that stems from the dynamism at the origin of all life.

In contrast to the Roman Catholic priesthood-tradition, which many Christians have believed susceptible to abuse, Protestant Christians developed the notion of a "priesthood of all believers," and it is this Protestant concept of priesthood, among all rivals, that most pervades the modern worldview. (Indeed, it is arguable that the Protestant notion of priesthood is absolutely foundational to the entire individualistic, modernist enterprise, though secularists would be loath to admit it.) The application of this idea has proved intriguingly double-sided. Outwardly, through the discrediting of church ritual, it has had the effect of eliminating overt "magic" and mysticism from public practice, seemingly ushering in a new, secular, demythologized paradigm. But inwardly, it has empowered everyone to be a "magician." By abolishing the intermediary priestly class, Protestantism argued that every believer could directly negotiate her own salvation (i.e., secure her own ontological status). This was indeed a type of profound transformative (priestly) power, and it was now available to everyone, even if it applied only to the self. This would eventually have much broader implications.

Thus, soon, self-transformation expanded into world-transformation. There was no longer a sense that one must ask for permission—that ritual bowing to an "other" would be required before momentous steps. Phenomena like the Industrial Revolution, broad-scale modernist utopianism, and the rise of plastic surgery emerged. Each of these developments have, at heart, sought the ontological reshaping of things, whether nature, the community, or the self. Rationalist modernism has often been viewed as paradigmatically secular, but it is, in fact, an extension of deeply religious ideas. It creates meaning, it proclaims destiny, it passes judgment, it deals out life and death.

It is, of course, the pop-culture manifestations of this new priesthood that have most captured the popular imagination. Many celebrities, for example, have followed figures like ORLAN and Morimura in crafting new,

virtual lives that replace their old ones in authority and importance. In her ability to self-transform, Kim Kardashian is a highly successful priestess. We know she dons an opulent mantle (not of brocade, but of Instagram filters, contouring make-up and corsets), and we thrill at the magical transmutation. Her husband Kanye West, in this her perfect match, has avidly and frankly pursued the role of priest. (He has appeared on album covers and in videos in Pharaonic, god-king regalia and in the guise of the crucified Christ, at once enacting and symbolizing the transformative power he claims.) Beyoncé Knowles's recent pregnancy photos recalling fertility goddesses are comparably ambitious. On a more modest scale, digital citizens everywhere do something similar with online personas that seem at once intimate and highly engineered.

Thus, paradoxically, our privacy-violating, image-saturated, techno-secular environment elicits a return to pagan magic. The great historian-philosophers of early modernity could not agree if time was a line or a circle. Do we progress, or do we repeat the same mistakes over and over again? Christian history would seem to have a linear structure: the ancient world prepared the way for the Incarnation, and then Christ prepared the way for the "fulfillment of all things." But divergence from the "straight and narrow" path (whatever that is and wherever it may be found) is likely to bend into withering spirals, like eddies from a boat or curls of flame from a rocket. These are the spirals of a peripheral history (peripheral to salvation history) disconnected from the God-Man engine and thus forever self-collapsing.

Let us consider, once again, the work of Catherine Opie. Opie is not a shape-shifter like ORLAN, certainly, but we find on inspection that she taps into a similar, almost magical power. Her work is strangely double-faced. On one level, Opie physically manifests the effect of the Spectacle, exposing it as searingly destructive. We are almost moved to pity. But to understand Opie's work in only that dimension is to dwell too much on a kind of sentimental passivity and helplessness. As her other works show (such as the confrontational self-portrait *Pervert*), Opie does not passively receive. Rather, she co-opts and owns: this is, after all, *self*-scarification. It is self-sovereign in its exercise, and in its accusations it proclaims the soul-weighing power of a god. Opie is in one way a sacramental scapegoat, physically bearing the people's sin. But instead of retreating into the desert like the scapegoats of the Bible, she is lifted up. And she does not die. She transforms persecution into triumph.

Modern celebrity culture—from art stars, to movie stars, to beyond— showcases the paradox at the heart of the human condition. In the Christian paradigm, humanity is the chief means by which we understand the divine (Christ's Incarnation was the epitome of this fact), and so it is no surprise

that we turn our eyes with longing to priestly wielders of seemingly divine power. But humanity is also separate from the divine along multiple dimensions: we are small and weak compared to God, obviously, and we also share a positive *purpose* of utter separateness from the divine. Temporally and physically localized, we are *defined by,* even ennobled by, our distance from the divine substance. We are *intrinsically separate by design,* and this is our own special glory, for only in separateness can there be communion. This makes priestly, vicarious, evocative solutions of the type we find in modern celebrity-divinities ultimately unsatisfying. There is something claustrophobic, even grotesque, at work when the division between human and God collapses, when the transcendent is folded completely into the immanent, and when high expectations are placed on vessels that cannot bear them.

As the Christian picture—the artwork—affirms, humans, as "images of God," are *windows.* We are separate from God, and we face out upon him, while at the same time revealing his glory to others through our own blessed emptiness. So what happens when the separateness is denied—when the distance is erased? What happens when the transparent window becomes an opaque totem, a *localized* imprisonment of the meaning-giving substance of deity? Will we, erstwhile windows of light, burn up in the sun we aim to reveal? And will our spirits, deprived of an answering divine gaze (because we effectively stand in that gaze's place) wither and die?

HUMAN SACRIFICE

The victims of human sacrifice in the ancient world across all continents, from Central America to the Greek islands to the Asian steppes, have been, in a way, pagan priests, inasmuch as they assumed vicarious roles and performed transformative rituals. (In Aztec culture, for example, sacrificial victims were often treated as manifestations of the gods before their sacrifice, being given sacred raiment to wear, rich food to eat and even beautiful women to impregnate.) These were human beings imbued with mysterious power to effect a great purpose, often on behalf of whole societies. But their fate strikes us today with almost sickening horror. From whence does this horror come?

Certainly it is not a horror to "lay down one's life" for the good. Few people would argue this—and today every global culture still lauds heroes who have paid the ultimate sacrifice for their fellows.[20] There is real admira-

20. Intriguingly, the theologian Richard B. Steele notes a propensity among today's younger college students to disapprove of self-sacrifice, especially when it leads to death. He links this tendency to the rise of violence-as-spectacle, particularly in the

tion and gratitude, not just fearful denial or "survivors' guilt," at work in these celebrations. From whence, then, the horror—the horror of the Viking sacrifice of warriors or the Celtic sacrifice of kings? It comes, I think, from the ontological diminishing implied—the ghoulish denial of personhood that assumes the power of a dark hex. It comes from an erasure, like the *damnatio memoriae*, that obliterates soul as well as body. For soul and body are no longer distinct.

First, there is the sense that the victim, in the end, is so identical with the sacrificial act that he becomes the weapon instead of the wielder. For "human sacrifice," ritually speaking, is a type of re-localization, a vacuuming-up of transcendent essence into a single, physical vessel to be obliterated on dual planes. It aims to placate the gods by doing something proportionally godlike: snuffing a divine spark that is extinguishable precisely (and only) because it can be captured and circumscribed. This, perhaps, is why child sacrifice (an event to which the child cannot consent, and one that forecloses on any development of a unique life narrative) has been viewed as especially abhorrent and effective, all at once; it seems to negate transcendent personhood to the utmost degree, assuming the glamor of real spiritual destruction. The war hero, the slain aid worker, the mother who dies in childbirth: all of these people are celebrated because personal dispositions of generosity and integrity culminated in final, gracious acts—acts that do not obscure the lives lived before them, but rather function as culminations. (Thus we speak of the "crown" of martyrdom—an ornament for the holy. This is humanity extended rather than humanity denied.) The child has had no such life to outshine the final ritual, and thus can be subject to perfect and total destruction.

From this point of view, human sacrifice seems like a potent foreshadowing of a Hell with a different character—not Dante's, but the evangelist Matthew's—the place where soul as well as body is destroyed ("be afraid of the one who can destroy both soul and body in hell," Jesus said).[21] That's not to say the misbegotten rituals of the past were sufficient to send their victims to the *real* flames of Hell (in the Christian system, no human has that power), but they have shown the meaning of Hell in a way we can grasp with our earthly imaginations. For Hell might be understood as the space where *axis* is impossible. There is no room for the separation necessary to share in God's gaze forever; there is only the suffering of stubborn out-of-placeness—of the human soul unable to swivel and resume the dance. The

context of mass shootings. See Steele, "Violence as Spectacle, Sacrifice as Icon."

21. Matthew 10:28.

sacrifice is bound, confined, utterly consumed, becoming identical with the greater force that swallows it.

In the introduction to this book, I suggested that the Christian worldview ushered in two new, mutually dependent ideas about the human–divine relationship. The first is that humans are meant to enjoy *personal relationship* with the divine; the second is that humans must *maintain distance* from the divine across an axis that I have likened to the mirroring *gaze*. I even went so far as to suggest that Christ's death and ascension were together a way of maintaining this tantalizing distance, so that we always strain and yearn, never identifying too much or getting too close. (Such distance, while sometimes exquisitely maddening, precludes our assimilation of God into our zones of subjectivity.) The Christian artwork, as I have called it, was an embodied symbol of this axis-relationship. In its earliest form, the icon, it hung separately from the viewer while *looking back*. Meanwhile, it avoided any pretense to localization—that is, it never made its subject fully, completely available, but always just out of reach, in a space of its own. It thus created a window-space *through which*, and *across which*, the viewer had to look in order to encounter one who was perpetually *other*. Christian art was a tool for maintaining *axis* in spirit and imagination.

One way to understand human sacrifice, then, is as a symptom of axis-space collapse, when the proper places of the divine and human, across the space of the gaze, are no longer maintained. From the sacrificial victim's point of view, this collapse amounts to destruction and "reabsorption" into the god-essence. From the divine point of view, this is cause for mourning, for it means the losing of desired communion (when he beheld Lazarus's destruction, "Jesus wept").[22] And from the human community's point of view, looking upon (say) the failed Celtic priest-king who had stood in the god's place, this is terror followed by frantic cleansing. The failure of the vicar to hold divine power incites a spiritual panic that must be neutralized. Thus for the early Celts, sacrificing a disgraced monarch was a matter of community survival, like disabling an unstable nuclear reactor. The king could no longer hold the power bestowed to him, and, so another would have to take his place.

Today we trivialize the priestly move—the collapse of god-power with human form—and hold it at an aesthetic distance. We imagine our indulgences in celebrity worship are cathartic exercises detached from real life. But will our impulses toward worship allow this trivialization for much longer? Some of the brutality we now see in digital spaces (twitter mobs, internet death threats, etc.) are symptoms of furious soul-disappointment—of

22. John 11:35.

a desperate soul-movement that invests scapegoats with superhuman power precisely *so that they can be sacrificed* on the altar of our wordless rage. Recall Tolstoy's account of the destruction of Vereshschagin. Do we see similar things, on smaller scales, in our everyday lives? Do we sometimes luxuriate in the satisfying destruction of righteous blame?

THE PLACE OF SEPARATENESS AND THE PROCESS OF FORMATION

The Society of the Spectacle, by encouraging both godlike arrogation and the weaponization of self (for one meaning of "god" is "person and act all at once"), threatens to turn everyone into a pagan human sacrifice. This, I think is what Jesus wished to avoid when he was tempted for forty days in the desert. According to the story in Matthew 4, Jesus retreated to the desert to fast and pray after his baptism. At length, he became hungry and the devil advised to him, "tell these stones to become bread." Jesus refused. Of course there is a sense here in which Satan encouraged Jesus, like Kierkegaard's "Aesthete," to regard the outside world as a mere occasion for the satiation of desire, as if he could make everything his food. This Jesus would not accept. But second and more subtly, Satan encouraged Jesus to deny his very *self* by stepping into God's dynamic place (as source, as gaze, as flame-life) and seizing an undestined role.

The temptation in the desert shows how the denial of life process and the seizure of god-role become one. To seize is to step outside the flow of life. It is to deny the events that shape authentic, *specifically human* identity (in Jesus's case, the ordained forty days of hunger) in order to forge a new, self-created destiny. With his second temptation, Satan told Jesus to "throw [him]self down from the highest point of the temple" and then summon angels to catch him. This, too, would avoid the slow, painful grind of God's evolutionary plan and achieve instant results; such a creation of *spectacle* would forestall years of ridicule and persecution, and probably the Crucifixion itself. But it would also (and devastatingly) displace Jesus from the gaze-axis—from his special position opposite the Parent-God in the community of reciprocity. As a result, Jesus would be enmeshed directly, destructively, incestuously, in flames meant only to illuminate, but now forced sadly to devour. Jesus was never supposed to declare his destiny on his own.

With his final temptation Satan made one thing plain: that to seize an identity that has not yet been earned, as Adam and Eve had done, was the same as bowing down to evil. ("Bow down to me and I will give you the whole world," Satan said.) By this means we step from our axis-place. We

abandon our ontology in favor of a single act with a limited, transient result. We divert our eternal selfness into the power of a single, utilitarian thrust, and by this means, we become arrows against our maker, who smarts at our abandonment. (Isn't this what Satan wished to make of Job?) The lesson of Matthew 4 is that we attain real life—heavenly life—through endurance, acceptance, and *waiting*, not through seizure and demand. Yet the glamorous weaponry of the Spectacle is dangled before us always, everywhere, coaxing us toward self-immolation in the attainment of fleeting glory.

EVERYTHINGNESS

A central truth shown by Jesus's birth, death, crucifixion, and resurrection is that true personhood does, and must, transcend social role. This is one meaning behind the many paradoxes Jesus embodied. He was a king who humbly served (washed feet). Therefore he was more than a king. He was a human sacrifice (a scapegoat) who came back to life—thus he was not *just* a sacrifice. He was a perfect rabbi who broke the Law –so he was not *just* a rabbi. Therefore he modeled a kind of personhood—a fulfilled humanity—that functioned as an "image of God" in its inability to be contained by any singular function. This was a meaning of freedom deeper than the mere freedom to act according to momentary preference. This was a complete ontological freedom to somehow *be everything*. Only Jesus was capable of becoming a literal human sacrifice and yet remain *human*. For the rest of us, that load is too heavy to bear. ("It is mine to avenge," God said. "I will repay."[23])

To somehow *be everything*. Such an idea seems ridiculous. (Yasumasa Morimura pretends, perhaps, to "be everything" in his own way, but his ontological tourism is knowingly shallow, temporary and sequential, like the transformations of a paper doll rather than a dwelling in a single, multifaceted Life.) In fact, to *be everything* today would seem almost to be *nothing*, for then one would have no obvious social role to play. Such a one would have no obvious niche in which to belong and become intelligible within a Spectacle that labels and gloriously objectifies.

Yet the Christian paradigm bids us to be "everythings." Consider: in the Gospel of John, the evangelist declares that "God is love."[24] Similarly, the Bible asserts that God "is over all and through all and in all," and, furthermore, that God "sees everything."[25] These concepts are neither unre-

23. Romans 12:19.
24. 1 John 4:8.
25. Ephesians 4:6; Proverbs 5:21.

lated, nor do they dissolve into an undifferentiated pantheistic mist. God is separate from his creation, but because he loves his creation he is one with it; true love, after all, is neither more nor less than perfect knowledge and perfect acceptance that leads to perfect co-suffering. Love is an ability to co-vibrate with every strike, every caress, like an exquisitely sensitive bell. We are bid to love perfectly also, and thus also resonate in sympathy with every tone.

In the high middle ages, the philosopher Thomas Aquinas wrote of the phenomenon of "connaturality," which he believed lay at the heart of all knowledge and comprehension. Yet "connaturality" was no mere facility with concepts, like a logician grinding out proofs. It was actually *co-suffering* with the object of one's knowledge, because through participation (true gazing) comes true understanding. The inner nature of the Trinity reflects just this kind of "connatural" relationship. Because God is love, God loves each part of his triune self fully, and in loving fully, he sees fully. And in seeing fully, God participates (vibrates) fully. Thus God's three parts are joined point for point, warp and weft, intimately and expansively, forever, in a total fullness of intimacy. It was this intimacy to which the apostle Paul aspired when he wrote, "then I shall know fully, even as I am [now] fully known."[26]

In an earlier chapter, I suggested that the individual's boundaries are defined by the *service* she offers in the drama of history. We are time-rooted creatures, destined to unfurl through time and to effect different facets of God's redemptive movement. When we unfurl in truth, we achieve our palm of glory (the palm of our own kind of martyrdom), but our journey doesn't end there. Also, thereby, we acquire the right to become *whole*— whole and full persons, emanating God's love in the same way we receive God's love. When we have reached that point—the point when we have become fully *resonant,* we find ourselves loving of everything, empathizing with everything, and thus, in a way, participating with everything, just like Jesus the Ascended. Like him, we will then participate in God's everything-life forever, because we added our lives to his through our obedience.

Perhaps, in the whole scheme of things, the lineaments of our providential, time-bound, earthly lives are unimportant. (They are exquisite in their precious, intricate, smallness, but they are not limiting of the boundaries of eternal life. They are badges or ornaments.) Meanwhile, it should go without saying that our true, providential roles are utterly distinct from our momentary social ones, as perceived through the Spectacle's eyes. This fact is placed in starkest relief by the notorious role-dissonance of Christ, whose social role was almost peerlessly ignominious in the end, but whose

26. 1 Corinthians 13:12.

5

Glory
(Lover, Scapegoat, King)

There is one thing I fundamentally believe: that humans need glory. And that glory is the answering gaze of God. It is something like the beatific vision of Thomas Aquinas—but maybe Thomas did not (until the end of his life) fully appreciate the vector of God looking back. "Everything I have written seems like so much straw compared to what . . .has been revealed to me," Thomas allegedly said in 1273, three months before he died.[1] I imagine that Thomas, having spent a lifetime mapping God's glory in his role as a philosopher-knower—as a human *subject* gazing across the human–divine axis—suddenly grasped what it meant for God to *return the gaze* with a love that bespoke the internal energies of the Trinity. The result was an intimation of glory far greater than any Thomas had imagined, for it was a glory that imparted glory in turn, creating a charge of participatory ecstasy. It was like melody turned into air-permeating symphony, or like diagrammatic black-and-white turned to immersive polychrome.

As human beings, our fundamental longing, beneath all others, is to look upon God and be looked at in return, in mutual recognition. This is what Hans Urs von Balthasar, and even Jacques Lacan, intimate, and this is what results when we obey what Jesus called the "greatest commandment": to "love the Lord your God with all your heart and all your mind and all

1. This widely available quote appears, for example, in Fr. Alban Butler's *Lives of the Saints*, in the entry for January 28 (the feast day of St. Thomas). Butler's *Lives* has gone through numerous editions since its first publication in London in 1756–59.

providential role was peerlessly exalted. Sometimes soc
dential role can overlap, to be sure (Christ said, "the kin,
your midst"[27]), but they don't always. Perhaps they *usual.*
tacle does not understand destiny; it understands only in
the judgment of mobs. Thus, when the Spectacle define
kills.

So we return to the paradigm of the Christian pictur
gestural, the early Christian picture made no claim to cap
hood of its referent. It took a "social identity," broadly unc
up its edges and flattened it out. Then it was hung in a pla
life, frankly a tool like eyeglasses or a telescope. It helped
into focus, from one tiny angle, but it was not *that thing.* F
For *that thing* was destined to be an *everything,* loving and
isting with the All. What is the bigness of a person? We canr
it. No costume or label can represent it, and no pain can e
where its acceptance of destiny is complete.

27. Luke 17:21.

your strength."[2] But how can we muster so much love? It is only possible when love has first been received, from the Parent-Source of Love, so that the flow of love can go back and forth forever.

Meanwhile our biggest challenge—the hardest thing we do, and the task we pursue even when we don't know we're pursuing it—is the *maintenance of axis*, so that the avenue of love is unblocked and free. It is so difficult for us to step into, and stay in, a place where our mutual gaze with God can be shared in total openness, trust, and vulnerability. When we are in this place, however, we know it. We are confident of our steps. We are not ashamed. We hide nothing, for we know that our flaws are taken up into something larger and more complete that covers all. We are free and at peace.

There is one, intractable condition that makes the rewards of "axis" possible—but this condition also intensifies its dangers: it is the experience that I have called the "death of God." It can be understood as God's tantalizing absence from our immediate view, which creates the longing and distance necessary for mutual "gazing," but which also leaves us alone to orient ourselves on our own. God's distance enables our purpose and our glory, yet it creates an opening for so many other possibilities, so many other interpretations of our lot, so many other callings and beckonings. It also creates an opening for adversarial movement—the schemes of the so-called "devil," when counterfeits are offered. Art helps us cope with this condition of distance, of death, by humbly figuring truth in a way that reminds us of our destiny.

THE JOURNEY SO FAR

In this book, I have discussed a dichotomy of "all or nothing": of infinite, proliferating diversity vs. the homogenizing, assimilating monolith. When we take up our proper position across the axis of "sight," we can participate in this diversity and even further it. However, when we turn away from the life-giving gaze (whether out of trauma or willfulness) we collapse inward and block the flow, turning the things of the external world, each also sustained in the gaze of God, into diminished objectifications.

I have suggested that "monolithic" impulses have been manifested in various ways. In the ancient world, they were exercised primarily through imaginative "localizations" of power that invested a bounded glory in chthonic deities (idols) or their human avatars, such as priests and "god-kings." In a way, this impulse came from a squinting fear: it lurched to grasp

2. Luke 10:27.

onto any handhold in the waters of Being, like a child who won't let go of the pool's edge to swim. Thus the divine itself was objectified, first of all, and then it was linked to a rich tapestry of other objectifications (e.g., the native land and its resources, which were said to exist *for* the people). A sort of zone of subjectivity emerged, though it was anchored to place and unlikely to fluctuate like the shifting worldview-spaces we navigate today. Unfortunately, to localize glory thusly was to invite a host of travesties, including xenophobic tribalism, human sacrifice, wanton cultural destruction (when circumstances ostensibly demanded), and also rampant soul-disappointment that issued in corrosive rage. Such were the dangers when matter was wishfully invested with the ability to contain the highest.

The Christian paradigm that developed in the early years *Anno Domini* wrested power away from localized manifestations. It said frankly that earthly things were insufficient to meet our desire for glory and the shelter of glory, yet it granted that embodied substances *could* function as "windows" nevertheless. This was summed up in the nature of Jesus, who was an enfleshed window that yielded perfectly onto God. Thus the person of Jesus could appeal to the Mediterranean pagan folk whose imaginations hinged on the local and concrete, and he could also honor the transcendent demands of the Jewish revelation.

After Jesus, the artwork, an Incarnation-echo, was born. In its nature, the Artwork was a paradigmatic representation of "windowness": that is, substance that *participates with*, but does not *contain or enclose* divine transcendence. Art became a replacement for the magical "glory containers" of the ancient world. Thus we saw the contrast between pagan idol and early Christian icon. And we saw how what I'll call "iconicity"—the quality of having window-potential, as an artistic subject—was extended gradually from the incarnate Jesus, to Mary, to other saints, and then, to a certain degree, to everything in the quotidian world. This process re-invested the localized with sacredness, but in an utterly different way than before. We also traced how the idol-form of sculpture was transmuted through centuries into sculpture as window-vessel, so that it could function similarly to the flat "icon" as a spiritual tool.

In the next historical phase, we saw how the notion of Art's glorious permeability, as an irradiated window onto something higher and timeless, imbued with a "witnessing" counter-gaze that beckons and elevates, persisted even in *milieux* where conscious Christian thoughtways and disciplines were no longer present (i.e., the *milieu* of Western modernity and modernism in art). This was evident in the critical theory of writers like Walter Benjamin and Michael Fried, neither of whom subscribed to

Christian doctrine, but both of whom upheld (in their own ways) the tradi-tional icon-power of the thing called "art."

Finally, we saw how postmodernity (at least in high culture) is trend-ing toward something like a re-localizing process, reminiscent of pre-Christianity. Perhaps this is driven, again, by a fear that must latch onto handholds. Because cultural change often filters down through the elite, this fear is at present, I think, experienced primarily by the elite, who no longer feel confident to move freely in the worldview-space they've built and curated (what Charles Taylor might call their "social imaginary"). Their re-localizing tendencies are evidenced by (among other things) the tone of celebrity culture, the rise of a superstitious horror toward certain taboo ves-sels of expression (specific words or images), and modes of performance art (and even theatricalized political discourse) that reenact ancient dynamics of deifying and scapegoating. Pagan magic is on the horizon once more.

SHIELDING FROM GLORY

So first there was localization (idols). Then there was the subtle, precarious delineation of the "window-space," as figured by fine art. And now we are returning (at least in some quarters) to another sort of localization. But in between those last two phases there was the phenomenon that art historians call "modernism," which culminated in the huge, totally abstract paintings of artists like Mark Rothko and Jackson Pollock. It is this phenomenon that defines how many of us think of "art" today. During this period, the range of subjects considered deserving of "iconicity"—of elevation to the art-context—dramatically contracted. Art became about form and color and nothing more. This narrowing of the field of art showed, I think, something very significant about how we have gazed, and how we have viewed the transcendent, in recent decades.

Much has been written about how modernism in art was purifying and beneficially deconstructive (in the sense that cutting-edge chefs "decon-struct" complex recipes to let the constituent ingredients shine). Modernism revealed the pure elements of art (line, color, space, texture) so that their full potential could be explored, independently of extraneous things like subject matter and symbolism. (Consider, for example, how Piet Mondrian's mature works are methodical reconfigurations of only a few things over and over again: vertical lines, horizontal lines and primary colors—fig. 1.) I think that account of artistic modernism is a valid one.

But modernism in art did other things, as well. It did not just limit itself to the almost scientific exercise of excavating the potential of line and color,

as medical researchers might probe the potential of a new drug. Rather, in addition to this practice of art-as-research, artistic modernism also tacitly assumed, often, that line and color, as elemental tools in the box of visual consciousness, actually evoked the transcendent better than external, living objects. Mondrian's intersecting lines became like magical runes.

This latter strain of modernism, I think, was a way of elevating the *zone of subjectivity itself*, or rather, the fundamental building blocks of zones of subjectivity, to a window-dignity now denied to the rest of the world. What did this mean? It meant that for artistic moderns, the human being's *capacity and drive to gaze* was the sole, reliable passage left to transcendence (a bit, perhaps, like Descartes *cogito ergo sum*: "I think therefore I am." It is the thinking itself—or the seeing itself—that reflects a higher dignity). The artistic modernists knew there was transcendence because they desired it and pointed their inner natures toward it, but that is all they knew. It was the power of the inner nature to rise toward transcendence that they therefore celebrated, and because this inner power was all they could firmly grasp, they imagined it was a fitting simulacrum—a fitting, even full, *incarnation*—of the very same transcendence they desired. The "Christian picture" was transmuted from images of saints to images of the building blocks of consciousness.[3]

From one point of view this movement seems solipsistic, like the accusation implicit in Victor Cousin's formulation from the introduction of this book—his Second Copernican Revolution, when everything came to revolve around the self. But from another point of view, the modernist movement can seem cautious and prophylactic, like a warding-off of feared cultural trauma or contagion (abuses of authority, counterfeit glories, broken promises)—a warding-off in some ways sadly justified due to past injury and suffering. Modernism, in other words, has in some ways been like the response of a rape victim to violation. It has been a retreat into a kind of cultural celibacy in order to heal from the tragedies of history. At their first stages, monolith-movements can indeed be like protective cocoons, or scabs. But when they persist for too long, they gulp and spread and disfigure. Meanwhile the slumbering life within, now at least partly restored, awakes and struggles to get out.

"Modernism," then, has tried to shield us from the promiscuous glory of earlier times, even denying glory as it has been traditionally understood, because that glory was often abused. (In art, this trajectory is followed along a narrow arc by the art historian Thomas Crow in his book *No Idols*, which

3. This is essentially the philosopher Jacques Maritain's argument in his *Creative Intuition in Art and Poetry*.

takes its departure from the eighteenth century).[4] Modernism has tried on purpose to block what was a frightening, uncontrollable surfeit of glamor and light.

For in past cultural matrices, those who professed to embody glory, to offer the shelter of glory, to return the gaze of glory, failed their so-called "children" again and again. I refer here to every institutional church, both from the past and to a lesser degree in the present, for it is precisely the institution of the church whose mandate is to claim and manifest glory, and every institutional church has failed or is failing in this task. Indeed, success in this task is impossible, but we still expect it. Our desperation for "hand-holds" is also a desperation that looks for sufficiency and responsibility where it does not belong. Thus everyone—both the people who run sacred institutions and the people who idolize them—is at fault.

At the openings of many of the chapters in this book, I have returned to the dynamics of the mother–infant gaze. I have suggested that this gaze, as an engine for both psychological and spiritual shaping, can be productive of either buoyant health or warping trauma, depending on how it is exercised. The Bible frames God as a parent, in some ways both Mother and Father, and I have suggested that his (or theirs) is the ur-gaze and the ur-visage toward which all lesser faces point and upon which, window-like, they also yield. The institutional church, in the years *Anno Domini*, self-consciously took upon itself the role of manifesting this gaze on the earthly plane, even calling its officers "fathers," and it failed dismally, often providing instead an exploitative and traumatizing leer. The present sexual abuse crisis in the Catholic Church is a manifestation and symbol of this twisted gazing, but it is not by any stretch alone. For I believe that *every gaze that fails to recognize proper dignity traumatizes. Every single one.* And insofar as any gaze is considered parental or authoritative, it wreaks greater trauma still. Every parent is liable to be hated for this reason, and every church is liable to be hated, too. The only salve is the True Gaze that flashes true recognition when everything else squints and gapes and lies.

We can, and often do, grant god-parent authority to gazes that never claimed it or at least don't deserve it—maybe the gazes of the state, of admired peers, of lovers, bosses, teachers, or even our children. And because none of these see us truly, our trauma is compounded each time we open ourselves to their unwitting power. It is possible to erect and then destroy countless gaze-axes in this way, out of hope, hunger, and disappointment, until we utterly despair of ever finding true recognition.

4. See Crow, *No Idols.*

So in a way, modernism said, "We do not need answering gazes, for all gazes have failed us. All we need to know is already right here within ourselves. It is our capacity to gaze alone that seals our value, so let us draw strength from that and revel in that strength." But how much pressure this is! How anxiety-inducing, to perpetually self-name and self-create by the light of this single pinprick (a pinprick that admits light enough to resemble an eye, but goes no further). What a crushing burden!

And so modernism has proved unsatisfying. Meanwhile, many others who never subscribed to its project chafe more and more at modernism's hollow, even risible, demands. If the modern subject self-creates heroically by the light of a single star, as it were, then what of those who have never been allowed to self-create? I think of laboring classes, the enslaved, or women—all of whom have remained under the glare of an unconscious social gaze that delegates limited, utilitarian roles, and consequently, subhuman status. For it is precisely in the *escape from any real gaze*, and therefore the *escape from any ontological determination besides self-determination* that full humanity has come (disastrously) to be defined. Hence the popular bromide familiar from after-school specials, graduation speeches, and even some Sunday School lessons: "you can be whatever you want to be."

When we reflect that the leisure to self-define (or at least pretend to self-definition) is very difficult to achieve, and is therefore open to only the most historically-advantaged few, it is not surprising that "white" masculinity has been associated with a notion of full humanity that has often been denied to everyone else. However, it is also not surprising that white masculinity has been simultaneously associated with qualities like emotional repression, an almost sociopathic lack of empathy, and simmering rage. In 2018, for example, headlines like these were common in mass-media outlets: "Toxic White Masculinity: The Killer that Haunts American Life" (*Salon*) and "Are We Witnessing a Crisis in White, Male Masculinity?" (*Newsweek*).[5] Meanwhile, a range of historical injustices (modern slavery, predatory capitalism) and contemporary atrocities (domestic violence, mass shootings) are inextricably associated with the white, male identity.

In retrospect it makes sense that these associations, and the real tendencies that underpin them, have developed. For the achievement of full humanness by the modernist standard—that is, free, unfettered self-creation—has come at a steep, often soul-killing price. First, it has demanded a total prophylactic shielding from all glories and goodnesses that have historically been associated with trauma and disappointment (this cramps

5. See Devega, "Toxic White Masculinity"; and Katz, "Are We Witnessing a Crisis in White, Male Masculinity?"

the soul and the imagination). Second, it has required self-creation from within the suffocating "shelter" of the modernist cocoon (this is punishingly difficult and wearying). With these prerequisites, a sociopathic blindness is bound to sometimes result. Meanwhile, parties not afforded the opportunity to pursue these goals—who are neither offered the conceptual "prophylactic" of the modernist worldview nor given the leisure to imagine they are engaging in self-creation—will understandably develop differently, and will simmer with anger toward social "exemplars" who seem either villainous or piteously ignorant.

And so the prophylactic of modernism doubly blinds. It blinds first because it effectively bequeaths the wounds of history to new bearers (these wounds are inflicted by the knee-jerk, protective structures modernism perpetuates and instills in each new generation), and it blinds secondly because it also forecloses on the development of wisdom-through-pain by erecting barriers to any new or expanded knowledge. It stunts its people's growth from the moment they are born. It is for this reason that parties outside the "halls of power," outside the models of "full humanity" as modernism has understood it, often evince a strange wisdom that is at once compelling, frightening, magnetic, threatening, and almost unintelligible. Because they did not inherit the same traumas, and because they are not swathed in the same spiritual prophylactic, they have been open to self-evident truths that others have long forgotten. This is perhaps why, for example, the Christian thematics in the work of the British-Trinidadian artist Chris Ofili, who is of Nigerian heritage, strike such a chord. Ofili finds redemption in the animalian, the scatological, the wild, where others cannot. Consider the mysterious, simian figures populating his installation *Upper Room*. Here thirteen, dazzling macaque monkeys, each one inhabiting its own florid panel mounted on elephant dung, recall Jesus and his disciples sharing the Last Supper. The lush solemnity of Ofili's room-sized installation, which paired dim ambient light with dramatic spotlight effects, seemed to invite all of nature into the hinted-at sacramental act. This helped shatter paradigms around notions of sacred and secular, wild and civilized, spirit and flesh.

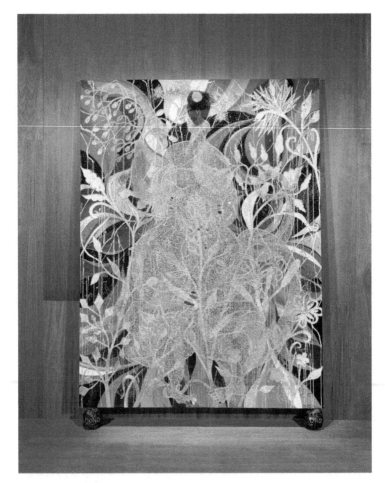

Fig. 5.1. Chris Ofili, *Mono Oro (The Upper Room)*, 1999–2002, 244 x 183 cm.
Photo copyright Tate, London. This painting functions as the "Christ" figure in the
installation. The other twelve panels flank this one in groups of six on the adjacent walls.

Yet each one of us is a complex field of traumas, barriers, desires,
and knowings. Not one of us sees everything truly. Together we enact the
Buddhist parable of the blind men touching the elephant. One feels a tusk,
another a leg, and none can grasp the whole.

REFORMATION, TRAUMA, AND FLIGHT

The history of Western art suggests that all Protestantism has been in some
way prophylactic. Betrayed by the ancient church, the Father-Mother on

earth, the avatar of glory, the people of the Reformation age gathered the wherewithal to flee and heal. In the process, however, they fled too far and shielded themselves too well. In art, we can see this in the careers of image-makers like Albrecht Dürer, Hans Holbein, and Rembrandt van Rijn, who worked in recently or unsteadily de-Catholicized *milieux*.

A follower of Luther and an accomplished, internationally famous artist whose career spanned the periods immediately prior to, and imme-diately following, the launch of the Reformation, Dürer quickly understood the threat to his livelihood posed by counterfeit artistic glories and the vio-lent reactions they spurred from a weary and traumatized populace. In the introduction to his volume *Underweysung der Messung* (Treatise on Mea-surement) of 1525, for example, Dürer forcefully denied that visual art in itself was responsible for the idolatrous manipulations decried by the early Protestants. Rather, like everything else, art was liable to be corrupted by corrupt men; in its essence, art was innocent.[6] Nevertheless, images every-where were being gleefully destroyed, and Dürer, in response, moderated his artistic ambitions, simplifying and self-censoring, so that his own works might avoid destruction. This may explain why most of his last great reli-gious works, including his own version of the *Salvator Mundi* (resembling Leonardo's), were never completed.

Meanwhile, four years later, in Holbein's (and Zwingli's) aggressively Protestant Basel, the annual rite of Carnival would devolve into a wave of iconoclasm. This linking of Carnival, traditionally a time of playful and re-bellious image proliferation, with image destruction is very telling.[7] Here, energies once creative and participatory had been directed into prophylactic scouring. Holbein's *Solothurn* and *Darmstadt Madonnas* were rescued from the mob—the former desperately and spontaneously, the latter because it was in studio for repair, but the sea change was not lost on the artist. Indeed Holbein's *Solothurn Madonna* itself had wittily reinforced the window-sense of art that was being lost during the Reformation—that was being collapsed, in paranoid style, into the category of "idolatry." In the *Solothurn Madonna* St. Martin, a major figure to the left of the Virgin and Child, wears a pluvial (a sort of liturgical apron) depicting the Roman centurion who bid Jesus heal from a distance ("Lord, don't trouble yourself [to]. . .come under my roof," the Centurion bid his emissaries say, "But say the word, and my servant will be healed").[8] It was exactly this sense of miraculous distance, and of

6. See Dürer's introductory dedication to Willibald Pirckheimer in *Underweysung der Messung* (Treatise on Measurement).

7. This episode is described in Baetschmann and Griener, *Hans Holbein*, 97.

8. See Luke 7:1–10.

God's power diffused everywhere as opposed to being densely consolidated in a near place, that art was supposed to evoke.[9] In the *Solothurn Madonna*, Holbein seemed to argue that there is no need to block oneself off from glory (in art, that meant heavenly beings in heavenly spaces) as long as an understanding of proper separation, proper vantage, is preserved.

Maybe it is no coincidence that violated women became especially popular subjects in art around the time of the Reformation. The archetypal rape victim, traumatized unto her very death, could serve as a potent symbol of the tender soul betrayed by the seductive-yet-ravening Catholic Church. In the Latin West, the Roman noblewoman Lucretia had long served as just such a symbol. Her story, recounted by the Roman historian Livy yet hailing from an earlier oral tradition, went like this: a great lady in the region of Collatia, east of Rome, Lucretia was charged with hosting the Etruscan prince Sextus Tarquinius at her mansion. Tarquinius, however, took advantage of her husband's absence to rape Lucretia while she slept. The next morning, Lucretia revealed her violation to the local authorities and then fatally stabbed herself in the chest; the preservation of her honor demanded no less. It must be no accident that Lucas Cranach the Elder, a committed Protestant and Martin Luther's close friend, produced at least six versions of the "Rape of Lucretia" from 1510–1533. (The theme was continued even after by students in his workshop.) And tellingly, it was Lucretia's suicide—not the rape itself—that Cranach worked and reworked. Cranach sympathized with a spiritual woundedness that found comfort in blocking and erasure. Destruction of self, of image, of beauty, was understandable in light of such trauma—trauma dealt by a figure (a prince) seemingly deserving of trust.

9. In their book *Hans Holbein*, Baetschmann and Griener argue that Holbein's witty reference to the Roman centurion was an early attempt to visually formulate an "Erasmian" image theory—that is, an image theory based on the writings of Desiderius Erasmus that would anchor holy images in a secure place of simultaneous sacredness and humility. This would forestall both the iconoclastic excesses of the Protestant rebels and the superstitious enthusiasm of uneducated Catholics. See Baetschmann and Griener, *Hans Holbein*, 112–14.

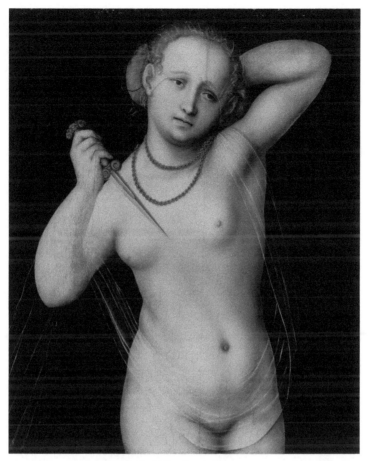

Fig. 5.2. Lucas Cranach the Elder, *Death of Lucretia*, 1525, 31 x 25 cm.
Photo courtesy of the Kunstmuseum, Basel.

Meanwhile, in the Catholic world, the trope of the violated woman took on a different cast. Starting before the Reformation, but gaining momentum later, Catholic artists began to depict the so-called "Penitent," or repentant, Magdalene in various postures and states of dress. (At the time, Mary Magdalene was considered to have been a reformed prostitute; this misconception persists down to the present day.) The Church's emphasis on the Penitent Magdalene was, perhaps, an attempt to dissociate the notion of soul-violation from the Protestant martyrs and redistribute it among all believers, all of whom had been violated by their own sins rather than by some "diabolical" church hierarchy. But also, images of the Penitent Magdalene may have been used to promise *healing* from spiritual trauma, however that trauma was understood. Under the sign of the Magdalene, a beloved

saint in Roman Catholic lands, this was a healing that would not require abandonment of the Church, but would instead culminate in deeper union *with* the Church. Whatever the case, the popularity of the Penitent Magdalene in Catholic places, and of Lucretia in Protestant ones, is evidence of the spiritual trauma, echoing out in sensory ways, that drove cultural change in the Reformation and post-Reformation West.

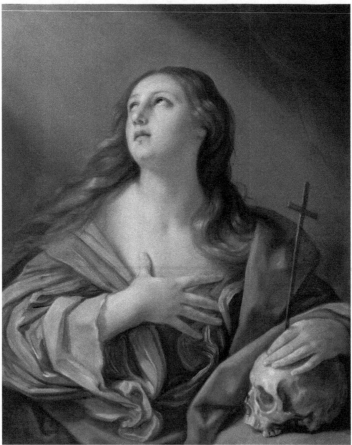

Fig. 5.3. Guido Reni, *The Penitent Mary Magdalen*, 1635, 91 x 74 cm. Photo courtesy of the Walters Art Museum and Google Art Project.

Of course the Catholic approach was not satisfying to the new Protestant rebels. Instead, an anguished and fearful tendency toward flight, begotten by trauma upon trauma, only increased in the coming centuries, when Christian denominations proliferated and rancorously split—when small bands of wounded believers repeatedly sought new "parents" who would be perfect at last. Alas, in so doing, they cut themselves off more

and more from their true and rich, but woefully compromised, inheritance. As evidenced by their almost total lack of aesthetic-sensory sophistication, modern fundamentalism and evangelicalism have been especially prophylactic and self-protective, at least insofar as visual stimuli are concerned.[10] This was perhaps needed for a short time. But now is the time for the children of this tradition, estranged from their deep roots, to emerge from their now-stifling cocoons and fearlessly seek glory—that weird, overwhelming intimacy, followed by deep knowledge and productivity, that our wounded ancestors fled from a long time ago.

Thank God modernity has failed. We seek glory, we project glory, we try to become glory, all to our pain, but in answer to the pain of our desperation. Thus we see the rise of localized idols, of priests, everywhere. We see the fury and the cleansing rituals, the "human sacrifices" on the public stage. The glory bulges through the cracks with blinding rays. May its vessels, its proxies, its usurpers, be preserved and forgiven, for "they know not what they do." Even old extremisms rise again (fascistic, blood-and-soil movements indebted to pagan magic) because we did not refute their glory in modernity—we only suppressed it. It is time to refute it now, with a higher glory of a different kind.

RETURN TO SIGHT

A renewed attention to the Parent-God's glory has not been, and will not be, instantaneous. There is much baked-in trauma and delusion to overcome. And then of course there is the perilous generationality of humans, which means lessons constantly have to be relearned. There must be the facing of trauma instead of flight. There must be the acceptance of pain that skewers you all the way through, so that there will be nothing to fear anymore—so that you won't be tempted to run away and hide. Only then can you face what came before in both its richness and its atrocity, sifting the wheat from the chaff. Only then can we escape from the sins of history: "the sins of the fathers visited upon their children."[11] It is by walking into our lamentable history that we escape. In other words, there is no escape. Be impaled, be killed and die. Face it head-on.

10. The fundamentalist/evangelical neglect of the visual may account, in part, for why Christians from these traditions have been especially susceptible to "idolatry" of different kinds: an idolatry of musicians or celebrity preachers. The visual having been excised, the aural takes on disproportionate power.

11. Paraphrase of Num 14:18.

Jesus faced atrocity head-on, and died, and rose in sovereign, free distinctness. We too must face trauma head-on, and die, and maintain our separate place. When we face trauma, it no longer controls us. We are free—free to gaze across the axis toward that which truly fascinates, which is truly beloved, plagued by no fear, out of a real independence and freedom to choose the best and receive the best.

Art is for the Viewer

This book has been an art-account based on the needs of viewers primarily, not the needs of makers. As such it may be out of pace with the last two centuries of artistic production, which have focused on artists' private experiences. (This is because the act of gazing and the act of creating have collapsed together in modern times, as described above. The arrogated power to self-create—and admire oneself while doing so—has become the lone, universally accepted mode of "gazing" toward transcendence, and has thus been effectively denied to all but a few.) But it's time viewers took back their historically crucial role in the shaping of a healthy and useful art.

For art is not a product of genius that we have to accept because the artist told us so. Art is something our culture evolved (in a God-directed way) because it is supposed to serve all of us and help us develop. C. S. Lewis once wrote:

> There are no ordinary people. You have never talked to a mere mortal. Nations, cultures, arts, civilizations—these are mortal, and their life is to ours as the life of a gnat. But it is immortals whom we joke with, work with, marry, snub and exploit—immortal horrors or everlasting splendors.[12]

The viewer is more important than the artwork. The viewer will last forever, and the artwork will shear away. Artists are privileged to perform their service, just as farmers are privileged to provide food. Indeed art is a type of food, as some have asserted: "food for the soul."

Art Looks Back

In earlier times, it was not so unusual for pictures to look back. The most famous example is probably the Cross of San Damiano, now lodged in the austere Basilica of Saint Clare in Assisi, Italy. Eight hundred years ago, the

12. Lewis, *The Weight of Glory*, 45–46.

crucifix hung in its namesake church: the tiny sanctuary of San Damiano (named after a benevolent Roman doctor), where a wealthy young man named Giovanni di Pietro di Bernardone prayed before it in a time of spiritual crisis.

That young man would later become known as St. Francis of Assisi. As he prayed before the San Damiano Cross in 1205, he heard it speak: "Francis, go and repair my church, which, as you see, is all in ruins!" The account of this miraculous communication does not relate whether the lips of the painting moved. It does, however, affirm that Francis heard the command "with the ears of his body"; this was not experienced as a completely internal epiphany.[13] Francis was awestruck and confused. His first response was to go out and campaign for the restoration of the tiny church of San Damiano, which had been neglected for years ("repair my church," the voice had said, after all). Sometime later, however, Francis realized that he was meant to restore the Church Universal, which languished in thrall to greed, corruption, and hypocrisy. There is something about this ambiguity (repair *which* church?) that is tremendously unsettling to the modern mind. But the ambiguity was in large part the *point*, for it meant the message was coming from a true *outside*.

The Cross of San Damiano is a hybrid artwork—in certain ways, both a sculpture and a painting. It is made of thick wooden panels, and its figures are painted on (these include Jesus and some smaller symbolic figures), but it is not shaped like a rectangle. Rather, it is shaped like a cross with decorative addenda. It is very large, measuring over six feet high and around four feet wide; its nearly human size gives it an almost mannequin-like quality. It, and other crucifixes like it, occupy a uniquely Christian place in the deep history of sacred images: with their flat surfaces like panes of glass, they barely transcend—but *do* transcend—the impression of "localized deity." They can be understood as windows or portals through which divine presence can distantly shine, with varying degrees of vividness, like the sun passing among clouds. From his contact with Jesus at San Damiano (a moment that was never duplicated later in his life), St. Francis began his official mission for the church of God.

13. These lines are from St. Bonaventure's *Life of Francis*, written around the year 1260 and subsequently issued in many editions and translations.

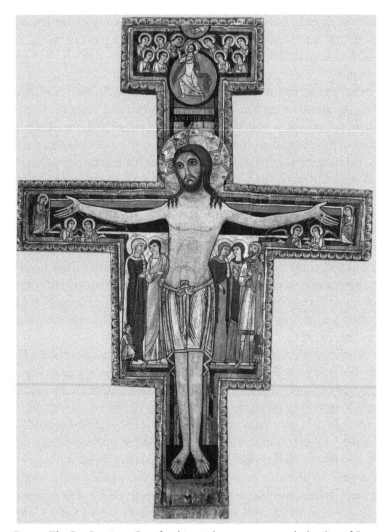

Fig. 5.4. The San Damiano Crucifix, thirteenth century, now at the basilica of Santa Chiara, Assisi. As a "rood cross" meant to serve as a devotional focus from any point in the church, this object is several feet high.
Photo courtesy of an anonymous photographer.

A similar "looking" and "speaking" artwork was the peculiar little reliquary of Ste. Foy at Conques, in France. This too was a hybrid product, consisting of metal, wood, gold leaf, crystal, and jewels. A sculpture of Ste. Foy (who was a young, female Early Christian martyr) sits stiffly in a jeweled throne. Her head is made of metal and her body is made of wood, though both are covered with dazzling gold leaf. The body is hollow, and St. Foy's

relics lay inside ("hollowness" is perhaps another form of "windowness"). The over-large head with glaring eyes and a rather masculine jaw is thought to have originally been part of a bust of a Roman emperor. At two-and-a-half-feet high, the reliquary is small for a full-length statue, and probably echoes the diminutive stature of the saint it honors. On some occasions this shimmering figure, transfigured to be more human-like, appeared to supplicants in their dreams, guaranteeing answer to their prayers.[14]

Episodes like these can make moderns scoff. It is stories like these that give us license to dismiss earlier people as "superstitious," "ignorant," and even "less evolved" because of their embarrassing credulity and their misunderstanding of natural laws. But our vantage is limited by the prejudices and wounds of our generation; it is no surprise that we cannot understand phenomena for which we lack ready-made categories. Were St. Francis and the pilgrims of Conques more open to a form of experience that we have repressed today? Were they able to inhabit a posture that welcomed *otherness-as-such* from any quarter, knowing that it lay at the center of all human striving? Today we celebrate things like "innovation," "problem solving" and "unique branding"—all of which encourage narrow focus and utilitarian calculation. What if we put goals of individual distinction aside and became radically, childishly open to the universe?

THE PRICELESS PICTURE

This book began with a discussion of Leonardo da Vinci's *Salvator Mundi*—the small oil-on-panel painting that sold for $450 million dollars in 2017 (see fig. 0.1). I suggested in my introduction that this book would try to explain the mystique of objects like the *Salvator Mundi*. I have argued subsequently that "art," as we understand it, is a vicar-object for the sovereign Person, and that its function is to bring us into harmony with ourselves, with each other, and ultimately, with a trinitarian God who contains the experience of beloved otherness within himself. Under this paradigm, the experience of beloved otherness becomes *the experience*—the experience toward which all others point, the one that brings fulfillment, the one that brings (according to Christian tradition) eternal life. Indeed, it is both the driver and precondition of life itself.

The *Salvator Mundi*, a "Christian picture" *par excellence*, is an apt representative for the functioning of "art" more generally. It shows Christ, who

14. For stories of the miracles surrounding St. Foy's relics and reliquary, see *The Book of Sainte Foy*, ed. Sheingorn. This volume is a comprehensive collection of the primary sources relating to the cult of Ste. Foy in medieval Europe.

literally embodied God's otherness before the humans of his time. It is a small, humble painting on wood that conjures a presence while pointing to something greater outside itself. Indeed, Leonardo's rendering in the piece makes this insufficiency obvious. The man pictured in the image is at once fleshy and ethereal, at once scrutinizing and impassive. He embodies the sovereign indifference Michael Fried looked for in art, but he also embodies the physicality perfected by Raphael. Emulating some of the most ancient Christian icons in composition, the *Salvator Mundi* proclaimed the continuity of Christian culture, and the Christian picture, into the early modern period, and declared the absolute necessity of both for human growth. The individual who purchased the *Salvator Mundi* may not have known all this, but on some level he may have felt it. Certainly the advertising campaign promoting the *Salvator Mundi* suggested as much. This was one of the most effective campaigns in recent years, drawing on deep-seated beliefs about the power of art in the centuries *Anno Domini*.

The campaign revolved around a 4 minute and 14 second video that captured visitors' reactions to the work via a small camera positioned right above the picture's frame in Christie's auction house. Accompanied by soaring classical music, silent faces, one after another, contemplate, sigh, raptly smile or uncontrollably weep. Their chins are tilted upward as if in reverence toward something literally higher (the auction house was smart enough to hang the painting just over eye-level), and their gleaming, spotlit visages are cocooned in a darkness that highlights the privacy of each visual journey. Each viewer is clearly *encountering* something and is struggling to come to terms with it. It is as if the image lives. (The advertising trade publication *Adweek*, taking a cue from Christie's auction house itself, said that the *Salvator Mundi* was "a picture [that] looks back.")[15]

How each viewer came to terms with the *Salvator Mundi* varied, perhaps, according to life experience or virtue, but everyone seemed transformed by the collision. And interestingly, the length of the video was a reference to John 4:14, which reads: "but whoever drinks the water I give them will never thirst. Indeed, the water I give them will become in them a spring of water welling up to eternal life."[16] In effect, Christie's promised a divine gaze that would literally raise the viewer to transcendence. This was a frankly theological version of the "timelessness" Michael Fried described.

When the video premiered on the internet a few days after the painting went on display, the reaction was seismic. Long lines formed (later accounts

15. Nudd, "Droga5's Sublime Ad for Christie's Captures the Power of a Leonardo Painting without Even Showing It."

16. John 4:14.

suggested an attendance of 20,000), with each visitor eager share an experience so moving and powerful. The *New York Times* interviewed several of the pilgrims. "I want to have the experience and the emotion," a visitor named Adam Patrizia said. After viewing the painting another visitor, Nina Doede, told the *Times* reporter, "Standing in front of that painting was a spiritual experience . . . It was breathtaking. It brought tears to my eyes."[17]

What Christie's and the ad agency Droga5 knew, and what the video proves, is that modern humans have certain innate expectations and likely reactions when it comes to the thing we call art. Repress it though we might, deep in our psyches we still have a category for the artistic "miracle." Maybe da Vinci's *Salvator Mundi* was heavily retouched by a lesser artist (as some critics believe). Maybe it wasn't his best work. Maybe its colors have faded. But for its viewers it nevertheless embodied, almost perfectly, an archetype they still unconsciously understood. They were easily persuaded that contact with this object would be both relational and transformational; they sought and expected healing and revelation.

NEW SAVIORS

In my previous chapter, I discussed the "Theater of the Self"; this is a movement that transfers the messaging power of the artwork from the canvas to the body, acknowledging that human bodies have inescapably become communications in our "Society of the Spectacle." Viewed from one angle, performance art is just an extension of the Spectacle, expanding the Spectacle's vocabulary with new subversions of pre-existing stereotypes. (In other words, performance artists fight fire with fire.) Viewed from another angle, however, performance artists self-sacrificially step in where "traditional" art can no longer go—taking upon themselves the responsibility to conjure *otherness* since more circumspect methods don't always work anymore. In the "Theater of the Self," at least a few of the actors wave their arms and shout, "Look at me! I am separate from you! I am not a part of your Zone of Subjectivity! Come regard me as a thing outside yourself!" In this they assume a role somewhat like that of the earliest Christian "fathers," and they make clear the connection between the artwork and the modest vicar-priesthood of the early Christian paradigm.

This has been illustrated most powerfully in a recent performance by Marina Abramović (she of the disturbing *Rhythm 0*), in which the artist herself became a sort of *Salvator Mundi* for pilgrims seeking contact and healing. In her 2010 performance *The Artist is Present*, Abramović sat

17. Reyburn, "Get in Line: The $100 Million Da Vinci Is in Town."

quietly in a gallery chair as viewers took turns sitting opposite her, returning her unstinting gaze. Crucially, she remained still and impassive just as a traditional artwork would, so as to avoid any circumstantial narrowing of the overwhelming *contact* (the "presence") she hoped to create. She also wore traditional, simple, almost liturgical clothing, as if to lift herself bodily and visibly out of the realm of time and fashion, in the manner of a classic painting. An archive of visitors' faces as they sat before Abramović strongly recalls Droga5's advertising campaign for Leonardo's lost masterpiece. Here, many faces crumble in vulnerability and surprise, and others openly weep. For some, we might imagine, contact with the open-eyed, attentive, non-judging Abramović briefly filled the Lacanian void described in this book's introduction. It is my contention that once upon a time, traditional art could also help fill that void (as the *Salvator Mundi* briefly did for its visitors), or at least it could direct the gaze toward something that could. Like Abramović, the "Christian picture" did not receive one "in the moment," for the circumstantial usefulness they could bring. Rather, it received a whole self, just as it offered a timeless whole in return.

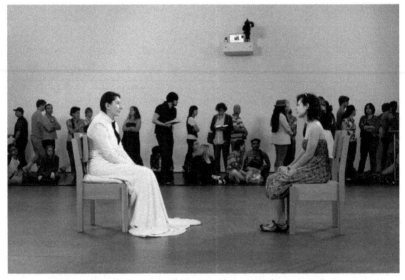

Fig. 5.5. Installation view of *Marina Abramović: the Artist is Present*,
Artwork copyright the artist and Artists Rights Society (ARS), New York. Photo
courtesy of the Museum of Modern Art, NY and SCALA/Art Resource, NY.

CHANGE

Because God *is* relationship, because God became incarnate, and be-cause the artwork produces a charge of relationship, art is a multi-faceted

symbol of personness: the Sonness of Adam, the Daughterness of Eve. In fact, Artworks function as *Coleridgian* symbols (after the poet Samuel Taylor Coleridge) in their multi-dimensional representational power. For Coleridge, the true symbol not only *represented* its referent, but it also *resembled* its referent. In an echoing way, a sort of emanatory way, it provided an experience of its referent at the same time that it seemed to speak the referent's name. The same is true of the artwork vis-à-vis human persons.

For life at its core is change in response to an outside (symbolized in nature by the processes of evolutionary adaptation). In God there is always life for there is always an outside (the other Persons of the Trinity) and always change. Death, meanwhile, is repetition and stasis, until every part crumbles to self-same motes of dust, flat and interchangeable and dark. There are phalanxes of demons gibbering in ancient tongues the same old tales, rote and clanging, in airless echo chambers. They cannot see that when Christ was resurrected, he was changed. And as God self-limited by space and time, yet still unfurling toward infinity, Christ always changes. He is like dappled light through shifting leaves, rainbows amid blowing clouds, or roses blooming in different soils, tints shifting by the season. If we are not changing, we do not listen. If we do not listen, we are dead.

We are invited to tread the golden path—or rather, to be borne upon it. Then our hard natures, our wooden natures, our finite natures, may vibrate forever with different tones, like reeds become vessels for wind. The song makes the dried reed live. The shape of the reed helps shape the song; but the reed cannot blow itself. Such is the human being. And such is the artwork, the wooden panel-window of Leonardo, vessel for a heavenly communication that "blows through" but does not stay—that is not localized but is ever-moving, through every one of its conduits all over the whole universe. The Holy Spirit's requirements are meager. She needs only a tiny aperture through which to pass; but sometimes she needs one to form that space, and then the space itself, and then others to stand and listen as she sings.

The artwork can be that which beckons beyond the prophylactic into realms of blushing intimacy. The artwork can call the soul from the false theater of Spectacle into the authentic life of Being. It can help force acceptance of permeability, hard love, and pain. It can be (always vicariously) a Lover, a Scapegoat, and a King.

LOVER
(Before the Modern Barrier)

In the tiny chapel of the Orsanmichele in Florence, Italy, there is an object something like the Old Testament Tabernacle in its majesty, opulence, and charge of "otherness." But the likeness is by no means self-evident at first glance, for while the Old Testament Tabernacle (in the modern mind) redounds with a fearsome, archaic, suffocating gravity, the object of which I speak is downright sweet.

This object is the so-called *tabernacolo* (tabernacle) of Andrea Orcagna and Bernardo Daddi. Completed in 1359, in the early generations of the Italian Renaissance, it rises like a paradox of stone and cloud, or summer flower and winter ice, within the cramped and simple devotional space of the Florentine guild-chapel. In a manner typical for its time, the construction is centered on a painted image of the Virgin and Child, who are posed majestically in the manner of Byzantine saints, but who are also ruddy and round in keeping with Florentine sensibilities. Somewhat less typically, however, the Virgin and Child are poised in a resplendent, marble, miniaturized palace whose doorway yields onto the holy figures like a gate into fairyland. Made of creamy marble and inlaid with lapis lazuli, glass, and gold, this remarkable little edifice has spires, a pediment, and a dome—it is a fantasia of ancient and Gothic architectural splendors that would be emulated on a gargantuan scale at St. Peter's basilica centuries later. Because of its hulking presence in this small, simple room, and because of the heavenly beauty of its surfaces and the sweetness of its inhabitants, this object elicits, in the viewer of open spirit, overwhelming admiration and love.

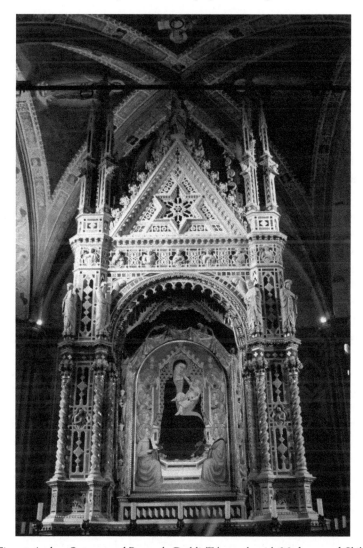

Fig. 5.6. Andrea Orcagna and Bernardo Daddi, Tabernacle with *Madonna and Child*,
interior of Orsanmichele, Florence, 1347–60.
Photo courtesy of Miguel Hermoso Cuesta and Creative Commons.

It is difficult to imagine the seismic magnitude with which the *Theoto-
kos* image (that is, the iconic form showing Jesus on his mother's lap) shook
the early Christian psyche. As we have seen, late antique audiences had a
difficult time accepting a transcendent God who had also passed through a
woman's anatomy and taken on flesh. The *Theotokos* image codified this par-
adox, bringing it repeatedly and forever before viewers' eyes so they could

learn to adapt to its tensions. What therapeutic power it must have had, once the initial offense was overcome! It gave one the sensation of bowing before something superficially powerless and contemptible—what a lesson in humility. It gave men the sensation of chastely honoring something (a beautiful virgin) they might otherwise have lusted to possess. And in its fleshy verisimilitude, Daddi's *Virgin and Child* reminded Florentine tradesmen of the mothers and children in their households, left behind during the workday and often taken for granted. It said, "bow before these, in their God-honored splendor!" This was an image that inverted the structures of ordinary public life and then made you love the inversion.

The Italian urban fabric is filled with *tabernacoli* (tabernacles). The pious Italian culture of the late Middle Ages transmuted the deadly, sublime, monumental Tabernacle of the Old Testament into something gentle and ubiquitous: so many Italian street corners are adorned with tiny sculptural outcroppings that frame an image of Mary and Jesus, or less often, an image of other saints. Thus at every turn, passers-by are encouraged to stop and adore. And these holy figures are not oppressive like Orwellian "Big Brothers," always watching. Daddi's Mary, for example, is no forbidding goddess with an impossible, off-putting anatomy, like the Ephesian Artemis. Nor does she, like the Venus de Milo, stand resplendent in a brash nakedness that transcends human morality and is therefore, paradoxically, indifferent to lowly human desire. Rather this woman is real, instantiated and sensibly clothed, relatable and lifted high *because of* her relatability. And her child is no Olympian Zeus seemingly aflame with gold and thunder. He is an ordinary baby squirming on his mother's lap. Every ordinary human affection (especially for the typical male viewer) is thus ennobled as holy and marshalled toward the achievement of a humane, humble and dignified public life. The quintessential visual product of a Christian philosophy, the Italian *tabernacolo* embodies beloved otherness from its center to its boundaries; it does not communicate so much as *manifest*, yet the manifestation is window-like, yielding onto an essence separate and transcendent.

C. S. Lewis once asserted that the fairy tales of George MacDonald had "baptized his imagination." That concept, and phrase, has since become influential among certain proponents of the arts. And I think it can be aptly used with regard to some of the earliest imagery of the Christian Era. At a time when imagery of women was typically sexualized or subordinate, the *Theotokos* formula (embodied in Daddi's painting for the Orsanmichele) "baptized" and redirected the love-impulses of the typical European man. The image of Christ Crucified, meanwhile, could do the same for the typical European woman.

It may be uncomfortable, at first, to link eroticism with images of the crucified Christ. Nevertheless, I think we do injustice to the particularist, embodied, incarnational energies of the Christian movement if we deny the connection. Mary the *Theotokos* is a specific woman who gave birth, with all the overwhelming physicality that implies. The infant Jesus was nurtured in her womb and passed through her "waters." The crucified Christ is similarly visceral and sensual. The Bible insists that Jesus was stripped of his clothes at his crucifixion, and so we are bound to behold his nakedness. At different times and in different places (depending on emotional need), this nakedness could reflect extreme, embarrassing vulnerability (as in the case of the Isenheim Altarpiece, which is downright grotesque), or it could reflect a potent and attractive manhood redolent with youth, strength, and beauty piteously lost. The remarkable tenth-century Gero Crucifix, now in the Cologne Cathedral, is heartbreakingly beautiful, with its dignified face, its graceful lines and its smooth, burnished surface. Cimabue's famous thirteenth-century crucifix, tragically damaged in the great flood of 1966, is almost achingly gorgeous in its proportions and elegance. This kind of image could inspire intense affection and admiration while insisting on a separateness (Christ is dead, after all) that draws sensual desire into heavenly channels of new experience. It commands the response of the whole person, body and soul, drawing our focused, total attention—and then, with its distance, it bids us contemplate an *otherness* that is so lovable, so satisfying, that we cannot help but be caught in dancing rotation with it forever.

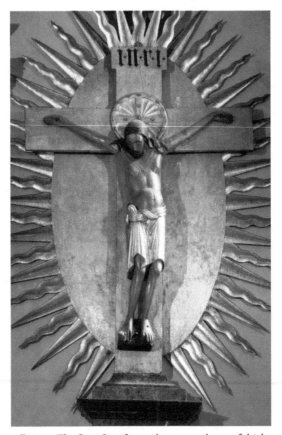

Fig. 5.7. *The Gero Crucifix*, tenth century, about 6 ft high.
Photo courtesy of Elke Wetzig.

The sensuality of mother and lover are linked. Both vibrate with a thrill of life sought and given. To hold and nurse a child is in some ways erotic, though we might be loath to admit it. In an anonymous nun's drawing from the convent of St. Walburg in Bavaria, Germany, dating to around 1500, a woman artist has shown this. There is a crucified Christ smiling beatifically down. His chest has expanded to become a great, swelling, red heart that covers both his torso and his loins. Treasured inside this heart, as if swept into a miniature, secret world, is a nun (perhaps the artist) sweetly smiling and holding the child Jesus on her lap. She looks into the child's eyes, and the child's eyes look into hers, while the eyes of the grown Christ look down at both. Here is generative love, nurturing love, and the love of the answering gaze, all caught together in a tripartite (trinitarian) movement. This is an earth-Trinity again, one of many, porous at their vertices, sweeping humans again into the God-life of the beginning. The nun at St.

Walburg says this: We can combine all loves together additively, sublimely, like lights combining to make pure brightness. In the heart of God there is no fear of transgression, only heedless surrender to the most exquisite of longings. Come lock your gaze in the right place, and you may love in totality and forever.

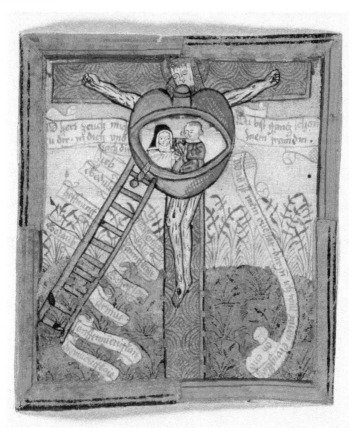

Fig. 5.8. Nun's devotional painting from the Benedictine Abbey of St. Walburg, Bavaria, ca. 1500. Photo courtesy of the Abtei St. Walburg.

SCAPEGOAT
(striking through barriers)

Cain tried to erase Abel, but Abel's blood continued to cry out. In a paradigm of allness, there can be no erasure. It is one thing to make something and then destroy it, like a so-called voodoo doll (on the sinister end) or

(more meditatively) a sand mandala. It is another to make and mar, and then *keep* and *contemplate*, facing our powerlessness and the impossibility of unmaking what exists. The Crucifix is one thing that denies erasure and asserts allness. Philosophically similar (in some ways) are the *Concetti Spaziali* (*Spatial Concepts*) of the Italo-Argentine artist Lucio Fontana, whose series *La fine di Dio* (The End of God) has a pretentious title befitting the early Space Age, but which secretly betrays a striking humility.

Fontana became famous in the 1950s for his punctured, and later slashed, canvases. Often covered with a uniformly thick layer of paint that seems inviolable like smooth enamel, his "pictures" (such as they are) feature gouges or wounds at their center. These (especially the slashes) might remind one of Christ's pierced side (as in medieval diagrams of the Holy Wounds), but that is not really the point. The argument is more generally this: 1) that all seeming "purity" is (and will be) violated, 2) that the violation is (and will be) permanent, and 3) that said violation has a capacity—as a gap or emptiness—to yield a view onto the entire universe. Some of Fontana's gashed canvases open onto deep, glittering darkness. Others merely cast complex shadows on the wall behind. Fontana said (grandiosely), "I do not want to make a painting; I want to open up space, create a new dimension, tie in the cosmos, as it endlessly expands beyond the confining plane of the picture."[18]

Fontana, in other words, wanted to make celestial windows—and he did so by showing how "windowness" often depends on the embrace of suffering, wounding, and pain.

18. Quoted in van der Marck and Crispolti, *Lucio Fontana*, 7.

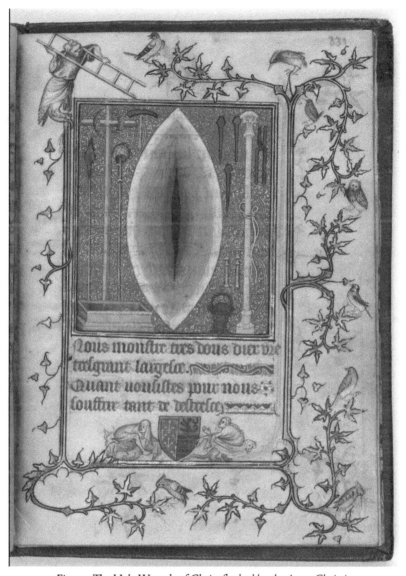

Fig. 5.9. The Holy Wounds of Christ flanked by the Arma Christi,
from the Psalter and Hours of Bonne of Luxembourg,
Duchess of Normandy, fol. 331r, fourteenth century.
Photo courtesy of the Metropolitan Museum of Art, New York,
and Art Resource, New York.

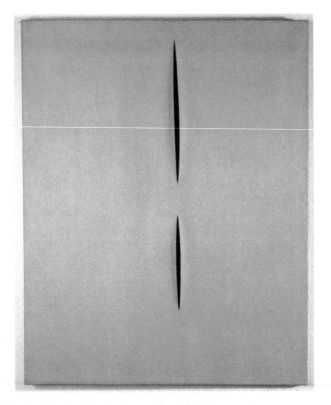

Fig. 5.10. Fontana, Lucio, *Concetto Spaziale—Attese*, 1958, 124 x 102 cm.
Photo courtesy of the Musee National d'Art Moderne, Centre Georges Pompidou
and CNAC/MNAM/Dist. RMN-Grand Palais /Art Resource, New York and ARS/
Fontana Estate.

Whether he knew it or not, in recognizing that the "plane of the pic-
ture" had become too "confining" (like the boundaries of the ancient idols)
Fontana honored the age-old window-sense of truly *Christian* art. That
which grasps and contains divine meaning, he knew, must burst or burn up.
It must release its pressure into the Void that is really God's fluid, amniotic
Life—thus Fontana's paintings release their pressure through punctures and
slashes. Cain's murder of Abel and the ancients' ritual sacrifices had been
alike in their attempts to seize ontological power while deflecting cosmic
blame. But in the end it proved true that power cannot be seized, nor blame
deflected. Instead (and oh, so mercifully) all will be absorbed in the capa-
cious God-life that beats swords into ploughshares—turning weapons into
astonishing, paradoxical instruments of life.

In this sense, Fontana's *End of God* series is not actually seizure (as if
the artist, or techno-modernity, has really captured and killed God, as the

title might imply). It is rather an acknowledgment of the "end" of God in an Aristotelian sense—that is, what God tends toward inevitably, by his nature. In Italian, after all, the "final cause" of Aristotle—a thing's destiny—is expressed as "*la causa finale.*" Accordingly, the "end," or *fine,* of God can legitimately be understood as "the destiny of God" or "the purpose of God." Within this paradigm, Fontana's prolifically pierced, egg-shaped canvases become incubators of life—nascent universes—through whose swirling, clustering window-apertures an eternity can be glimpsed. We gash and destroy, we vicariously punish, but our violence will be effortlessly transformed into redemption. The artist zealously gashed, making holes jagged and rough with grit, but he, too, made a vehicle for redemption, where absence vibrates with the filaments of a new presence.

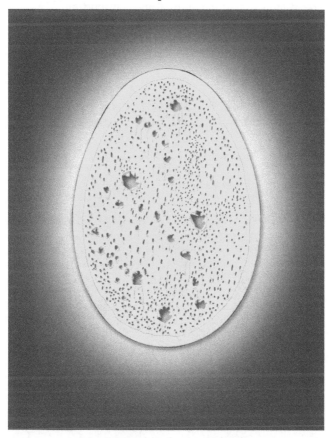

Fig. 5.11. Fontana, Lucio, *Concetto spaziale, La fine di Dio,* 1964, 178 x 124 cm.
Photo courtesy of Christie's Images Limited, 2015 and ARS NY/ Fontana Estate.

(As it was since the beginning)

On Sendlinger Strasse in downtown Munich, Germany, there is a small church, easily ignored, nestled among commercial facades and part of their fabric. It is the church of St. John Nepomuk, who was a medieval martyr priest killed for keeping the secrets of the confessional. (Appropriately, this little church is full of confessionals.) The structure is better known, however, as the Asamkirche, or Church of the Asams, because it was designed and made by two artist brothers who desired a space perfectly suited to heavenly meditation, and who had the means to bring it about. These brothers, Egid and Cosmas, built the church adjacent to their own house and relied on no ecclesiastical or royal patronage for its completion. They had total artistic license. The result is something unusual and transporting.

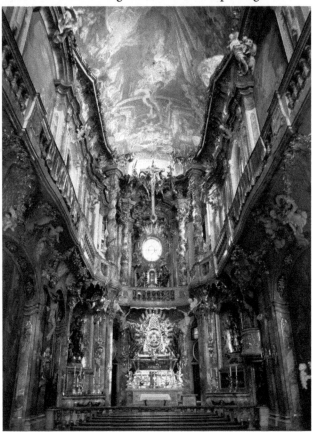

Fig. 5.12. Asam, Egid and Cosmas, interior of St. John Nepomuk, Munich
(called the "Asamkirche"), 1733–46. Photo by Schlaier, 2010,
available via GNU Free Documentation on Wikimedia Commons.

To enter St. John Nepomuk is to step from gray, rectilinear urban clatter into the serene, swirling heart of an opal or moonstone. The chapel is very small—only 8 by 22 meters—and its extreme narrowness, combined with a ceiling unusually high for the building's size, creates a tunnel effect. Sufferers of near-death experiences often tell of a "light at the end of a tunnel" and an urge to walk toward that light. The Asam Kapelle, with its precipitous walls and its resplendent window above the altar, conjures what I imagine is a similar sensation. But instead of a dark tunnel, this constricted space is undulant and lilac, almost emitting a visual fragrance. Swelling lengths of purpled marble, traced in gold, yield onto a small apse with spiral columns. Beneath the heavenly window is the glittering, gold and silver reliquary of the martyr saint surmounted by a shining crown of thorns.

To the twenty-first century eye, the Asam Kapelle can at first seem tacky, even grotesque, but just a moment's pause will challenge the "enlightened" modern viewer's inclination to judge. To receive the Asam Kapelle on its own terms to is to discover, in a flash, the poverty of a modern imagination that prefers things like structural clarity and sharp monochromality over the sensory wealth of an entire universe. One realizes that the modern preference for "clean," simple, and minimal order is tantamount, at least in part, to a willful lack of patience and a related desire for control. We find the complexity of the Asam Kapelle ugly because it makes us feel *out of control*. It makes us feel a need to hide and cringe, or supplicate and bow, and this is intolerable. Even the most "religious" among us reject all true obeisance as groveling. Even the most "religious" among us tell ourselves that we honor God because we have chosen him by our own lights, not because he compelled us with an almost sickening, overwhelming, intolerable majesty.

This "sickening" majesty (making one faint, making one crumple, making one queasy with fear and inadequacy, like the heavenly inverse of the terror provoked by Lovecraft's Elder Gods) is, I think, a little of what the solitary custodian James Hampton wanted to capture in his *Throne of the Third Heaven*. Surely, for Hampton, there was special meaning in his deployment of trash. He didn't choose these things because they were the only materials available—or at least, he didn't choose them solely for that reason. As someone arguably rejected by society himself, Hampton used what had been rejected *because of its rejection*. ("The stone the builders rejected has become the cornerstone."[19]) Hampton's materials were grotesque, cast out by the impatient modern consciousness as soiled or useless. But precisely in their cast-outness, his materials generated an offensive charge that could

19. Matthew 21:42.

"destroy the drawers of the brain,"[20] reducing the prideful viewer to a feeling of helplessness—not only cognitive helplessness ("what maddening complexity! And how did I not understand before?"), but also a deeply visceral and panicked helplessness of throat and hands and gut.

In today's America it feels as if we have two choices: we can conform to meet society's expectations, or we can "be our true selves," self-creating. But maybe there is a third way. It is a foregone conclusion that society's expectations are limiting and damaging. Thus our first choice can be discarded at once. Being our "true selves," then, seems more promising—until we realize first, that we cannot grasp our "true selves," and second, the self we can grasp is often not the self we "want." So perhaps the third way is to embrace radical disruption. To say, "I am a servant of the Good," with our heads internally bowed in complete subjection and humility. Then, as I have suggested before, we must wait. The result of this will be unexpected—will be a self we did not fathom and may not have wanted. But it will a self that will give us peace. This process of bowing and submitting is what Kingship offers in art.

SEEING AND BEING

Sight in Love

Hidden within the rather strange example of the "invisible" Leonardo in Droga5's advertisement (discussed above) is an interesting truth: the truth that art (like the Tabernacle) is both a *thing* and a *context*. By simply calling something "art" we arouse in the viewer a disposition toward contemplation and reverence, and we create a space for that disposition to flower. In calling viewers to such a disposition, artists have an enormous responsibility that they should wield with "fear and trembling."[21]

Love is required to see things truly. Only the sight of love is true sight. This is because sight-in-love is completely free from self-protective tendencies toward taxonomization, "boxing," diminishing and mastering. Sight-in-love allows its object to be its full self, and so it comes closer to correct apprehension than any other kind of sight. Truly loving parents see their children more clearly than dispassionate school administrators (for example), who may see them only as examples of certain demographics or

20. The phrase refers to the exploding of mental categories, and it appears in the 1918 manifesto of the Dada art movement, written by the poet Tristan Tzara.

21. ". . . continue to work out your salvation with fear and trembling" (Philippians 2:12).

aptitudes. Loving spouses see each other more truly than passers-by, co-workers, bosses, or even friends. Implicit in Droga5's advertisement was the insight that humans *know* true sight hinges on love, and they know *art* is an occasion for the practice of this loving sight. As a result, we come to art with a vulnerability productive of love. We could argue, then, that instead of being hyped into a false state of mind (as some critics of the ad campaign had claimed), the crying viewers of Leonardo's *Salvator Mundi* had actually been allowed to achieve a *true* state of mind. The painting helped them, at least for a moment, to see with the "objective" eyes of love.

The Dignity of the Other

Art does not just tell a story, communicate a message, stake a political position or convey an idea. None of those things are intrinsically "arty"—they are all, rather, status-obsessed compromises. If one's response to an artwork is to "read" it and then walk away, then the object has not functioned as art at all. Art must assert a presence that rescues us from solipsism—whether through inviting love or awe, or through inciting pained reaction (as Fontana's slashes, or Anselm Kiefer's abstract graveyards, or any image of suffering, might do). If art doesn't do this, it fails. Art defined by its political advocacy does not actually rescue us from our solipsism; rather it feeds the internal dialogues we use to define ourselves in the Spectacle. The true artwork, however, makes us stop and regard its *thingness*. It forces us to come to terms with its existential demands.

When I think of how late modern and postmodern art figures a new (and old) understanding of community—of the meaning of allness and the dignity of each—I think of Eva Hesse's 1969 *Contingent*, completed while the artist was dying of brain cancer. This work has been seen as a political statement—a feminist one (think home space, fragility, vulnerability, defiance). But it is certainly something more. Here beautiful, lightweight textiles hang in a row, seeming to sway relative to each other and with the breeze. Hesse's title captures it perfectly: each piece of luminous, hanging fabric is at once both self-sufficient as an object and also dependent (*contingent*) on its "fellows" for meaning and equipoise. The installation figures our networks of dependency in a humane and sympathetic way: there are openings between and openings within, all trembling with their gifted dignity. True art, in the same way, calls us to be open as it itself is open, so that we can contemplate, connect, and truly see.

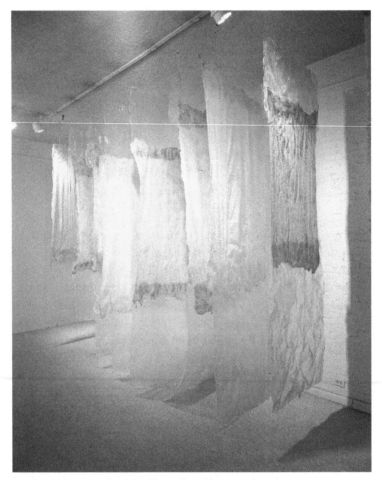

Fig. 5.13. Hesse, Eva, *Contingent*, 1969,
350 x 630 x 109 cm, copyright the Estate of Eva Hesse.
Photo courtesy of the National Gallery of Australia/ Galerie Hauser and Wirth.

Person as Viewer and Person as Art

At the end of *That Hideous Strength*, the third book in his *Space Trilogy*,
C.S. Lewis described a mystical robing ceremony in which his heroes, now
come to the end of their great quest, would don splendid raiment in sight
of all the angels. But as they prepared, the celebrants were not allowed to
choose their own vestments. Instead, they would be dressed by their fellows,
who decided by mystical, rapid consensus how each in the company would

appear. In the end, of course, the glory of all shone like the sun, and they went forth in satisfaction and peace. In this strange episode, each participant is both creator and created, both a fixer of ontology and a being to be fixed. But there was no violence here—only a mysterious flow from god-life to creature-life and back again, as if everything had at last been properly united, everyone at last saw truly, and every heart was at long last full of trust and rest.

This, I think, was Lewis's way of showing that our destiny, as it were, is not finally the product of our conscious strivings and ambitions, but of the *real work we do* amidst the secret life of the universe, with God's providential help. We are shaped like sculptures by God's transforming power, and by the power he wields through the vectors around us, pushing, pulling, distending, wrinkling, strengthening, polishing.[22] We are too fallen, too foolish, to see the real work we do through this process of reaction and growth, but love sees it. We are images that shine, but that cannot see themselves—artworks that hang in speechless self-darkness. When Lewis's heroes chose raiment for each other, here in a moment that symbolized the end of time, they became at last conscious of their own shaping power as vectors in the geologic immensity of God's sculpting process. And this consciousness depended finally on *their having been shaped aright*—their having been *completed*—so that they could own their place in the Kingdom. This was a kingdom of love—of loving, reciprocal gazing, with no mirrors except the eyes of lovers: eyes that coax into joyful self-awareness each royal child. We will be artworks come awake in that time, but now we must learn from that which sleeps.

22. See, for example, Ephesians 2:10, which begins, "for we are God's handiwork . . ."

Afterword
Mark-making

This book, *Bezalel's Body*, was about art as a *substance*. Hence the word "body" in the title; artworks are surrogate bodies for working out our stance toward the universe. Accordingly, this book lays the groundwork (or fleshwork, or bodywork) for a consideration of the function of art in the years *Anno Domini*. But as an account of art's uses and components, this book has by no means been comprehensive. For just as the human body wears clothing, and has since its exile from the Garden of Eden, so the artwork wears garments as well.

In a later book, therefore, I intend to discuss the markings of art—its surface symbolism, its dressings, its scarifications (like tattoos), its communications. This second book, tentatively titled *Brazen* (after the Brazen Serpent from the book of Numbers), will lay the groundwork for a visual theology of mark-making. Biblical episodes will be considered, starting with the mark of Cain and continuing through the placemarking of the Old Testament, the ornamental marking of women's bodies and the eternal marking of Christ's body with the wounds of his crucifixion. These early forms of marking will be connected to the modern and contemporary experiments of artists like Agnes Martin and Yves Klein.

This book will also consider the social dimensions of marking (for marking, as *signal*, is a distinctively social practice), including audience address, the shaping of collective imagination, the claiming of territory and the drawing of boundaries. I will contend that communal marking, which over time wears paths of distinctive culture heritage, is a type of meaning-giving spiritual work whose importance is not properly recognized. (This is different from the Spectacle, which is not *marking* but false *capturing*.) As a reflection of the transcendent, this kind of outward expression (and

its ritual continuance) is on par with more recognized forms of spiritual "work" like mysticism and prophecy, and its loss (whether through military, economic or political violence) understandably provokes collective despair. Thus we must work harder than ever to preserve the many different cultures that have evolved in God's world. For the beginnings of this discussion, I refer the reader to my essay "Christ the Chimera: The Riddle of the Monster Jesus."

Bibliography

Aelred of Rievaulx. *Spiritual Friendship*. Translated by Marsha L. Dutton and Lawrence C. Braceland. Collegeville, MN: Cistercian, 2010.

Alter, Robert. *The Art of Biblical Narrative*. New York: Basic Books, 1981.

Althusser, Louis. "Ideology and Ideological State Apparatuses." In *Lenin and Philosophy and Other Essays*. Translated by Ben Brewster. New York: Monthly Review, 1971.

Anderson, Jonathan, and William Dyrness. *Modern Art and the Life of a Culture*. Downers Grove, IL: IVP Academic, 2016.

Antonova, Clemena. *Space, Time and Presence in the Icon: Seeing the World with the Eyes of God*. Surrey, UK: Ashgate, 2010.

Aquinas, Thomas. *Quaestiones disputatae de veritate*. Edited by Roberto Busa. http://www.corpusthomisticum.org/qdvo2.html/.

Armstrong, Annie. "We're Testing the Limits!' *ArtNews* (2018). http://www.artnews.com/2018/09/28/testing-limits-freewheeling-swiss-institute-event-artists-critics-curators-create-anti-museum/.

Athanasius. *On the Incarnation*. Translated by Archibald Robertson. In *Nicene and Post-Nicene Fathers*. 2nd ser., vol. 4. Edited by Philip Schaff and Henry Wace. Buffalo, NY: Christian Literature, 1892.

Athenaeus. *Deipnosophistae*. Translated by Charles Burton Gulick. New York: Putnam, 1927.

Auerbach, Erich. *Mimesis: The Representation of Reality in Western Literature*. Translated by Willard R. Trask. Princeton: Princeton University Press, 1953. Reprinted, 2003.

Baetschmann, Oskar, and Pascal Griener. *Hans Holbein*. Princeton: Princeton University Press, 1997.

Balthasar, Hans Urs von. "A Résumé of My Thought." Translated by Kelly Hamilton. *Communio* 15:4 (Winter 1988) 468–73.

Barrett, Lisa Feldman. "When is Speech Violence?" *New York Times*, July 14, 2017.

Basil of Caesarea. *On the Holy Spirit*. Translated by Blomfield Jackson. In *Nicene and Post-Nicene Fathers*, 2nd ser., vol. 8. Edited by Philip Schaff and Henry Wace. Buffalo: Christian Literature, 1895.

Belting, Hans. *The End of the History of Art*. Translated by Christopher S. Wood. Chicago: University of Chicago Press, 1987.

Benjamin, Walter. "Experience and Poverty." Translated by Rodney Livingstone. In *Walter Benjamin: Selected Writings*, edited by Marcus Bullock and Michael W. Jennings. Cambridge: Belknap, 1996.

————. "The Work of Art in the Age of Mechanical Reproduction." In *Illuminations*, edited by Hannah Arendt, 166–95. Translated by Harry Zohn. New York: Schocken , 1969.

Bois, Yves-Alain. "Whose Formalism?" *Art Bulletin* (March 1996) 9–12.

Boime, Albert. *The Art of Exclusion: Representing Blacks in the Nineteenth Century,* Washington, DC: Smithsonian Institution Press, 1990.

Butler, Alban, *Lives of the Saints.* Edited by Herbert J. Thurston, SJ. Westminster, MD: Christian Classics, 1990.

Chesterton, G. K. *St. Francis of Assisi.* 1923. Reprint, Peabody: Hendrickson, 2008.

Citron, Danielle, "Deep Fakes: A Looming Challenge for Privacy, Democracy and National Security." *The Center for Internet and Society*, https://cyberlaw.stanford. edu/our-work/topics/deepfakes/.

Clifford, James. *The Predicament of Culture: Twentieth-Century Ethnography, Literature, and Art.* Cambridge: Harvard University Press, 1988.

Copeland, Mathieu, ed. *The Anti-Museum: An Anthology.* New York: Koenig Books, 2018.

Cousin, Victor. *The Philosophy of Kant*, London: Chapman, 1854.

Crow, Thomas. *No Idols: The Missing Theology of Art.* Sydney, Australia: Power Publications, 2017.

Davis-Weyer, Caecilia. "The Caroline Books: A Frankish Attack on Iconodules." In *Early Medieval Art 300–1150: Sources and Documents.* Toronto: University of Toronto Press in association with the Medieval Academy of America, 1986.

Debord, Guy. "The Society of the Spectacle." Translated by Fredy Perlman. Kalamazoo: Black and Red, 1977.

Devega, Chauncey. "Toxic White Masculinity." *Salon*, Feb. 15, 2018. https://www.salon. com/2018/02/15/toxic-white-masculinity-the-killer-that-haunts-american-life/.

Dewey, John. *Art as Experience.* New York: Minton, Balch, 1934.

Dürer, Albrecht. *Underweysung der Messung (Treatise on Measurement).* Nuremberg, 1525.

Epitome of the Definition of the Iconoclastic Conciliabulum, Held in Constantinople, A.D. 754, from The Seven Ecumenical Councils of the Undivided Church, trans H. R. Percival, in *Nicene and Post-Nicene Fathers, 2nd Series,* edited by Philip Schaff and Henry Wace, 543–44. Reprint, Grand Rapids: Eerdmans, 1955.

Fried, Michael, "Art and Objecthood." *Artforum* 5 (June 1967) 12–23.

Gilman, Benjamin Ives. *Museum Ideals: Of Purpose and Method.* Cambridge: Boston Museum of Fine Arts and the Riverside Press, 1918.

Gombrich, Ernst. *The Story of Art.* New York: Phaidon, 1995.

Haidt, Jonathan, and Greg Lukianoff. "Why It's a Bad Idea to Tell Students Words Are Violence." *Atlantic*, July 18, 2017. https://www.theatlantic.com/education/archive/2017/07/why-its-a-bad-idea-to-tell-students-words-are-violence/533970/.

Hegel, G. F. W. *Aesthetics: Lectures on Fine Art.* Translated by T. M. Knox. Oxford: Clarendon, 1975.

Herodotus. *Histories.* Translated by G. C. Macaulay. New York: MacMillan, 1890.

Höller, Carsten. Interview with Vincent Honoré. https://www.tate.org.uk/whats-on/tate-modern/exhibition/unilever-series/unilever-series-carsten-holler-test-site/carsten

Irenaeus. *Against Heresies*. In *Ante-Nicene Fathers*, Vol. 1, edited by Roberts, et al. Buffalo: Christian Literature, 1885.

John of Damascus. *Apologia against Those Who Decry Holy Images*. In *St. John Damascene. On Holy Images*. Translated by Mary H. Allies. London: Baker, 1898.

Katz, Jackson. "Are We Witnessing a Crisis in White, Male Masculinity?" *Newsweek*, January 14, 2018. https://www.newsweek.com/are-we-witnessing-crisis-white-male-masculinity-781048/.

Kierkegaard, Søren. *Either/Or*. Translated by Howard V. Hong and Edna H. Hong. Princeton: Princeton University Press, 1987.

————. *Fear and Trembling*. Translated by Walter Lowrie. Princeton: Princeton University Press, 1941.

Krauss, Rosalind. "In the Name of Picasso." In *The Originality of the Avant-Garde and Other Modernist Myths*, 23–40. Cambridge: MIT Press, 1986.

Kresser, Katie. "Night Vision: Jacques Maritain and the Meaning of Art." *Image* 61 (Spring 2009) 45–56.

————. "Christ the Chimera: The Riddle of the Monster Jesus." *Image* 99 (Winter 2018) 38–47.

Kristensen, Troels Myrup. *Making and Breaking the Gods: Christian Responses to Pagan Sculpture in Late Antiquity*. Lancaster, UK: Gazelle Book Services with Aarhus University Press, 2013.

Lacan, Jacques. *The Seminar of Jacques Lacan: The Four Fundamental Concepts of Psychoanalysis*. Translated by Alan Sheridan. Edited by Jacques-Alain Miller. New York: Norton, 1998.

Ladd, George Eldon. *The Gospel of the Kingdom: Scriptural Studies in the Kingdom of God*. Grand Rapids: Eerdmans, 1958.

Laing, Olivia. "A Stitch in Time." *Frieze*, 13 Feb 2016. https://frieze.com/article/stitch-time-0

LaFarge, John. *An Artist's Letters from Japan*. New York: Century Co., 1897.

Langner, Dietlind, et al. *Gottesfreundschaft: christliche Mystik im Zeitgespräch*. Fribourg: Academic, 2008.

Lewis, C. S. *The Abolition of Man*. Oxford: Oxford University Press, 1943.

————. *Mere Christianity*. Rev. ed. 1955. Reprint, New York: HarperCollins, 2015.

————. "The Poison of Subjectivism." *Religion in Life* 12 (Summer 1943).

————. *The Weight of Glory*. New York: HarperOne, 2001.

Lewis, Thomas, et al. *A General Theory of Love*. New York: Random House, 2000.

Lilienfeld, Scott. "The Science of Microaggressions: Its Complicated." *Scientific American*, June 23, 2017. https://blogs.scientificamerican.com/observations/the-science-of-microaggressions-its-complicated/.

Malevich, Kasimir. *The Non-Objective World*. Translated by Howard Dearstyne. Chicago: Theobald, 1959.

Malraux, André. *The Psychology of Art*. Translated by Stuart Gilbert. New York: Pantheon, 1949.

Marck, Jan van der, and Enrico Crispolti. *Lucio Fontana*. Brussels: La Connaissance, 1974.

Maritain, Jacques. *Creative Intuition in Art and Poetry*. New York: Pantheon, 1953.

Maryland Historical Society. "Return of the Whipping Post." October 10, 2013. http://www.mdhs.org/underbelly/2013/10/10/return-of-the-whipping-post-mining-the-museum/.

Moorman, Mary Trevelyan. *George Macaulay Trevelyan: A Memoir.* London: Hamilton, 1980.

Morimura, Yasumasa. *Daughter of Art History: Photographs by Yasumasa Morimura.* Reading, PA: Aperture, 2003.

Noland, Rory. *The Heart of the Artist.* Grand Rapids: Zondervan, 1999.

Nudd, Tim. "Droga5's Sublime ad for Christie's Captures the Power of a Leonardo Painting Without Even Showing It." *Adweek,* November 10, 2017. https://www.adweek.com/creativity/droga5s-sublime-ad-for-christies-captures-the-power-of-a-leonardo-painting-without-even-showing-it/.

Pettegree, Andrew. *Brand Luther.* London: Penguin, 2015.

Picasso, Pablo. "Discovery of African Art." In Jack Flam and Miriam Deutch, *Primitivism and Twentieth-Century Art: A Documentary History,* edited by Jack Flam and Miriam Deutch, 33–34. Berkeley: University of California Press, 2003.

Plato. *The Republic.* Translated by Benjamin Jowett, 1871. http://www.gutenberg.org/files/1497/1497-h/1497-h.htm.

Pliny the Elder. *The Natural History.* Translated by John Bostock and H. T. Riley. London: Taylor & Francis, 1855.

Pugin, A. W. N. *The True Principles of Pointed or Christian Architecture.* London: Weale, 1841.

Ramirez, Mari Carmen. "Brokering Identities: Art Curators and the Politics of Cultural Representation." In *Thinking about Exhibitions,* edited by Reesa Greenberg et al., 21–37. New York: Routledge, 2007.

Reyburn, Scott. "Get in Line: The $100 Million Da Vinci Is in Town." *The New York Times,* Nov. 13, 2017.

Reynolds, Joshua. *Discourses.* London: Walter Scott, 1887.

Rookmaaker, H. R. *Modern Art and the Death of a Culture.* Downers Grove, IL: InterVarsity, 1970.

Salz, Jerry, and Rachel Corbett. "How Identity Politics Conquered the Art World." *New York Magazine,* April 2016. https://www.vulture.com/2016/04/identity-politics-that-forever-changed-art.html/.

Schapiro, Meyer. "Cain's Jaw-bone That Did the First Murder." *Art Bulletin* 24:3 (September 1942) 205–12.

Schindler, D. C. *Hans Urs von Balthasar and the Dramatic Structure of Truth: A Philosophical Investigation.* New York: Fordham University Press, 2004.

Schwarz, R. C. *Internal Family Systems.* New York: Guilford, 1995.

Sennett, Richard. *The Fall of Public Man.* New York: Knopf, 1977.

Sheingorn, Pamela, ed. *The Book of Sainte Foy.* Philadelphia: University of Pennsylvania Press, 1995.

Shklovsky, Viktor. "Art as Technique." In *Twentieth-Century Literary Theory: A Reader,* edited by K. M. Newton, 3–5. 2nd ed. New York : St. Martin's, 1997.

Small, Zachary. "Has the Salvator Mundi *really* gone missing?" *Hyperallergic,* January 10, 2019. https://hyperallergic.com/479260/has-the-salvator-mundi-really-gone-missing-unpacking-the-latest-conspiracy-theory/.

Sokolove, Deborah. *Sanctifying Art: Inviting Conversation between Artists, Theologians and the Church.* Eugene, OR: Cascade Books, 2013.

Steele, Richard B. "Violence as Spectacle, Sacrifice as Icon." https://blog.spu.edu/signposts/violence-as-spectacle-sacrifice-as-icon/.

Suzuki, Michitaka, "Invisible Hibutsu (Hidden Buddha) and Visible Icon." 2011. https://www.academia.edu/7934756/Invisible_Hibutsu_Hidden_Buddha_and_Visible_Icon/.

Taylor, Charles. *A Secular Age.* Cambridge: Harvard University Press, 2007.

Tertullian. "Against Praxeas." Translated by Alexander Roberts and James Donaldson, in *Ante-Nicene Fathers*, Vol. 4. Edinburgh: T. & T. Clark, 1885.

Tillich, Paul. *The New Being.* New York: Scribner, 1955.

Tolstoy, Leo. *War and Peace.* Translated by Richard Pevear and Larissa Volokhonksy. London: Penguin, 2008.

Tzara, Tristan. "Second Dada Manifesto." 1918. https://391.org/manifestos/1918-dada-manifesto-tristan-tzara/

Weintraub, Linda. *Art on the Edge and Over.* New York: Art Insights, 1996.

Zizioulas, John D. *Being as Communion: Studies in Personhood and the Church.* Yonkers, NY: St. Vladimir's Seminary Press, 1997.

Lightning Source UK Ltd.
Milton Keynes UK
UKHW022304070223
416603UK00012B/220